PAINTING FROM SKETCHES PHOTOGRAPHS AND THE IMAGINATION

Don Rankin

PAINTING FROM SKETCHES PHOTOGRAPHS AND THE IMAGINATION

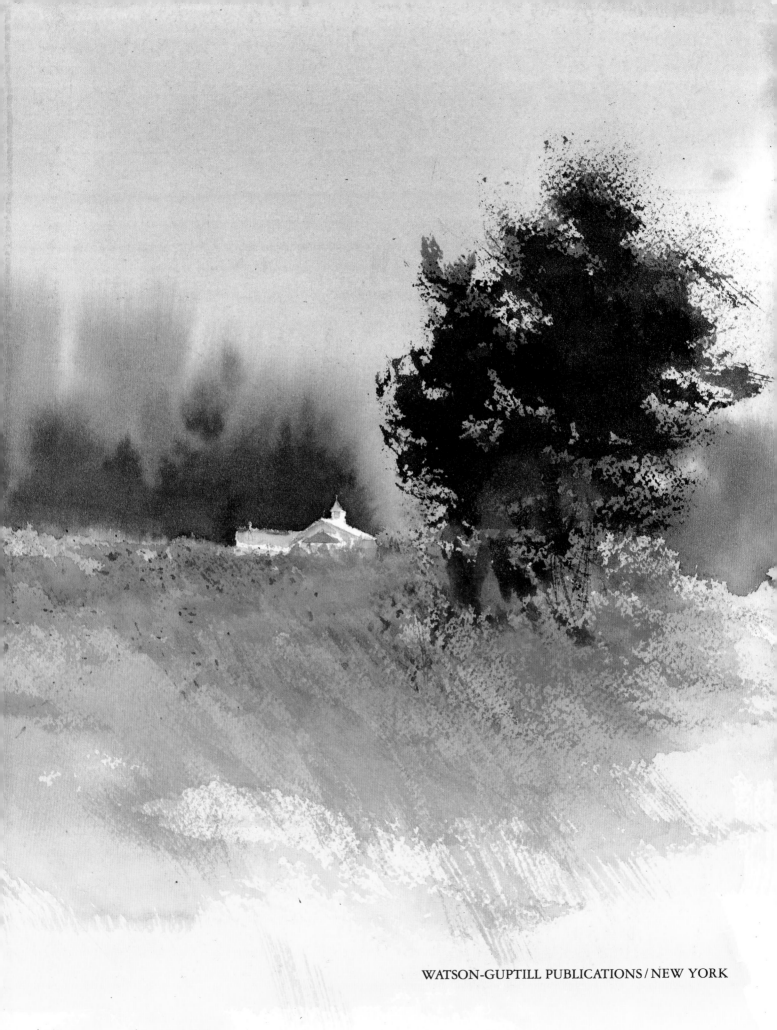

WATSON-GUPTILL PUBLICATIONS / NEW YORK

To my wife, Geneal, for her support
and the uncanny ability to know
what I should do before I do it, and
for our two children, David and Carol.
You have all enriched my life.

Paperback Edition
First Printing 1990

Copyright © 1987 by Don Rankin

First published in 1987 in New York by Watson-Guptill Publications,
a division of BPI Communications, Inc.,
1515 Broadway, New York, N.Y. 10036

Library of Congress Cataloging-in-Publication Data
Rankin, Don.
 Painting from sketches, photographs, and the
imagination.
 Includes index.
 1. Watercolor painting—Technique. I. Title.
ND2420.R364 1987 751.42′2 87-10478
ISBN 0-8230-3638-3
ISBN 0-8230-3637-5 (pbk)

Distributed in the United Kingdom by Phaidon Press Ltd.,
Musterlin House, Jordan Hill Road, Oxford

Manufactured in Japan

1 2 3 4 5 / 93 92 91 90

ACKNOWLEDGEMENTS

I shall always give thanks to God for His grace and the talent He has bestowed upon me. I also thank Him for the many people in my life who have helped me along the way.

To my editors: Mary Suffudy for your vision and your patience in seeing this project through.

Candace Raney for your patience and endurance through so many manuscript revisions.

To my art director: Bob Fillie for excellence in design.

To my family: For your sacrifice, patience, and understanding.

Contents

This book is an attempt to deal with the subject of creating art. More specifically, it is about how I create my art and some of the tools I employ in that creative process. As its title states, this book deals with sketching and the imagination in conjunction with the use of a camera. Many artists wonder how to combine the technical advantages of the camera with their art making process without "selling their soul" to a mechanical dictator.

I realize that among artists cameras can be a sensitive subject. In fact, I have heard of artists who occasionally make use of a camera but who will completely deny that they use photographic references in their work. Other artists reluctantly admit to the ownership of a camera, and still others completely disavow the camera and will try to make you feel guilty if you even admit to owning one. Happily, there are some artists who recognize that the camera is a wonderful advancement and that like any tool it has advantages as well as disadvantages. In my early painting years, I purposely did not own a camera, and I refused to purchase one for fear that it would compromise my work. After ten years of hard work, I bought my first 35mm single lens reflex camera.

At first, my experiences with photography were sharply divided from the business of painting. (I was the art director of an advertising agency, and photography was an important part of my job.) It took several years for the two disciplines of professional photography and the art of watercolor painting to begin to overlap in my work. Today, I use the camera from time to time, as a valuable piece of equipment in developing reference material for my painting sessions. In no way do I feel that the proper use of photography inhibits or hampers my work.

In general, I have avoided developing a lot of "step by step" solutions in this book. Rather, the book is an analysis of the process of making paintings. My personality dictates that I use several approaches in creating my art. These approaches all seek to accomplish one thing: the creation of subtle, hopefully powerful paintings. In each section, I have tried to give personal insight into my approach and discuss why I chose a specific procedure for a particular painting. I only have one unchangeable rule that I follow: I never adhere to a rigid formula in creating any work of art. Although a body of work will tend to have similarities, I always try to let each subject dictate my solution. I have also tried to blend enough necessary technical information concerning cameras and lenses, with the most important ingredient—the spirit of creating art.

Throughout this book, I discuss the role of the camera in making art, but bear in mind that I am appraising the camera from a representational artist's standpoint—not from a photographer's point of view. While both the painter and the serious photographer seek to make an artistic statement, their methods are not the same. For the painter, the photograph is not the final product. As an artist, I approach art via the paintbrush. I can take a photograph and utilize a portion of it or all of it. Just like painting on location, I can change the season, time of day, or any other physical characteristic of the scene if I so desire. I can take flights of fancy based upon emotions or sensations the photographic image may inspire. If need be, I can combine several photographs to produce a different image or setting. I have a freer reign to create or adapt. In this way the camera becomes a modern recording device that helps to enrich my sketching time with fuller images that will help to reinforce memories of the site long after the encounter.

If you seek to use the camera in hopes that it will remove the burden of sketching and planning from your creative shoulders, then perhaps this book is not for you. In my estimation, sketching and planning are absolutely vital, for sketching charges your creative batteries and produces energy for your creative mind. As you work on your sketches, you will begin to rely more on your inner feelings and less upon the frozen image before you in the photo. Allow your inner feelings to direct and inspire you in design and color decisions. Seek at first to understand the technical, so that you have a sound foundation, but then dare to respond to your creative center. As the artist you can weave your own reality from the experiences around you. It is my hope that this book will help you understand the possibilities.

—Don Rankin

Bald Eagle, egg tempera, 24″ × 28″ (60.96 × 71.12 cm).

Basic Working Methods

This first section is about my basic working methods, but I want to stress that I don't approach every work in the same way. Very often a painting is a quick, fleeting thing for me. I see a subject, my response is immediate, the painting develops rather quickly, and I go on to something else. Then there are those paintings that come into this world kicking and fighting all the way until the concept for the work has become firmly entrenched in my mind.

I think the important thing to remember here is that I am suggesting a system for gathering information. For me, the key to successful painting begins at this stage, where I explore as many of the possibilities as I can. Years ago, as a young art student, I was constantly urged to plan ahead and make sketches. But I was terribly impatient. Back then I didn't have time for sketches and planning; I wanted to jump right in and paint. After a period of time I learned that I needed to develop patience and discipline in order to produce successful paintings. So now, I gather my information carefully, storing the fire for the final painting.

The subject matter you will see throughout this section is an old house that has been converted to an antique shop. I have been familiar with this subject for many years and remember it well when it was an abandoned, derelict building. However, it has only been in the last two years that I finally decided to take the subject seriously and considered it as material for a painting. Bear in mind that for many years I had a mild attraction but nothing really strong enough to take me beyond the observation stage. Something about the house's interlocking forms intrigued me, but the key to stating this through watercolor continued to be elusive. The series of photographs you see will give you an idea of the type of analysis I employed while searching for the key that would set the painting free.

I took over twenty photographs at this location. Any number of the shots could provide subject matter for sketches or paintings. These photos represent my search for a key element, or shape, or anything to set my energies working. Therefore, the photo process is very methodical, very analytical; I don't want to leave any possibility untouched. Also, by gathering information photographically I am sure to have ample detail material.

BEGINNING TO PHOTOGRAPH

Since I am quite familiar with the site, I already know that the lighting is best at certain times of the day. All of these slides (opposite page) were taken around 3 PM. With each frame, I moved laterally to the left. Note the shadows in the driveway, and that each shift of my position reveals a different accent on lighting.

Color Reference Photographs 1–4. The first four slides helped me to see a general *overview* of the buildings and grounds. This overview helps me to see the basic shapes and how they relate to one another.

Color Reference Photographs 5–6. In these three shots, I decided to move in a little closer in order to gain a little more detail. While my first four shots helped me to have a general overview, these photos help me to see *specifics*. In this series, I moved to the right in order to examine several angles of the house and the caboose.

Color Reference Photographs 7–8. When the subject is too big to fit into my camera's viewfinder, I use the panorama, or "pan," shot. If you put the two shots together like a puzzle, you will have an entire view of the caboose as well as the house. I discuss this technique in more detail on pages 124–125.

Color Reference Photographs 9–11. This is a classic example of panning a subject in order to get as much detail as possible. Considering the size of the caboose and the restricted space I had to work in, this was the only logical way to capture the subject on film, without using a lens that might tend to distort the image. Once again, if you put the pictures together, overlapping where necessary, you have one big caboose.

Color Reference Photographs 12. This is a detail shot of a lantern I found on the caboose. It made an inviting subject, especially with the foliage as a backdrop, so I captured it on film. Time will tell if it ever develops into something more.

Color Reference Photographs 13–15. Now it was time to move to the front of the building to see the shop as most people see it everyday on the road. This view is from the east. In three of these photos I concerned myself with the detail around the front door. The final shot shows a detail of the upstairs windows.

Color Reference Photographs 16–18. In this series I began near the entrance and started to walk away from the buildings. Once again, not only did I want detail, but I wanted to see how the shapes fit into the landscape from this angle.

Color Reference Photographs 19–20. In the last color shots, I left the road and wandered over into the grass near the large water tank that now dwarfs the antique shop. I wanted to get a view from this area. I also wanted a closer look at the large oak trees near the shop.

1

2

3

4

5

6

7

8

9

10

11

12

13

14

15

16

17

18

19

20

Basic Working Methods

Black and White Reference Photographs. I almost always prefer to use black and white film, because when I record a site on film, I am most interested in the basics of elemental shapes and forms that comprise the scene. Those shapes and forms are best captured in black and white, in essence they reveal an abstraction of the real scene. By using black and white film, I am able to isolate the forms away from the prevailing natural color and also to interpret color any way I see fit.

That doesn't mean that I don't make use of good color photography. I am moved by color and I enjoy capturing it in my paintings. And color photographs can be helpful for capturing the color in any scene. They can also give you a clue as to what the dominant color scheme is at a particular site.

The following black and white shots were taken around 9:30 AM on a clear day. If you compare the shapes of the highlights and shadow values between the morning and afternoon (when the color photographs were taken), you'll see the character of the scene change. This subject is no exception. I am sure that each reader can think of similar situations you have encountered.

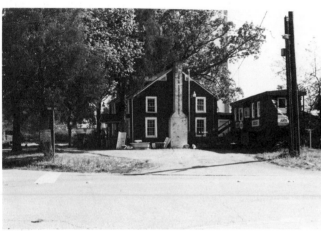

PHOTO 1

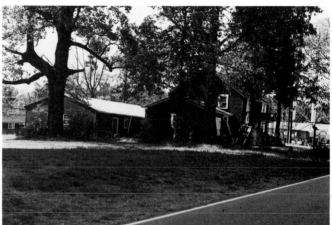

PHOTO 2

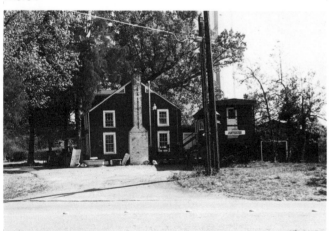

PHOTO 3

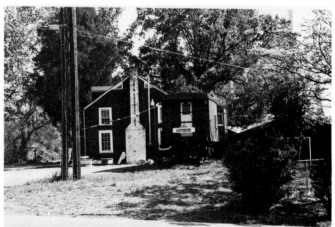

PHOTO 4

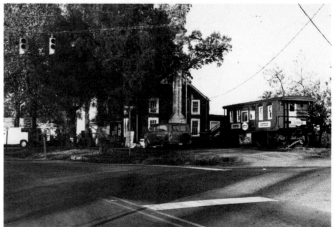

PHOTO 5

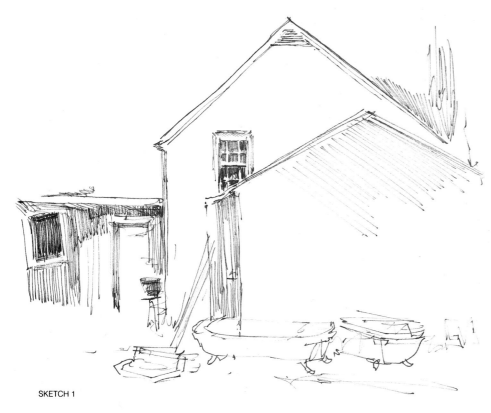

SKETCH 1

DEVELOPING A CONCEPT—SKETCHES

The sketches you see here were done pretty much at the same time I took the photographs. After the photos were developed, some sketches were modified and further refined.

My first sketches were the ballpoint line sketches. These show all of the angular planes of the buildings converging into one another. On both sides of the shop there are planes that jut out toward you. For example, in these two sketches it is the garage that comes out toward you. On the other side, the red caboose creates the same type of tension. This projecting form is one of the things that intrigues me about the subject. These first line sketches explore the relationship of a projecting form to the form it's attached to.

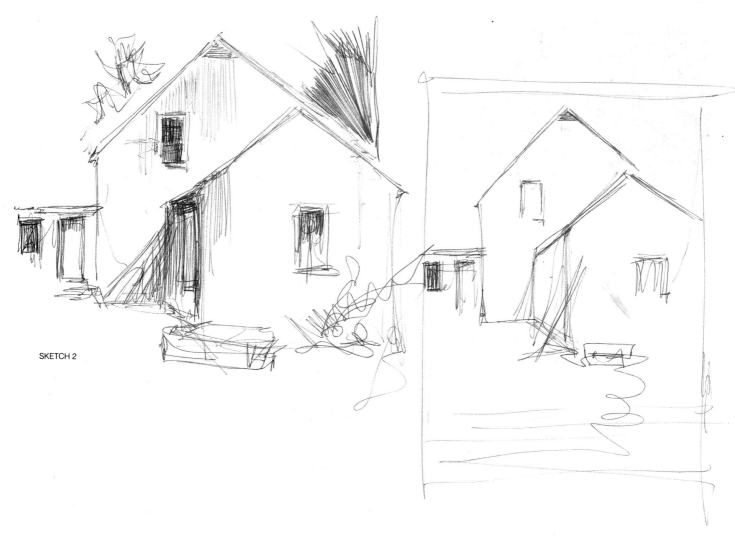

SKETCH 2

Basic Working Methods

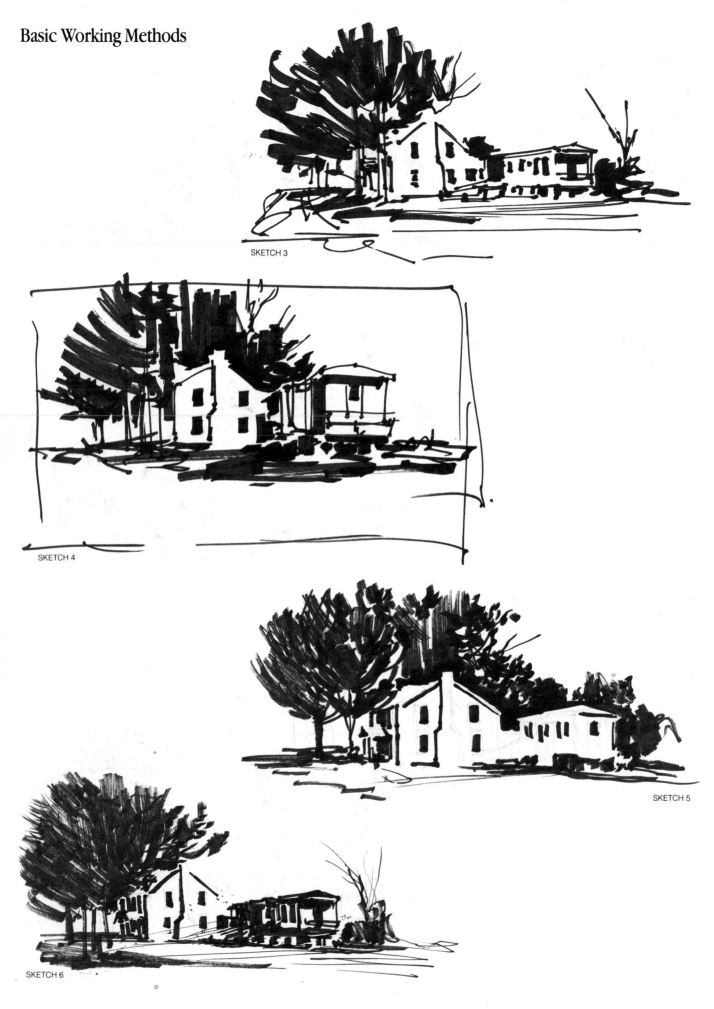

SKETCH 3

SKETCH 4

SKETCH 5

SKETCH 6

When working in the field I like to use a wide-nib, felt-tip marker. Years ago this medium intimidated me greatly; worst of all—it had no eraser! it also left big, bold marks on my paper and that scared me. After a while, however, I realized that all of these difficulties were actually blessings. Now I favor this choice of sketching tool because it is fast and direct. By using the wide-nib marker, I can translate my sketches into simple, bold black and white shapes. In these sketches there is no middle ground, just stark black against white. The starkness means I can "prove" my design very easily. Very simply put, either the sketch works or it doesn't work. I study it and look for alternatives until it does work. Attempting to paint from a poorly realized sketch is only a waste of time. If you look at sketches 3–8, you will see that I keep alternating the angle or point of view. In sketches 3, 5, and 6, you see more of the side of the caboose, and in sketches 4, 7, and 8 you see less. Sketch 9 shows you the view from the other side of the house. Light patterns are also explored in these sketches.

Probably the most important thing to observe in these sketches is that I constantly simplify shapes; I am not trying to copy a photograph. While I am trying to maintain a likeness, I have no qualms about removing elements that don't seem to work for me. The approach I use is basically the same whether I am using a photo as my model or the actual scene. Look at the shapes of the trees, study the movement of the shadows, compare these elements as they appear in the photo, and then look at the sketch.

SKETCH 7

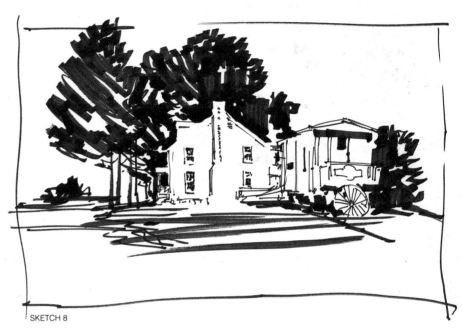

SKETCH 8

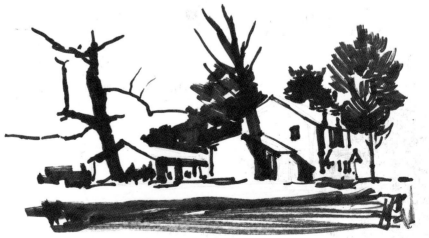

SKETCH 9

Basic Working Methods

Unlike the photos, in the sketches the jump from light to dark is abrupt. But there are still important relationships between the photos and the sketches. If you squint and look at the photo, the first thing that will happen is the loss of unnecessary detail; your eyes will get down to the basic shapes, which are reflected in the sketch. Perhaps you don't agree with my particular arrangement of forms, and you find that your own way is much more satisfying. Well, so much the better. It means you understand the concept of arranging shapes harmoniously. Successful sketches and ultimately fine paintings are built in large measure upon a balanced arrangement of the large shapes.

When sketching from photographs, try not to be too literal minded, or you will be worried about all sorts of unnecessary things. You'll be concerned about the number of windowpanes or the slats in the shutters before you have even built the foundation of the house. Even though these details may have some importance to your overall painting scheme, absolutely nothing must stand in the way of your starting your painting upon a firm foundation. That foundation will be the realization that strong basic shapes properly related to one another form the beginning of a good painting. Just as no good cook would try to cover up a bad cake with fancy icing, you can't expect the literal details gleaned from a photo to cover up poorly conceived compositional plans.

WATERCOLOR STUDIES

Once my sketches were completed, I decided to explore some color ideas through watercolor. The actual painting borrowed ideas from sketches 3 and 8. I began by painting the site as I had initially seen it, with the sky blue and the foliage green. Unfortunately, I didn't like the result. Although it adheres closely to the actual scene, it just didn't excite me. I knew there was a painting in this, but what I had done was not the answer. There was more to be done with this subject. For one thing, I didn't like the way the shapes related to one another, and I wasn't pleased with the color, which lacked force and sparkle.

Color Studies. On a Shoestring (opposite page, top) is a prime example of a near miss because the photo and the site were allowed to exert too much authority. If you compare the scene with the photos, you can see that a lot of the detail was simplified. This is as it should be, but I felt that my colors were too dull: The reds could have stood a little more strength; and the shadow patterns needed to be intensified and developed further.

It was time to try again. This time I decided not to make the translation so literal. For *Evening Sun* (opposite page, bottom), I reached into my memory and recalled the effect of the late afternoon sunlight in autumn when the sky turns golden. To capture this effect, I allowed the washes to become freer and respond to the vision inside of me instead of to the vision in the photograph. While I was still faithful to my subject matter, I had a greater desire to respond to my inner feelings about the subject.

Evening Sun is based on the same sketch as *On a Shoestring,* although a few minor modifications have been made around the platform and underneath the caboose. But basically the sketches are the same. The primary change is in the palette and in the strength and arrangement of the shadows. If you examine black and white photo 5, you should be able to see the faint suggestion of the light and shadow play on the house and caboose. In *Evening Sun,* I have used the warmer, fall-like colors to create an essentially warm painting that still contains a lot of contrast. Note, too, that I made an alteration in the house's entrance by trimming the foliage back a bit so that the front of the house is more exposed. If you look at black and white photos 1, 3, and 5 (page 12), you'll see how certain aspects of these shots have been combined. For example, the basic angle comes from photo 5 while 1 and 3 provide additional information. The final sketch is a composite of more than one photograph. As the artist you can do something the camera can't do—you can gather specific information from more than one angle and put it all together in a single painting.

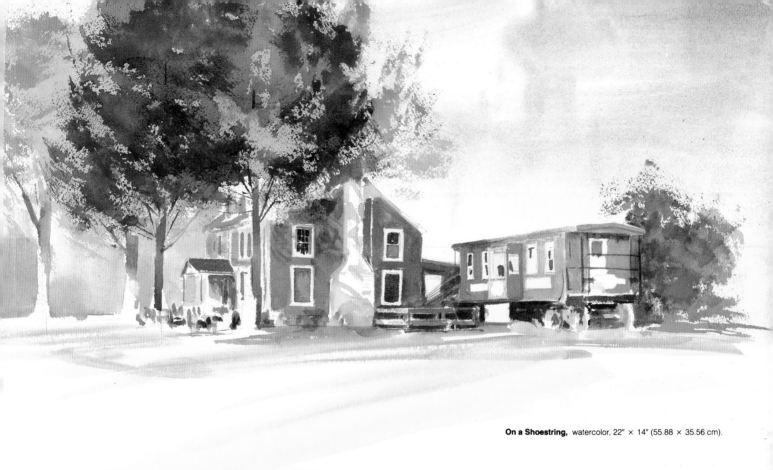

On a Shoestring, watercolor, 22″ × 14″ (55.88 × 35.56 cm).

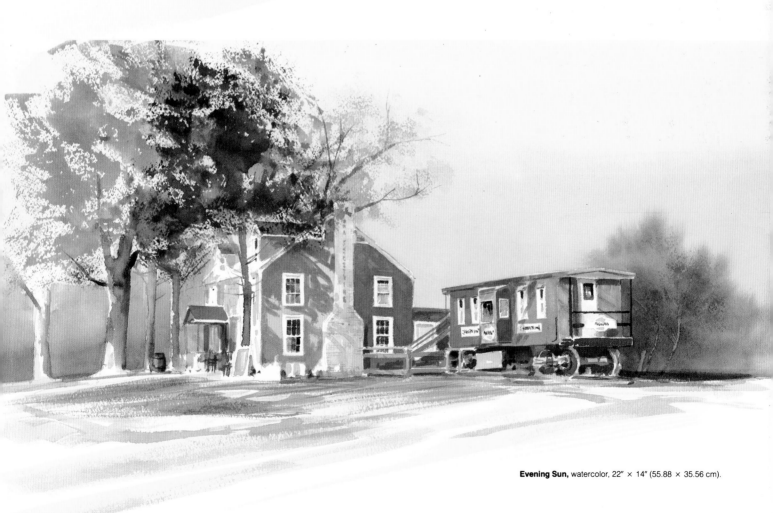

Evening Sun, watercolor, 22″ × 14″ (55.88 × 35.56 cm).

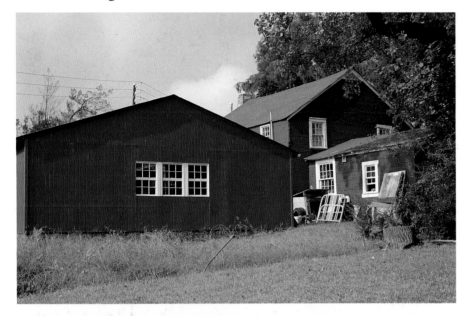

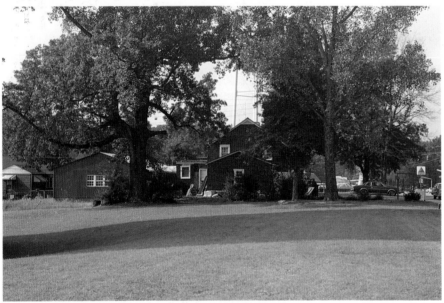

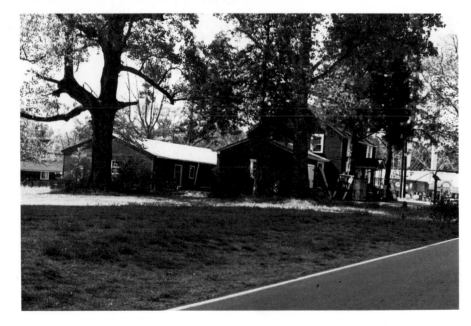

A VIEW FROM THE OTHER SIDE

I wasn't completely sold on my progress. For some reason, I still felt that I hadn't captured all the potential in this scene. I remembered that during my sketching and photo sessions, I kept coming back to the play of light as it crossed the eastern exposure of the house. You can see this in color photos 19 and 20, but it is best revealed in the black and white photo 2. That photo was taken around 9:30 in the morning, when the light was exceptionally beautiful. So even as I worked at recording the other side of the building, the view from the east side haunted me. I especially liked the shaft of light that ran diagonally across the ground from the road to the bluff behind the house. This light is set off by the presence of the darkened road that passes the house.

Color Studies. My first color study (opposite page, top) is a very straightforward rendition that depicts the subject as I saw it on the day I was working. However, I didn't feel strong enough about it to paint it that way. Somehow I kept seeing the scene in another context. I then recalled a terrific ice storm we had had a few years back, when the mountain where I live was a wonderland of ice and snow. In particular, I remember that the area around the old house caught much of the full force of the storm. So I found that, as I began to play with the shapes and the angles, I felt compelled to turn the scene into a winter one. The quick value study (opposite page) confirmed these feelings.

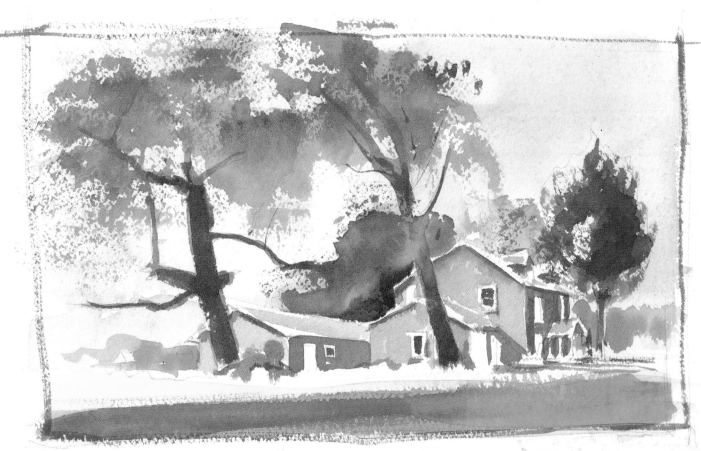

COLOR STUDY 1

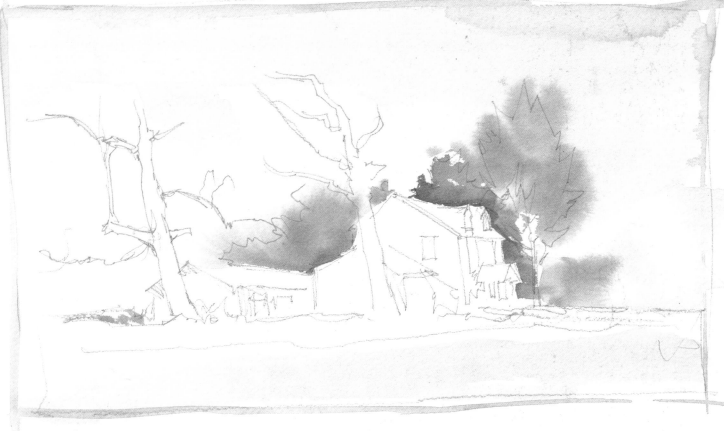

COLOR STUDY 2

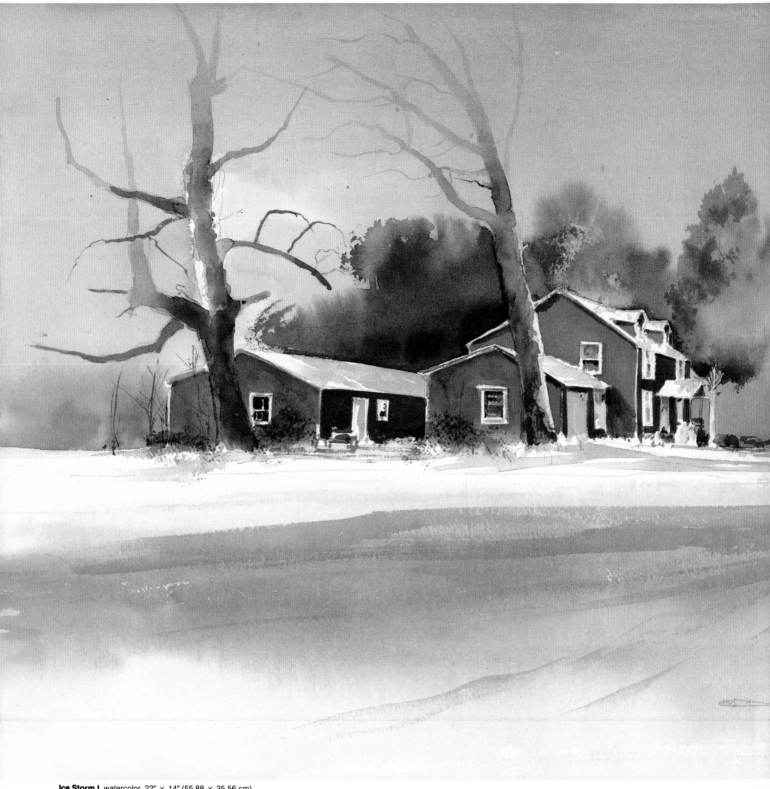

Ice Storm I, watercolor, 22″ × 14″ (55.88 × 35.56 cm).

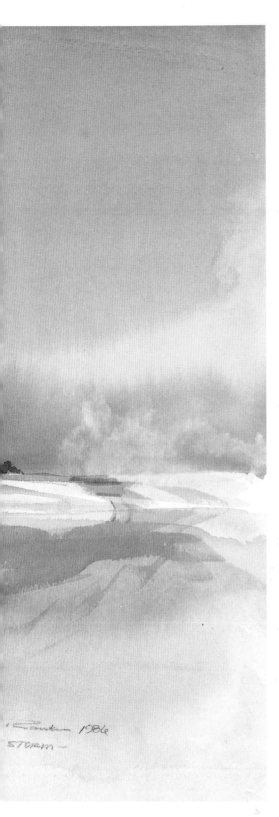

STORM

Preliminary Paintings. At first glance these two works are rather similar, but if you look closely, you'll see that they are different in many respects. I also feel that one is more successful than the other, and the following is a discussion on the relative merits of both interpretations.

My first attempt *(Ice Storm I)* that you see on this page was based on a palette of Winsor blue, new gamboge, vermilion, and Winsor red. Since I wanted to capture the atmospheric quality of the heavy clouds and mist, I worked the first washes using a wet-into-wet technique. The treatment of the trees behind the shop helps convey the feeling of mistiness. This effect was accomplished by continuing to apply washes of Winsor blue to a dampened surface. I did this by applying one wash, letting it dry, then dampening the area again, and applying another layer of wash. The gradations of the mixture of Winsor blue and Winsor red helps to create the misty appearance. Although many of the washes behaved well in this little watercolor, the basic flaw lies in the preliminary drawing. For my taste, the houses look awkward and stiff, and the two big trees in the middleground seem overly large.

As I continued to analyze the problem, I decided that the basic sketch was the culprit. It was just too faithful to the actual photograph. The buildings are almost perpendicular to the ground and while this is perhaps a desirable trait architecturally, it doesn't do a whole lot for the mood I'm after.

In *Ice Storm II* (pages 22–23), I am more concerned with how the shapes interact and relate to one another. There is no merit in being technically accurate but still producing a dull painting. While I don't think you have to trade accuracy for expression, there are times when you need to take liberties. For me, this was one of those times. In the second attempt, I feel that the shapes are flowing and interacting with one another in a more pleasing manner. Although many of the elements are almost identical in the two pieces, the key changes are in the trees and the building shapes. First, the size relationships of the various parts of the house have been altered. The building behind the house is smaller in the second attempt, which makes the house and garage appear larger. As a result, they seem to take on a more important role.

Attention to subtle detail is also more apparent in the second attempt. The main house now leans just a little to the left, to suggest years of strain against the wind, and the light source has a more enhancing, softer effect than in the first version. The mass of trees behind the house, as well as building forms, have been slightly reduced and moved slightly to the left of the picture, a change which helps to balance the forms of the painting better. Also, the sense of depth in the second version is stronger because the various levels of the picture plane are more developed. Finally, the sign in the front yard helps to accentuate the flow, or direction of movement, in the painting.

In the end it's up to you to see which of these versions is the most successful. Do you agree that the changes I made in *Ice Storm II* make an improvement in the work? To my mind, the first attempt allowed the photos to hamper the development of the work instead of enhance it. In the second, approach, the photo was used as a valuable aid but artistic license ruled and had the final say in the creative process. I think it vital to keep this in mind as you work with photography. Let it be your helper but suppress its attempts to master your own inclinations.

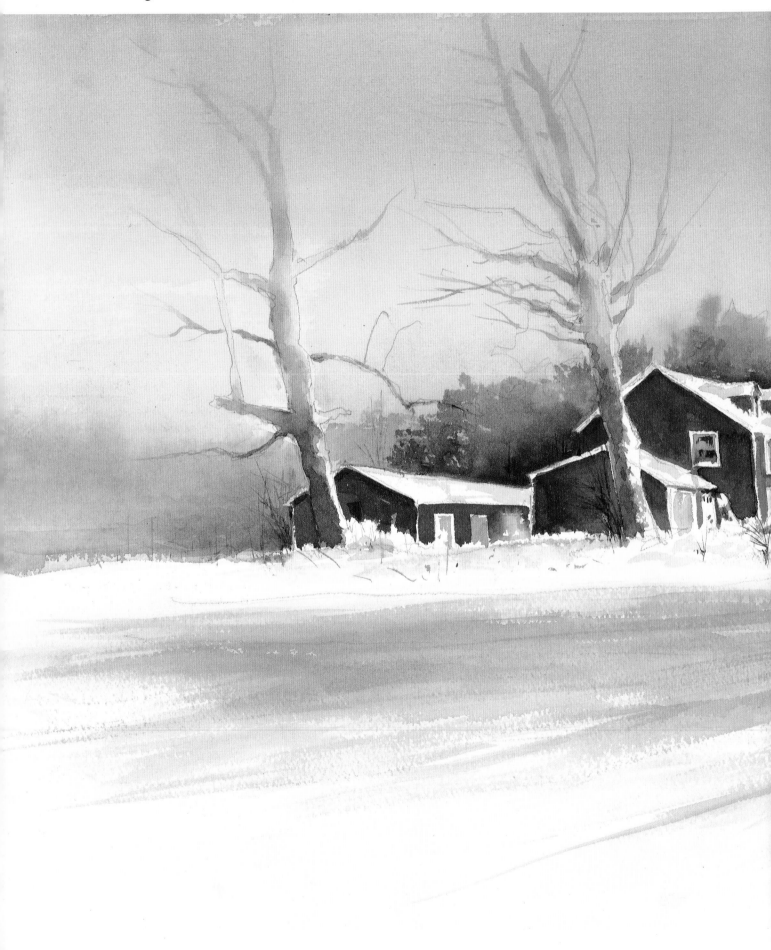

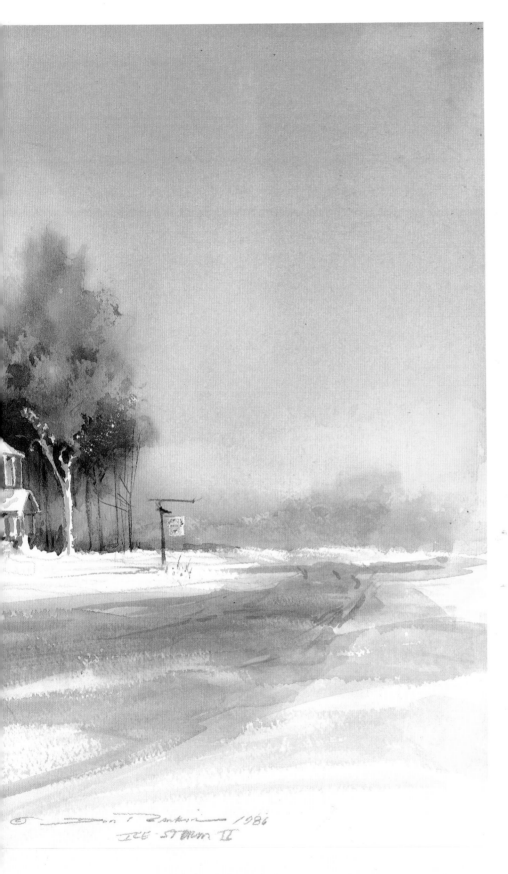

Finished Painting (overleaf). My solution for *Ice Storm III* revolved around its design. If you go back and examine the photographs, no doubt you will see many of the details that were eventually used. But you will also see that I have made several alterations to the photographic image. First, I simplified some of the shapes, especially the trees in the background. Rather than being concerned with individual trees, I allowed this portion to become a moving band of variable color. In some ways this is not a radical departure from the earlier attempts, except that this time the shape is more simplified. Second, I have rearranged the trees in the middle ground. I pulled the two large trees closer together and allowed the limbs to weave together, thereby creating a sweep that extends down the trunks and into the cluster of buildings. I have also emphasized the atmospheric effect by allowing the tops of the trees to disappear into the mist. Although it's true that I am altering reality, I am also making my design stronger. Now the trees blend into the buildings and both shape areas become an interesting unified form.

Additional changes include creating two softly focused fir trees in front of the old house. This was done for effect and to help create an intriguing patch of light through the trees. Turning a light on inside the old house also establishes contrasts of color temperature and color values.

Once these changes were made, I decided to create a snowfall effect. I did this by loading a toothbrush with white acrylic and splattering the entire painting. Holding the brush close to the paper, I aimed the splatters diagonally to create the wind-blown effect of blowing snow.

Summation. The camera is a wonderful tool for the contemporary artist, but it must be used with caution. Learn to use photographs for what they are—a highly effective means of gathering information. But never be misled into believing them to be the final authority on reality.

Ice Storm II, watercolor, 22″ × 14″ (55.88 × 35.56 cm)

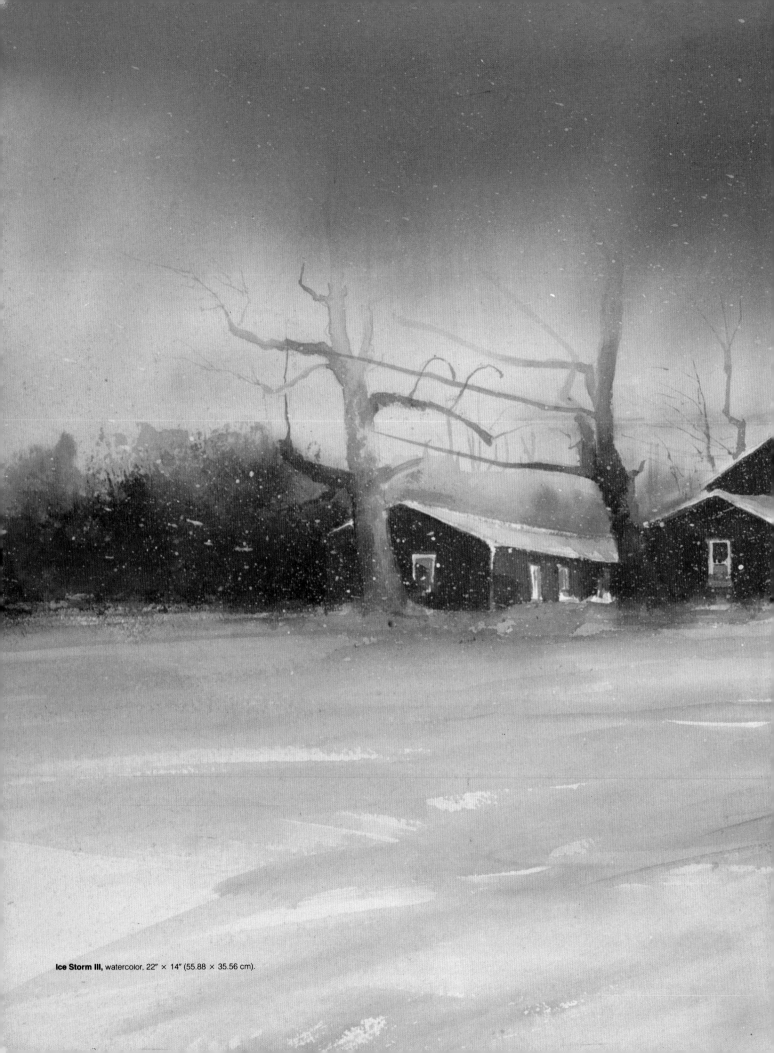

Ice Storm III, watercolor, 22″ × 14″ (55.88 × 35.56 cm).

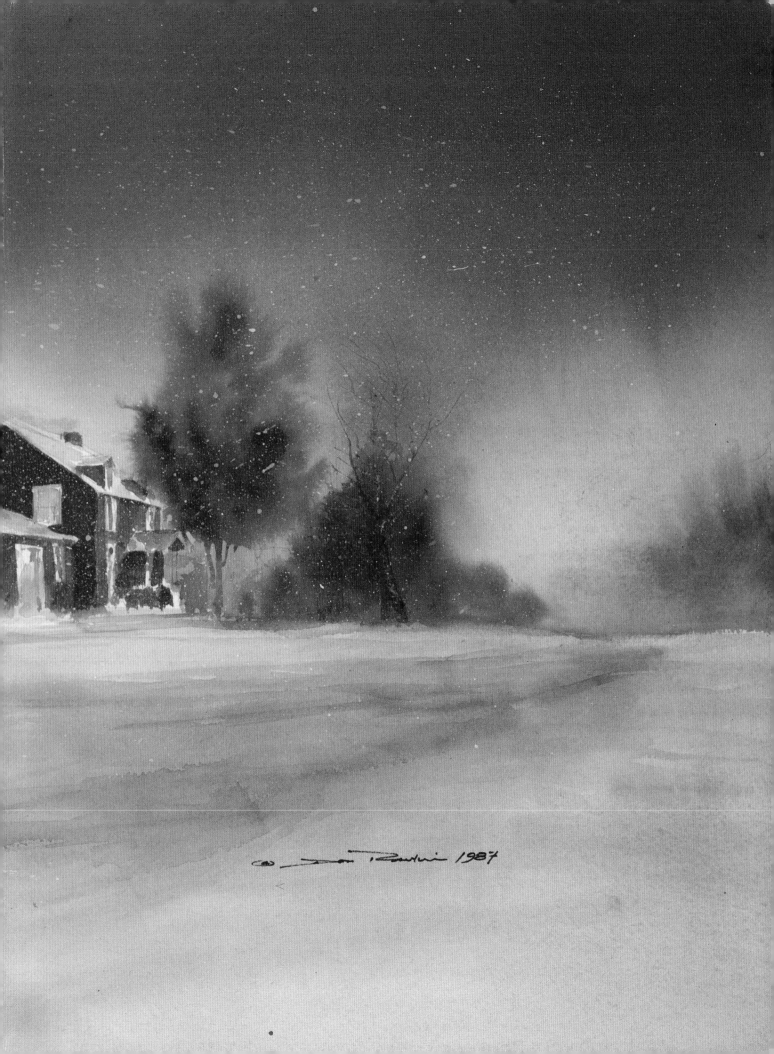

50mm

105mm

A COMPARISON OF LENSES

One of the many advantages of the 35mm single lens reflex camera is the availability of interchangeable lenses. In a short period of time you can shift from a wide angle, to a telephoto, to a macro lens for intricately detailed close-ups of nature's wonders. In short, your lens plays a tremendous role in developing the final image you see on your film.

It is important to understand that not all lenses "see" the subject in the same way as your eye sees it. Thus, if you want to paint subjects that look natural, this is an important point for you to consider. Lenses with a focal length of 50 to 58mm are considered to be "normal" lenses. They are designated this way because their angle of view most closely approximates the angle of the human eye. The normal human eye has an angle of view around 43°. The normal type lenses mentioned here will have an angle of view of approximately 45° to 50°.

Many camera buffs soon tire of the 50mm lens because it views the world pretty much as we see it. In a quest

for variation, some artists want to express the world in a slightly altered state via their camera. As the artist you are completely free to interpret and rearrange the world to suit your vision. However, keep in mind it's not a good idea to go out shooting with the intention of gathering information with a lens that distorts reality. Once you become aware that all photographs are not necessarily a true rendition of the world as we see, you are off to a good start.

In my work, I typically use two lenses. My first choice is a Nikkor 50mm *f*/1.8. It is excellent for scenery, snapshots, and for close-up work. My other favorite is a Nikkor 105mm *f*/2.5. While this lens doesn't fall into the usual "normal" category, I use it because it makes an excellent portrait lens. An advantage that this particular lens has is that it eliminates the tendency that other lenses have to distort the human face. As you look at the photographs here, note that the 105mm lens makes the subject matter appear larger in the frame.

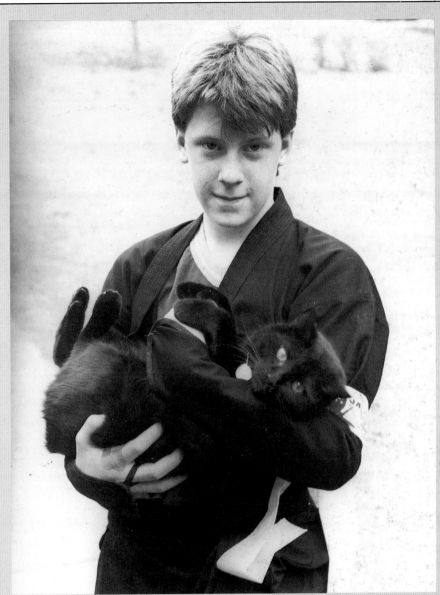

This portrait shot of my son, David, and his cat was taken with a 105mm lens.

Exploring Positive and Negative Shapes

Using photographs is one way to think about and plan your paintings. If you are not aware of certain principles for analyzing photographs in preparation for painting, the picture can beguile you and lead you astray.

The black and white value studies you see in this section reduce shapes to their simplest forms, to a clear-cut, graphic black and white. Accompanying these value studies are color interpretations of the scene. These color sketches soften the severity of the two-value sketch by adding middle-tone values. They are included here as a necessary bridge to the finished painting. They are also helpful for seeing how values translate from black and white into color.

TRANSLATING COLOR INTO A VALUE STUDY

The photo above was taken at a boat-yard. I was immediately attracted by the placement of the shapes here and by a certain potential that I saw. If you squint and study this shot, you'll see the detail melt away and see nothing but shapes. By doing this, you allow the subject to become a negative image. This happens because the subjects of interest—the boat and the boathouse behind it—are lighter in value than all the surrounding shapes. When you plan your sketches and paintings, you will use either a positive image (where the subject is darker than the surrounding objects) or you will use a negative image (where the subject is lighter than the surrounding objects). As you gain skill you can modify this rule, but if you are having trouble with your paintings, it's best to begin by simplifying your images either to positive or negative.

TWO-VALUE STUDY 1

TWO-VALUE STUDY 2

TWO-VALUE STUDY 3

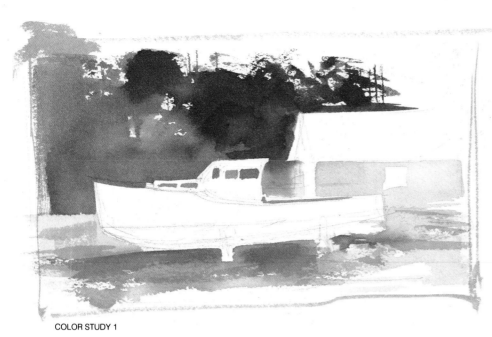

COLOR STUDY 1

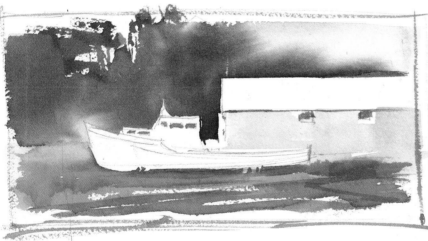

COLOR STUDY 2

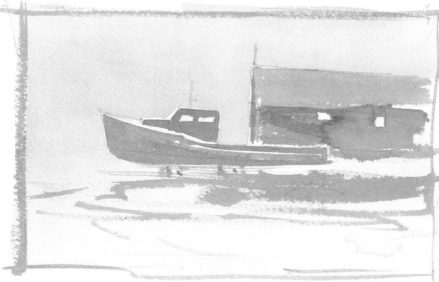

COLOR STUDY 3

To reduce a scene to its essential components, you must first remove as much detail as possible without destroying the identity of your subject. Look at the lightest value elements in the boatyard photo. Note that the sky, the building, the boat, and the rocks are all very light in value. Because my intention was to paint the boat, the boat becomes the primary subject, and everything else is secondary. However, in this case, I still want to indicate some of the surrounding atmosphere. So I began to consider my options.

Color Study 1. I first decide that I want the boat to be primary, so it must command a certain position of importance. I also see it as a light shape, and everything else as darker. In the initial sketch, I reduced all darker elements to the value of black. The white shapes represent the areas where the lightest values predominate. Of course, this doesn't mean that white highlights won't appear in other areas. It means that I am planning to keep all of the lighter and/or warmer colors in the prescribed areas of the sketch. One other element I took into consideration here was to see the entire composition of shapes as a sort of puzzle. In this respect, I was keenly aware of how the white shape fits into the black.

During this planning stage, I also decided to make the roof a light value so that it would provide a contrast for the treeline silhouette. My decisions concerning this arrangement of shapes were made in about the space of a heartbeat. There are other possibilities. Planning sketches should never become rigid straitjackets that confine your creative endeavors. They are merely an aid to composition and a way to interpret the photograph before you.

Color Study 2. The second interpretation basically repeats the first one, but the composition has become elongated. In this case, the photograph has been edited to enhance the design.

Color Study 3. For a third interpretation I decided to explore another alternative and reverse the values. Now the boat and the boathouse are dominant dark elements in a light field. This arrangement reminded me of a foggy day, where objects in the landscape appear dark in comparison to the white atmosphere.

Exploring Positive and Negative Shapes

DECIDING ON WHICH SHAPES TO EMPHASIZE

This street in historic Williamsburg is a pleasant little scene that seemed to be just made for a beginning perspective study. Notice how the picket fence draws you into the center of the picture and then continues to draw you even farther into the picture plane. If you are drawn to detailed paintings, you'll love this shot, as there are hundreds of stakes that make up the picket fence, thousands of leaves on the trees and on the ground. There is also a great deal of detail to be found in the siding and window-

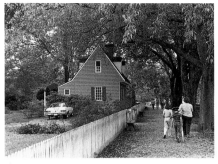

panes of the house. I mention this complexity because many photographs are deceptively simple. The first two photographs in this section were much simpler. In those examples, the subjects were clearly defined; and the subjects' lighter values and the easily identifiable clutter made each scene easy to edit. This shot, however, is one that can be extremely deceptive and there are several temptations to go astray here if you don't know how to decipher a photograph in preparation for a painting.

In this case, the best thing to do is to squint at the photograph. Two or three dominant shapes become apparent: the house the picket fence, and

the cluster of people. Thus, the objective of the painting must be decided right now—do you want to emphasize the people, the house, or the entire scene? If you want the house to be the star, some changes are in order. First, you must make a decision concerning the house—will it be a negative or a positive shape? If it weren't for the white trim, the house would disappear into the trees. The photograph reveals very little on this score. As the artist you are in charge. You can make the painting work merely by enhancing the contrast, thereby making the house either lighter or darker than the surrounding foliage. But if your intention is to make the house the star of the painting, you must find a way to make it visually important.

Color Study 1. My first watercolor sketch (below) reflects a close approximation to reality. I took the photo in late spring when the leaves were very green. After I had flooded in the green, I made sure the house was a lighter value than the leaves. I also exaggerated the light coming in from the right side of the picture. If you

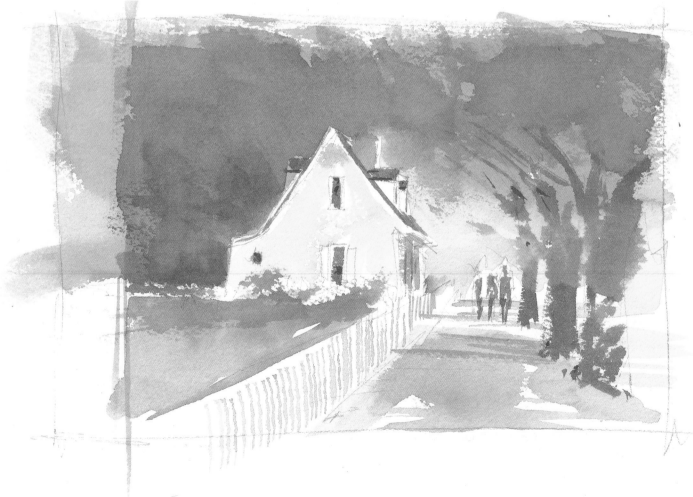

look closely at the photograph, you can see only the faintest hint of this light. Now for the people: There are six figures in the photograph. I decided to eliminate the group in the background, and I moved the trio in the foreground farther into the picture plane. Somehow, I felt this helped the flow or sense of movement in the scene. Remember that in the photograph, the lighter values of the foreground people make them a clear silhouette and a very dominant element. If I had left them where they are in the photo, this group would probably have blocked the flow of

movement from foreground to background.

Color Study 2. I thought it might be interesting to reverse the positive and negative shapes. In the study below the house is the positive image. I did this by changing the season to autumn with its light-value yellow leaves, and making the house a darker value, colonial red. The lighting remains about the same as in the first study, and the figures have moved only slightly. If you compare the two color sketches, you'll see a definite mood change from one to the other. And, as you compare this positive color sketch to the two-value studies, note that the middle-tone value of the picket fence in the watercolor has been interpreted in the black and white as black. This is true because a two-value simplified study is nothing more than a guideline, an organizational plan to help you make decisions about the placement of lights and darks.

The sketches in this section have been kept quite simple. This is to show you that if you can boil your

sketch down to black and white alone, without intermediate grays, your design should be pretty solid. It's a good idea to develop the habit of reducing your work down to a few solid shapes. Once these shapes are established and working together to produce a pleasing composition, you can go ahead and model them with additional tones to enhance your painting.

Notice that many of the elements in these photos have been altered and exaggerated. For example, the diagonal light coming in from the street toward the colonial house and picket fence has been amplified or exaggerated. The sweep of the tree trunks has also been altered. In the boatyard scene, the scaffolding has been simplified, and in the boathouse scene, various elements have been removed and the boat's hull has been stretched. The primary point here is that I have allowed my perceptions and desires to take control over the dictates of reality as presented by the camera. Do not allow the so-called authority of the photograph to regulate your creative approach.

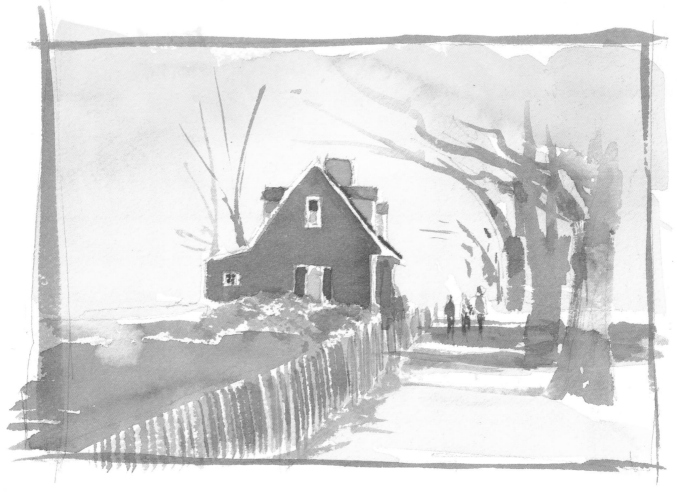

Exploring Positive and Negative Shapes

ELIMINATING CLUTTER

In this scene I was interested in capturing the sleek forms of the sailboat hull. The photograph suggests that the primary subject could be seen as a negative shape because the sailboat's hull is lighter than its surroundings.

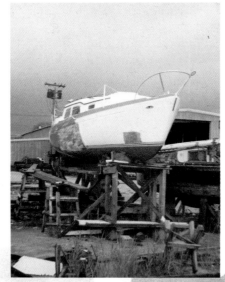

There is also a great deal of clutter.

In both the color sketches and the value studies, whether positive or negative, I cleaned up all of the nonessential details and distilled the subject down to one basic element, which is appropriate since my main interest was the boat and not the entire scene.

COLOR STUDY 1

COLOR STUDY 2

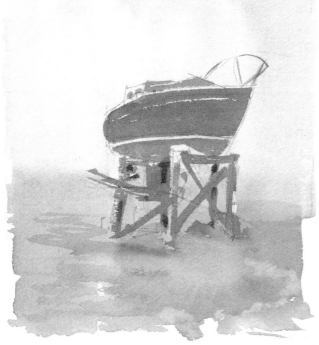

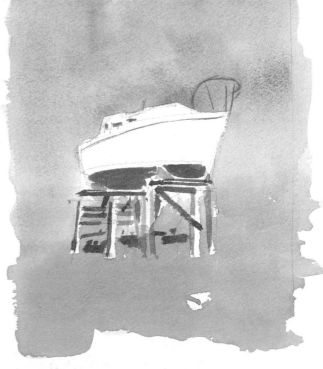

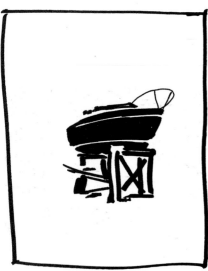

TWO-VALUE STUDY 1

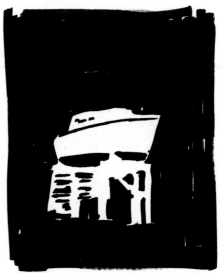

TWO-VALUE STUDY 2

REDUCING ELEMENTS TO THEIR SIMPLEST FORMS

The photograph at right was taken late in the afternoon when the light was just starting to turn a golden red. If you squint your eyes and look at this scene, it's easy to see the subject as one large dark mass or shape. This is what I would call a positive image.

If you compare the color photo with the two-value studies you'll see that much of the detail has been eliminated. However, just because details have been omitted in these beginning sketches doesn't mean that they will be permanently banished from the final painting. Depending upon the mood of the painting, many of these details return. What is important here is to make your beginning sketches basic and strong enough to create the composition upon which the finished painting rests, just like a proper foundation for a house. Learn to distill your subject down to the absolutely bare essentials. When you have that foundation firmly established, then you can build upon it.

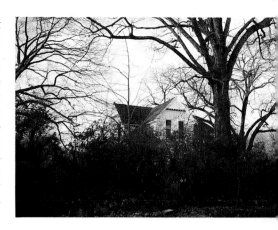

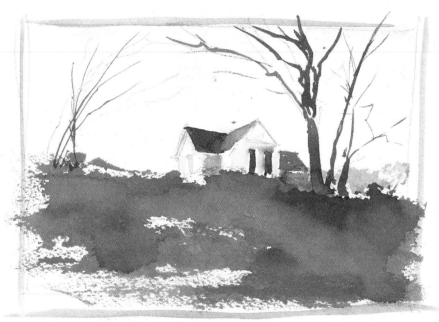

COLOR STUDY 1

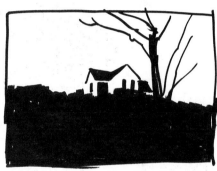

TWO-VALUE STUDY 1

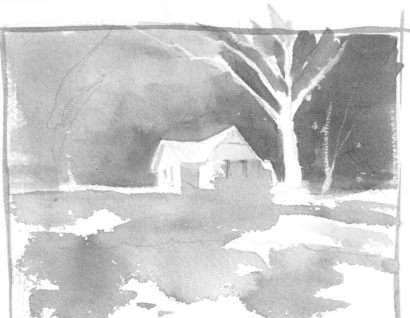

COLOR STUDY 2

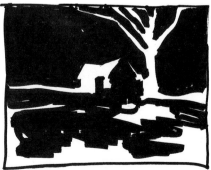

TWO-VALUE STUDY 2

Looking for a Strong Composition

Successful compositions don't just happen; they require work and thought, plus a certain degree of intuitive feeling. For this section, I have chosen several photographs, all of which possess the seeds of a successful composition. They all, however, require a rigorous working out of the design solution through the use of simple compositional sketches.

As you examine the photographs that follow, forget about detail. In the planning stages, detail is superfluous and downright dangerous to your efforts. In composing, designing, or planning successful paintings, it's best to begin with basic shapes.

BEHIND TRURO LIGHT

The photograph above was taken one lovely, hazy June day at Cape Cod. I was expecially excited by the sweep of the land, and the way the large shapes of color laced together, and by the various shapes of the buildings. Compositionally, I felt I had the elements needed for a successful painting.

I made the diagram you see at right to acquaint me with the underlying forms and to help me simplify the shapes. The divisions of space that you see indicate how intersecting forms in the middle ground help to tie the different planes of color together. This process of simplification is vital to understanding and making full use of any site whether you are on location or using a photo. Then you can work up possible compositions. Those compositions you see on these pages may appear to be different from one another, but they all possess one particular characteristic, which is that the images have been reduced to simple color shapes. If you are of a very literal mind you might wonder why the basic shape of the pine trees has not been included. It is not because what I'm describing in these simple color shapes are the *underlying* shapes. Consequently, the pine trees are treated as detail to be added later in the development of the painting.

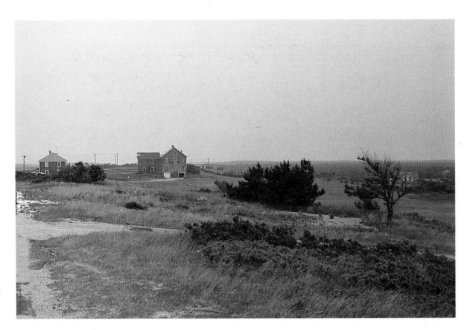

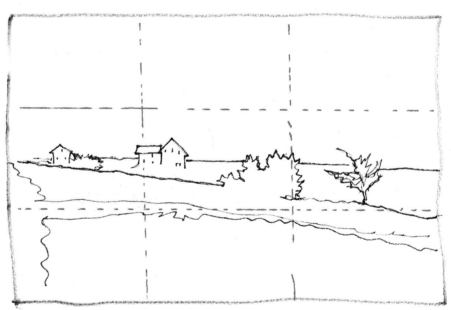

This diagram of the photograph helped me see where major elements in the composition occurred in the picture plane.

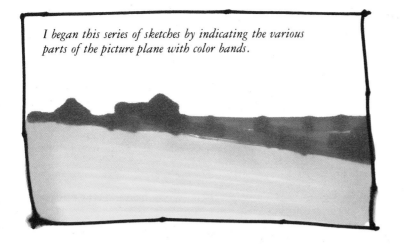

I began this series of sketches by indicating the various parts of the picture plane with color bands.

Color Studies. These seven simple color sketches do not represent all solutions to the original picture. However, they do offer some possibilities, for compositional variation. By reducing the major elements into large shapes I was able to arrange and rearrange the elements of the photo quickly and effectively. Remember, if the shapes don't relate and work together in this early stage, they won't work in the finished painting.

These studies are seven different attempts at interpreting the information found in just one photograph. The foreground area has been indicated as a stretch of horizontal yellow and the middle ground as a horizontal shape of blue-green color. While this obviously eliminates a great deal of detail and subtle color, it is vital to understanding the underlying shapes. Once you have that information then you can begin to add all the other elements in the scene.

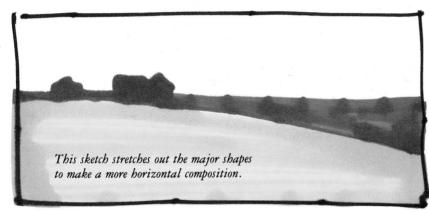

This sketch stretches out the major shapes to make a more horizontal composition.

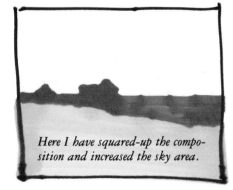

Here I have squared-up the composition and increased the sky area.

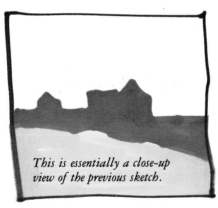

This is essentially a close-up view of the previous sketch.

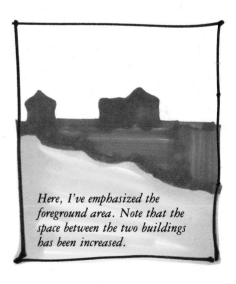

Here, I've emphasized the foreground area. Note that the space between the two buildings has been increased.

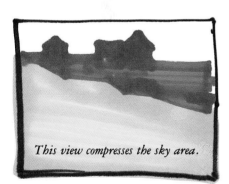

This view compresses the sky area.

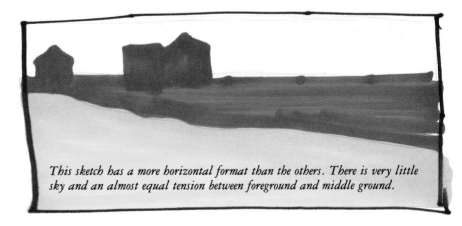

This sketch has a more horizontal format than the others. There is very little sky and an almost equal tension between foreground and middle ground.

Looking for a Strong Composition

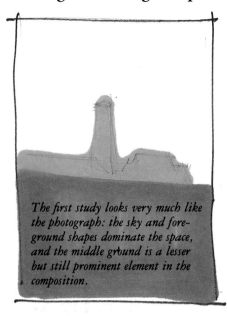

The first study looks very much like the photograph: the sky and fore-ground shapes dominate the space, and the middle ground is a lesser but still prominent element in the composition.

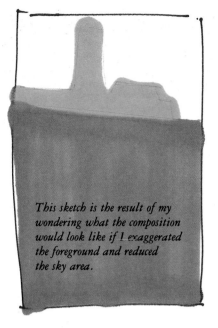

This sketch is the result of my wondering what the composition would look like if I exaggerated the foreground and reduced the sky area.

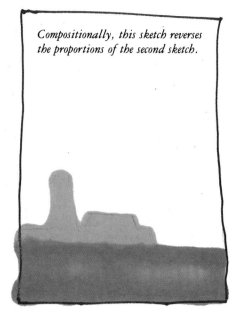

Compositionally, this sketch reverses the proportions of the second sketch.

TRURO LIGHT

My next photo in this series is of a lighthouse. Lighthouses have been traditional subject matter for artists for centuries, and it is for that reason that paintings of lighthouses can look cliché if not handled in an original manner.

The five color sketches I did of the lighthouse were all based on one pho-tograph. Even so, many possibilities presented themselves.

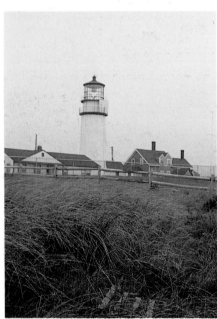

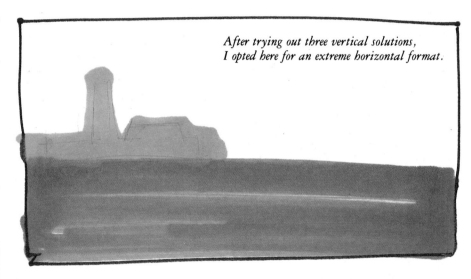

After trying out three vertical solutions, I opted here for an extreme horizontal format.

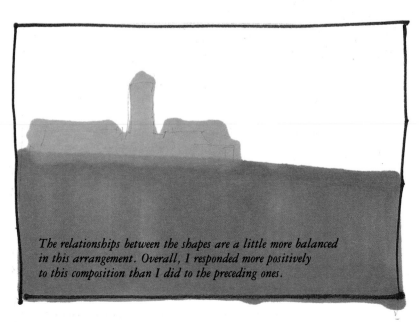

The relationships between the shapes are a little more balanced in this arrangement. Overall, I responded more positively to this composition than I did to the preceding ones.

SPATIAL PROPORTIONS: VIRGINIA FARM

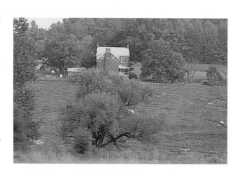

This photograph was taken while driving along the interstate. I do this at times because I have found that it's the way to get some very beautiful subjects. The sketches below show in two values and a line drawing some of the compositional options.

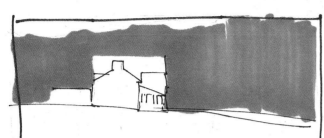

I felt there were some very good possibilities with this shot. But the first order of priority was to establish some definite shapes and to place the farmhouse correctly. Note that most of the shapes, except for the backdrop of trees and the farmhouse itself, have been eliminated.

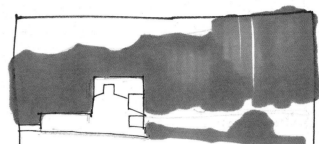

The sky is proportionately larger in this sketch. Also, in order to develop the various elements of the landscape I moved one farmhouse farther to the left. If you compare this sketch with the first one, you'll see that the movement of the shapes has been affected by this relocation.

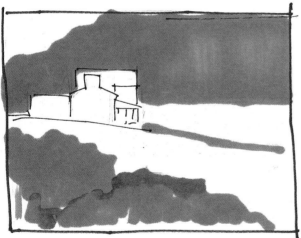

In this attempt I am exploring the addition of still another element to the design. In many ways this sketch conforms fairly closely to the feeling of the photograph.

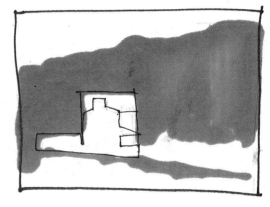

Here, the picture plane has been quite altered. The foreground is greatly reduced and the sky is expanded.

The tree line dictates the compositional force in this sketch. Its diagonal horizontal path becomes the major focus of the composition.

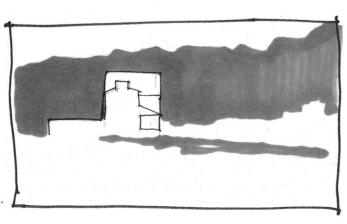

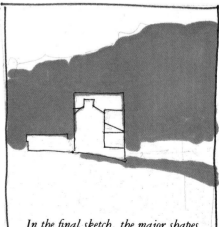

In the final sketch, the major shapes have been compressed to create a vertical format. Here, the farmhouse comes close to being at the center of the picture plane.

Looking for a Strong Composition

THE SHAPE OF LIGHT: BASS HARBOR

Contrasts in lighting can make for exciting compositions. I especially like either early morning or late afternoon light, where the sun is hitting objects at a sharp angle and producing strong, flowing shadows. This twilight shot contains a whole host of possibilities for beautiful light effects. I especially responded to the warm glow of sunlight hitting the side of the white boat contrasted against the dark side of the building. The flag as it floats and glows against the shadow of the building is also an interesting element in the composition. The sketches below are some of the possibilities I saw in this photograph.

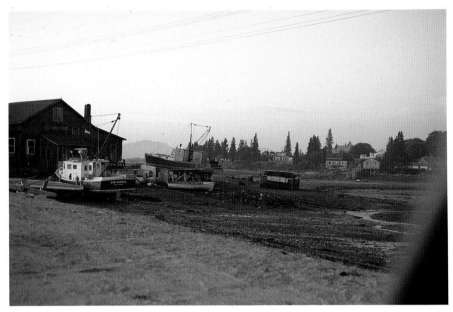

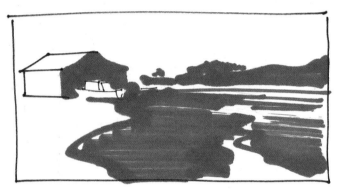

The presence of more or less light dictates many of the major shapes and compositional elements in this scene.

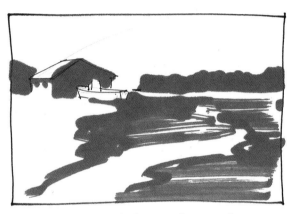

This sketch opens up the foreground area with more light. Once again, note that the light shape inside the dark area of beach repeats the flowing, swirling shape of the light area on the left.

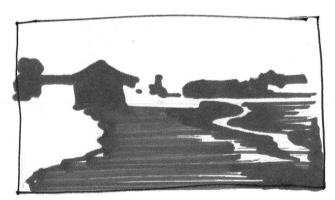

Here, I decided to take more artistic license. I changed the relative size of the boat and I also indicated the entire shape of the boat as the lightest value area. The light value of the rivulet behind the boat bends and sweeps in harmony with the light area of the beach. This composition harmonizes the natural shapes I found in the photograph and adjusts them for the purposes of an eventual painting.

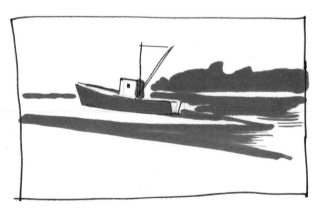

In the last sketch, I did away with the building altogether and focused on the boat contrasted against the dark shape of the beach. I also changed the basin shapes from a swirling, complex design to the clean, rather elegant lines you see here.

In this first sketch most of the elements remain in the same position as those you see in the photo. The only exception is the shadow line on the shed which has been exaggerated.

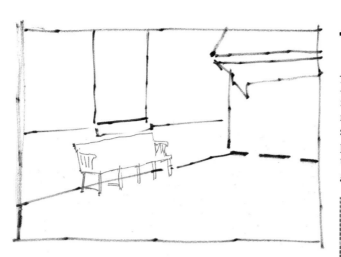

THE SHAPE OF MOVEMENT: PORCH BENCH

I was attracted to this scene because of its simplicity and also because of its many textures and contrasts. Compositionally, it is not the most dramatic photo I have ever taken, but I knew that the sweep of the lines suggests a great deal of movement.

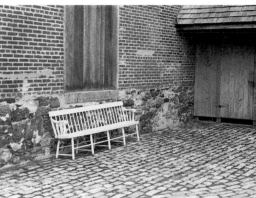

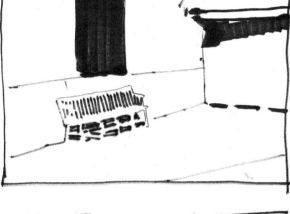

This attempt deviates only very slightly from the first sketch. The main change is that I raised the rock wall just a bit so that its contours don't compete with the back of the bench.

Once the bench was moved, the shed reduced, and the boarded-up window shifted to the right, I began to sketch in the design pattern of the rock wall.

Here, I tried moving the bench toward the center to see what effect it would have on the composition.

The final sketch was done simply to determine if there would be any merit in moving the bench to the left.

This arrangement increases the horizontal format of the sketch. Although all other elements are in basically the same position, this adjustment changes the mood.

Looking for a Strong Composition

THE SHAPE OF TEXTURE: LOG CABIN

Although this picture of a log cabin is less than compositionally splendid, I took it to gather information about the textures in the cabin wall and roof. The sketches you see are the various interpretations I saw in the scene.

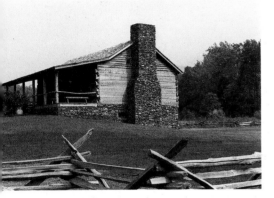

In this first sketch, I added some additional width to the picture plane. Note that I have basically used all of the elements you see in the photograph.

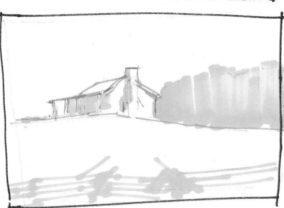

Here, I decided to move things around a bit and alter the placement and sizes of some of the elements. Now the foreground area is expanded, suggesting that the fence is farther from the cabin.

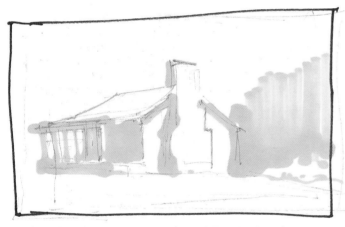

I decided to move in for a closer view of the cabin by reducing the foreground and sky area. The cabin is the dominant element in the composition.

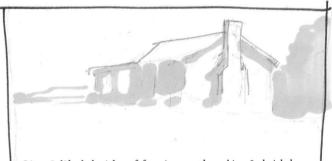

Since I liked the idea of focusing on the cabin, I decided to alter the design by raising the cabin into the upper portion of the picture plane and reducing the sky.

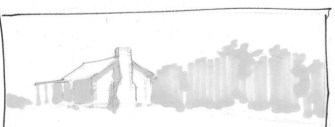

This horizontal format keeps the cabin in the middle ground even though its placement has shifted to the left. The foreground shape suggests more depth in the picture plane.

Finally, I decided to bring the fence back into the picture. Its inclusion in the picture adds both an interesting intersecting shape to the composition as well as an opportunity to play with the intricate textures and shading of the fence.

CHOOSING THE RIGHT FILM

If you use a 35mm single lens reflex camera for your photography work, you'll find a large selection of film on the market. The choice you make depends upon your assignment or project, the lighting conditions you expect to encounter, and the results you wish to obtain. Film, especially 35mm, comes in a wide variety of exposure speeds and types. For example, you can choose from black and white, color, positive and/or negative film, and fast or slow exposures.

Your first consideration probably will be to decide whether you want black and white or color film or whether you prefer slides or prints. Next, you'll be presented with choosing from the various brands of film. The most widely known brand is probably Kodak, but Fuji, Agfa, and Ilford are also well known and available. I use mostly Kodak film; I buy it in bulk and keep it stored in my refrigerator. When I want film, I roll off the amount of exposures I need into a film cassette, or cannister, and load it into my camera.

I like to work from black and white prints. And for this purpose I've found that Kodak Plus X works very well. This film is good for most of the lighting situations I encounter. Years ago, I used Tri-X Pan; it is much faster film but the photos that result have a grainy effect, whereas the slower Plus-X produces a print with a much finer texture. When I speak of faster and slower film, I am describing the film's sensitivity to light; the higher the ISO number, which is an international measure of film speed, the faster the film is exposed. This means the higher the ISO, the less light and time that are needed for a good exposure. The lower the ISO, the slower the film and the longer it must be exposed to light in order to record an image. Bear in mind, however, that even the slowest of films requires a very short period of time for an exposure, usually in fractions of a second.

Both Kodak Plus X and Tri-X Pan are negative films, by which I mean that a negative is produced from the exposed film. Prints are then produced from the selected images on the exposed roll. In color film, you have a choice between a negative film, such as Kodacolor VRG, ISO 100, or a positive film, such as Ektachrome ISO 100 or 200. The negative film will produce a photo print you can hold in your hand, or you can use the positive film to produce slides. Ektachrome is also available with an ISO of 400. This film will allow you to shoot pictures in extremely low-light situations. Ektachrome is also very likely to produce pictures with a definite blue cast. In terms of color accuracy, this is an important consideration.

I seldom find an opportunity to shoot with color negative film; too many shifts can take place when developing color prints from negative film. I prefer the slide for basic color accuracy. The color accuracy of slide film, properly exposed, is hard to beat.

In addition to Ektachrome film, there is Kodachrome, which is available in an ISO of 25 and 64. Many photographers prefer Kodachrome for color work; it is a slower film and has a finer grain quality than does Ektachrome. As opposed to the tendency for Ektachrome to highlight blues and greens—the warmer tones—Kodachrome tends to highlight the reds and yellows in a subject—the cooler tones. One reason I favor Ektachrome is because any competent processing lab can develop your film quickly, sometimes in a matter of hours. On the other hand, Kodachrome, requires a more specialized lab and you may have to wait a few days for processing.

One very important thing about film that I think everyone should know is that film is available in both general purpose and professional quality. There are, of course, some very important differences between the two types. General purpose, or commercial, type film is made to endure some shelf-life. It is designed to sit in inventory from twelve to eighteen months and go through a cycle of maturation before it is used. The manufacturer has planned for the film to be at its optimum at the time of its purchase. Thus, it has been suggested that if you purchase so-called green film, that is, film that has not completed its maturation cycle, you wouldn't be able to accurately predict the color accuracy of that particular film.

With professional film, color accuracy is not the problem. Professional film has been fine-tuned by the manufacturer so that its true ISO rating has been determined and stamped on a sheet packed with the film. For example, if the true ISO rating of the film is 195 instead of 200, you are informed by the manufacturer's enclosed sheet.

Professional film is kept and sold under refrigeration. When you buy it, you are advised to also keep it refrigerated. Naturally, when you are out taking pictures you can't always keep your film refrigerated, but you can keep it as cool as possible and out of direct sunlight. As a general rule, I keep my bulk film loader in the refrigerator at all times and take it out to roll film as I need it. After I load a few cassettes I place them in a freezer bag and put them into the refrigerator until I am ready to shoot. When I am ready to shoot I take my film out of the refrigerator about forty-five minutes before loading my camera. This allows the film to come to room temperature so that it will function properly when I use it. Cold film has a tendency to make your photographs too blue. If I'm on an extended trip, I take my bulk loader with me. Since I often travel into northern regions, heat is not usually a problem for me. Even so, I keep my film in my camera bag, away from direct heat.

Linking Basic Shapes to Build Your Painting

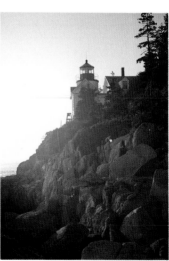

PHOTO 1

Each of the following paintings is built upon the idea that various shapes and forms in the landscape must be linked together in order to create a successful painting. Far too often, painters get so caught up in the "reality" and subject matter of the scene that they forget that a painting must possess its own level of reality. The mere fact that your subject matter is a compelling, interesting scene is of no consequence unless you are able to translate it into a viable painting language. While there is more to painting than linking shapes, if you get that part right you are off to a very good beginning.

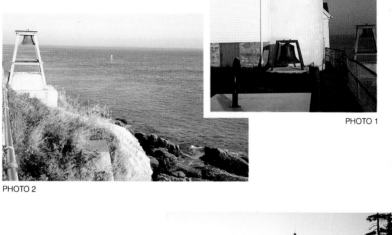

PHOTO 2

BASS HARBOR LIGHT

On my first trip to Bass Harbor, Maine, I arrived at this lighthouse just a half hour or so before sundown. The quality of the light was perfectly clear and golden. Prepared with a small sketchbook and a camera, I began to work. Since I had seen beforehand several commercial photographs of the lighthouse, I knew immediately that I wanted to avoid duplicating any of these efforts. That is, I knew what I *didn't* want to paint. While a completely original statement may not always be entirely possible, I think that it is the artist's duty to himself or herself to try. So in this context, my most important concern was to record my own reaction to the evening light. Each one of the following photographs records my reaction to Bass Harbor and suggests a different painting.

Back in the Studio. Some weeks later, I was back in my studio with some fine memories, a few good photos, and some sketches. Now it was time to go to work, so I began to examine my preparatory materials and make some final decisions about my approach. The sketches provided me with a good indication of the movement of shadow shapes up the cliff toward the house. They also told me how the fairly clean lines and shapes of the house related to the jagged rock shapes below. After examining the photographs, I found that I favored those that had the van-

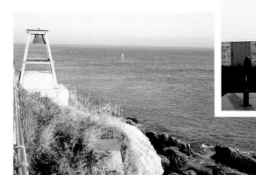

PHOTO 4

PHOTO 3

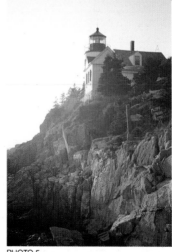

PHOTO 5

PHOTO 6

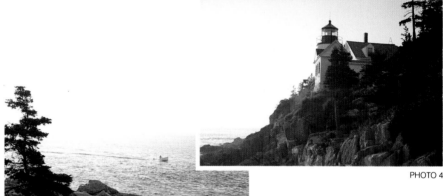

tage point of looking up. I then began to develop my composition with quick sketches. Most of the inspiration for these came from a combination of memory, an earlier sketch, and the photos. On the surface, it appears that photo 5 influenced the final painting most. This is true as far as the angle of the building is concerned, but the truth is I like several elements in all the photos that deal directly with the lighthouse. For the most part, the composition is pretty well spelled out by the photograph; my alterations had to do primarily with the handling of the various shapes, the light quality, and development of detail areas. While planning the painting, I borrowed the strong points that I liked from each of the three photos. In photo 4, I liked the strong shadows off the side of the lighthouse, the strong silhouette of the pine trees against the sky, and the way all of the dark shapes angle down toward the left. In photo 5 I liked the vantage point of viewing both the lighthouse and the rock ledge from below. Of course, it's good to remember that decisions about what to use or omit are based largely upon personal taste. I knew I wanted a strong graphic image and a pleasing range of color and contrast.

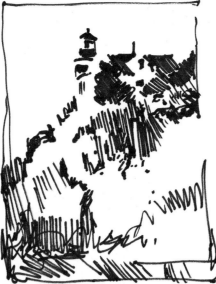

This rough sketch was done to help me begin to think about the large shapes and how they made up the painting. At this stage subject matter is not as important as the movement and relationship of the masses.

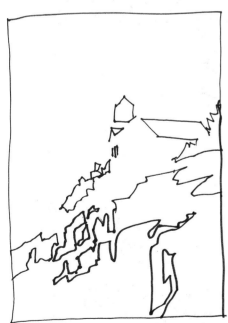

Study this simple outline drawing. While there is no detail as such, you can almost imagine the finished painting based upon these flowing shapes. It is these interlocking shapes that will ultimately create the feeling of the work.

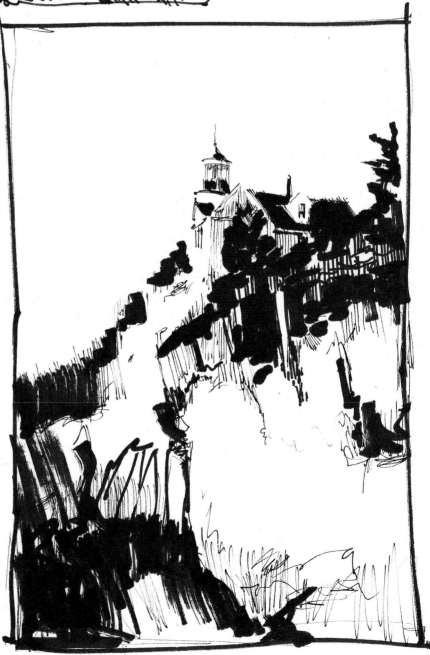

Linking Basic Shapes to Build Your Painting

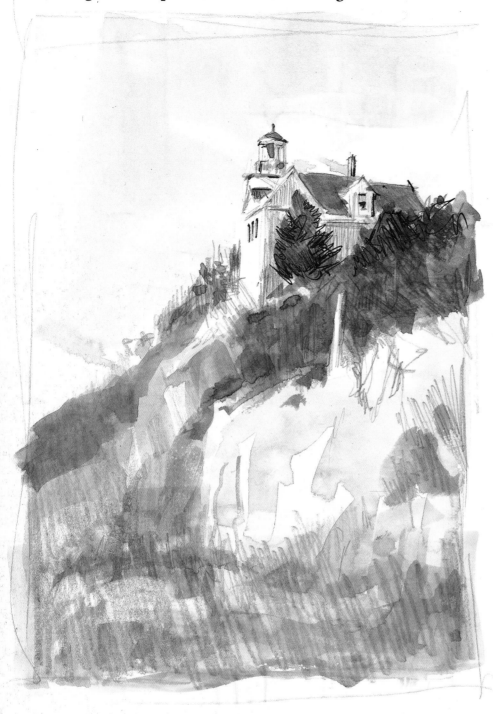

This color study was a helpful exercise in setting my energies in order. Not only am I making decisions about the colors I want to use and how they will relate to one another, but I am testing my ideas about the shapes and how they relate. It is also an attempt to study the lighting effects a bit more before committing to a final painting. As you compare this study to the final, you'll see how the shapes are still very basic and not fully defined. There are also some very definite changes from this stage to the final. If I tried to duplicate this small study for the final work, it would be like trying to work in a straitjacket. The final work has to fly on its own merit or not at all.

Finished Painting. Once all the preliminaries were completed, I was ready to begin the actual work. One problem that the photos and sketches did not solve was that they did not really reflect the color I had seen that day, or at least, the color I "felt." Whatever the case, the camera just wasn't able to record the rich glow of the light that evening. It was this quality of light as much as anything else that motivated me to paint.

The photographs helped me to recall the scene and the experience I had had there. For me the experience itself is crucial to good painting. In this case, I was intent upon capturing the glowing quality of the light, but in order to do this I needed to build a foundation of interlocking shapes. The forms of the rocks and the way the house fits into the rocky cliff needed to be carefully drawn in first. The preliminary sketches were invaluable to me because they provided a framework for the painting.

I began by applying diluted washes of new gamboge and manganese blue to the sky and to the shadow areas of the rocks. Once this was completely dry, I changed to a mixture of new gamboge and Winsor red, using this mixture until I had a strong division between the sky and the highlighted side of the lighthouse. As I continued to develop the painting, I was extremely intent upon maintaining the atmospheric effect of the light as it fell across the rocks and shadows. Much of this effect was maintained by keeping the washes transparent and allowing the edges to be somewhat indistinct. The shadow areas were the last to be clearly defined. At several points I toyed with the idea of plunging the foreground into fog and perhaps in another painting of the same site I will do this.

If you look at the shaded side of the house, you'll see that a tree and a window have been omitted. I did this because when I applied the new gamboge and Winsor red mixture to that side of the building, the paint took on the exact glowing quality that I remembered. The effect also looked like reflected light. I liked it so much that I stopped and left well enough alone.

Bass Harbor, watercolor, 24″ × 14″ (60.96 × 35.56 cm)

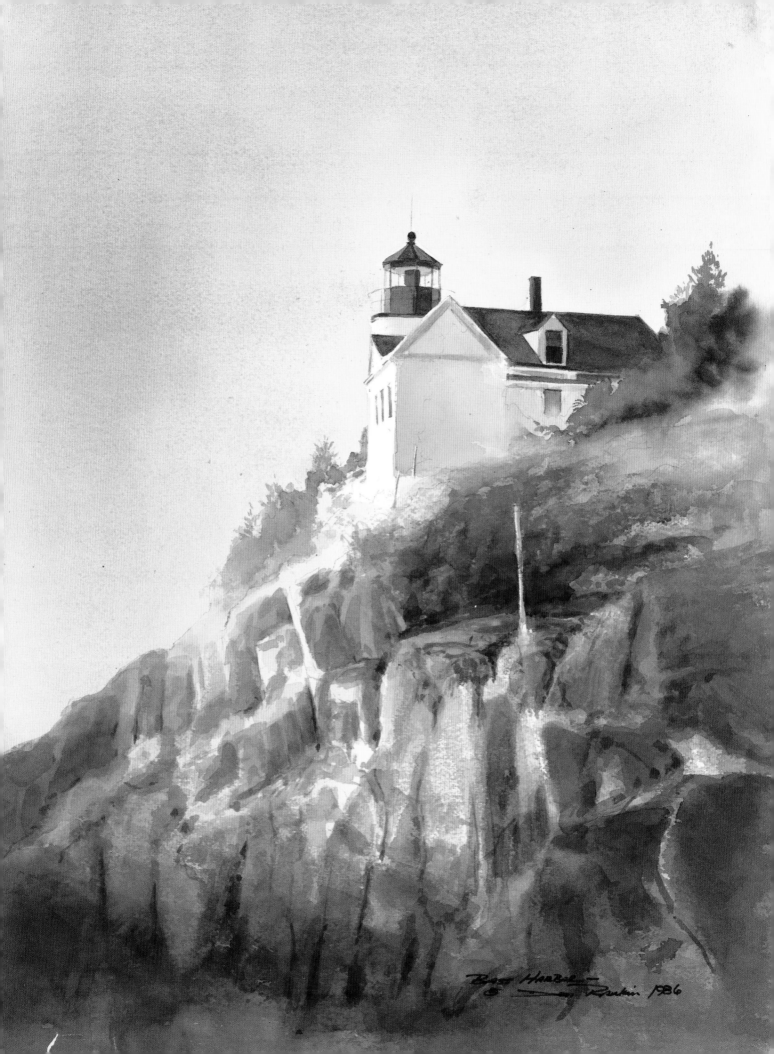

Bass Harbor
Rankin 1986

ABANDONED FARM, PRINCE EDWARD ISLAND

How many times have you traveled down a road when a compelling scene caught your attention, but you were either too busy to stop or for some practical safety reason couldn't stop? This abandoned farm on Prince Edward Island in Nova Scotia is one place where I made the extra effort to get what I thought of as an intriguing subject.

The photo sequence gives you an idea of the type of information I'm seeking when I'm photographing a potential subject.

Back in the Studio. After looking at the reference photos for a while, I realized that perhaps the most important aspect of this scene was the way the shapes interlocked in the relationship of the farmhouse to the outbuilding or the relationship of the organic (trees and grasses) to the geometric (buildings). It was this lacing together of shapes that would make a successful, interesting painting.

Finished Painting. To make the elements in this scene relate harmoniously to each other, I decided to alter some of the shapes. For example, I thought the plywood color that boarded up the front of the house discordant with the overall feeling of the painting. This scene required the clean lines of simplified shapes. As a result, I let my brush renovate the front of the house, making pure shapes out of complex ones. Somehow the simplicity and elegance I saw in this house lent it an air of order and civilization. I just couldn't see its doors boarded up.

Once the major landscape and building shapes had been developed, I tried to capture the incredible glowing quality of the clear Canadian air, especially the radiant glow that hovered over the roof of the house. One way that I indicated this auralike quality was by allowing the blue wash to go very pale—almost white—near the edges of the roof.

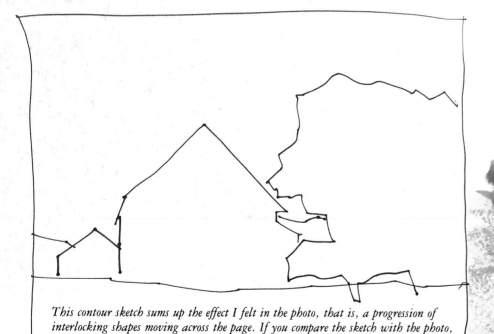

This contour sketch sums up the effect I felt in the photo, that is, a progression of interlocking shapes moving across the page. If you compare the sketch with the photo, you will see that I have emphasized the overlapping shapes by moving the large foreground tree closer to the house.

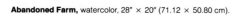

Abandoned Farm, watercolor, 28″ × 20″ (71.12 × 50.80 cm).

Linking Basic Shapes to Build Your Painting

FRESH AIR FARM

I have driven by this site, a camp for city children, in all kinds of weather for nearly twenty years. Each time I was intrigued (out of the corner of my eye) by the configuration of buildings which was hidden by heavy foliage during most of the year. So one day, I stopped and took this series of photographs. Luckily, I took these photos during the winter when the trees, stripped bare, offered a better view of the subject. Now I could scrutinize and paint this subject at my leisure.

I found this subject an almost inexhaustible series of intriguing shapes and colors. Although it would not have been difficult to obtain permission to go inside, somehow the trees, and shrubbery, and various types of fencing increase the mystery of the location. My imagination was stirred wondering what went on beyond that stone entrance. If you look at the photos at right, you'll see why just the suggestion of shapes can make for an intriguing subject.

Back in the Studio. Since this subject is less than a few miles from my studio, I can either work there, if need be, or go back to the site for more reference material. There is a tremendous amount of subject matter in this location and its character changes with the light and the season. Several paintings should eventually evolve from this material.

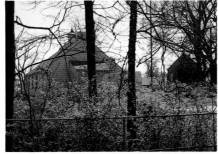
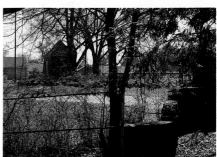
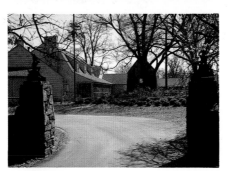

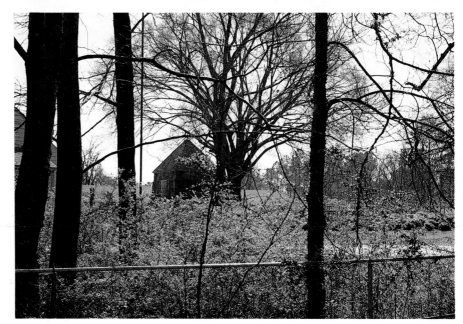

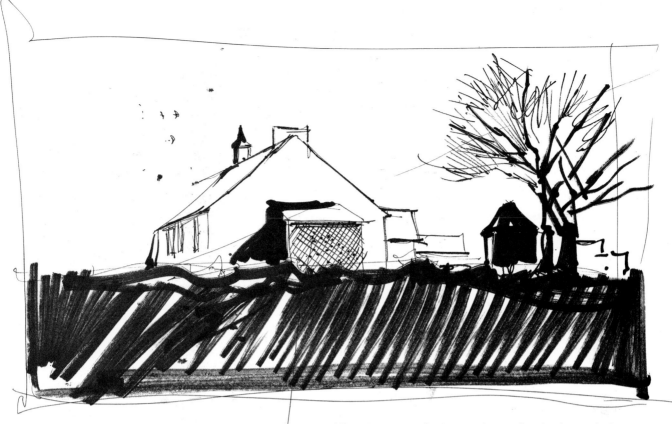

lattice

The primary consideration in this marker sketch was the large dark masses in relation to the smaller shapes. Note how the dark shape of the shadow on the main building and the dark shape of the tree and the small smokehouse invade the lighter values of the composition. The small sketch at left shows in detail the structure of the lattice work on the side of the building.

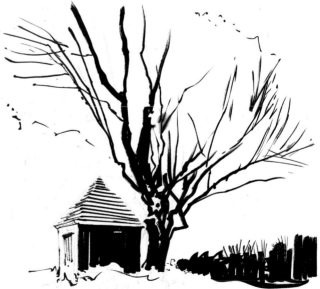

The contour sketch (left) helps to define the energy of the marker sketch (right). The important idea here is the relationship of one shape to another. Can you see the relationship between the two sketches?

Linking Basic Shapes to Build Your Painting

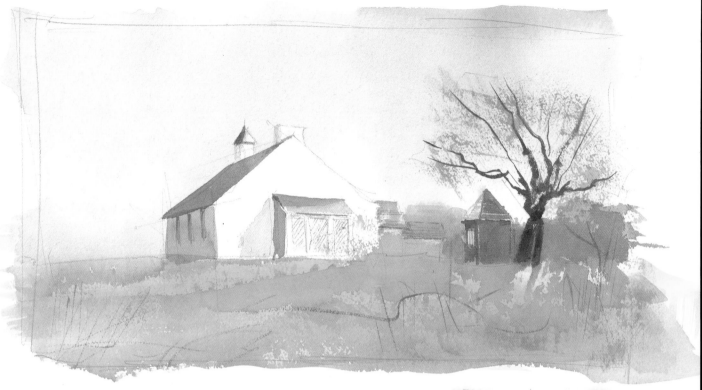

This watercolor study is a direct result of the marker sketch on the previous page. The bold black of the foreground has been replaced by the bold green of spring, and the darker areas have been converted to middle values.

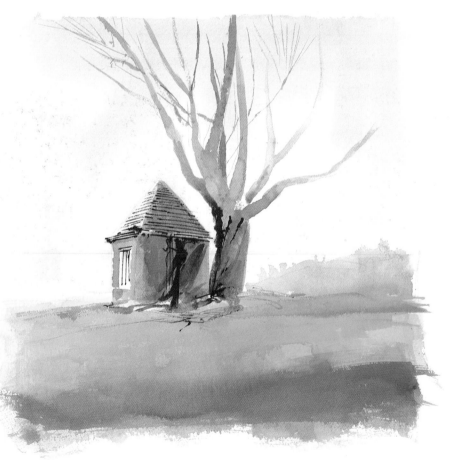

This small sketch above was another look at a possible solution. Note how the shape of the foliage encompasses and frames the white of the house.

The earlier sketches and studies helped me think through to choosing this composition (left), where the little stone smokehouse and the stark shape of the tree have become the primary subject matter for the finished piece.

Although this color study (right) is not a final statement, it did help me to resolve a number of visual problems. In this case there was a wide variety of possible solutions for this subject, but having already explored several options, I was ready to begin what I would consider a finished work.

Linking Basic Shapes to Build Your Painting

SEEING SHAPES AS ONE UNIT: MOUNTAIN FARM

In many ways, I stayed very close to this subject, but in some very important ways I didn't. *Mountain Farm* is to some degree "historically" accurate, although it does contain some modifications. The time I had to spend at the site was somewhat limited. My sketches had to be done quickly and they turned out to be very helpful for jogging my memory. The photographs served as bits of supporting information that were used later to their fullest extent back in the studio.

Armed with fairly accurate recall of the farm and also some decent photos, I began to work. I wanted to retain the integrity of the site, but I didn't want to be totally controlled by it either. For example, I could have focused all of my attention upon one element. But in this case, I felt that the site's biggest appeal was based on the way the basic shapes of the various buildings were linked together. The composition must work as a unit. It will help you to see the big picture as a cohesive whole and not as individual little clusters of trees, fence rails, and buildings. In this instance I saw the small outbuilding on the left as a triangular form tied to an assortment of geometric shapes by the long horizontal form of the fence line. These shapes in turn fit together between the horizontal sweep of tree-covered mountains and the horizontal sweep of grass in the foreground. (Of course, horizontals are invariably rectangles also.) When you begin to develop your image in this manner, you have a stronger foundation upon which to paint.

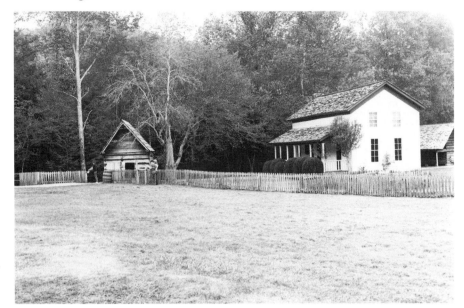

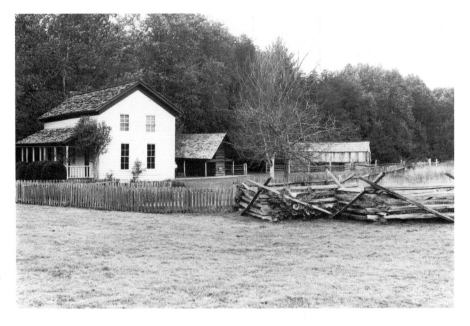

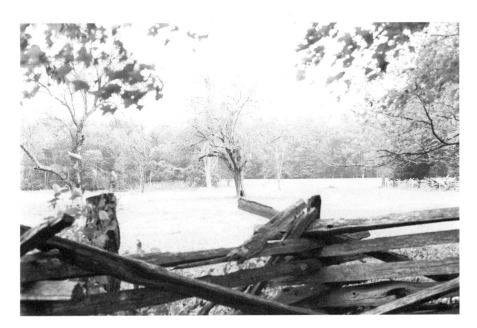

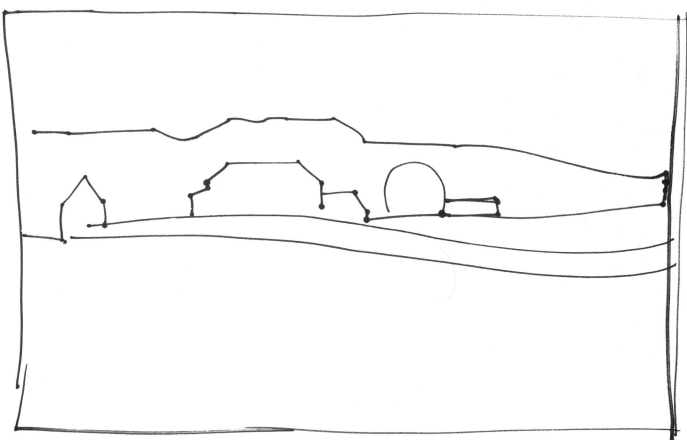

This contour drawing gave me a fairly good indication of how the actual elements in the landscape translated into simple shapes. Remember, relationships and shapes of the actual subject matter are not as critical as the relationship of shapes in your sketch. The sketch should be about creating the "reality" of painting, not the literal image of the scene before you.

Linking Basic Shapes to Build Your Painting

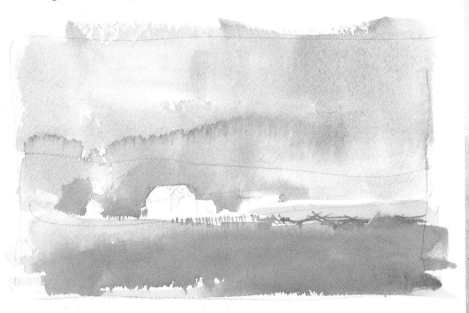

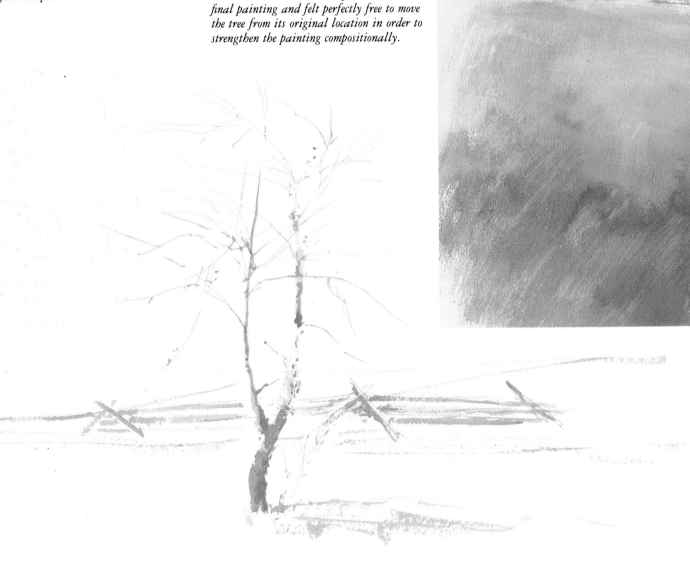

This rough color sketch (above) helped me explore the color relationships I wanted for the finished piece.

I love the rugged, hardy character of fruit trees, especially those that grow in the mountains. I used this study (below) in the final painting and felt perfectly free to move the tree from its original location in order to strengthen the painting compositionally.

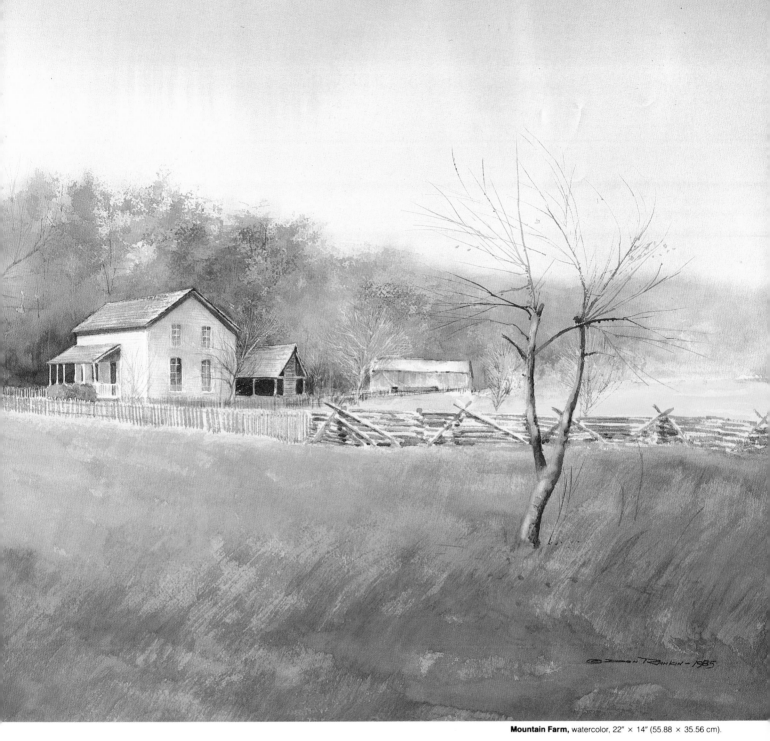

Mountain Farm, watercolor, 22" × 14" (55.88 × 35.56 cm).

Finished Painting. For the actual painting process, I used color that was fairly accurate to the original scene. I made the greens in the foreground a little more intense by using several layers of new gamboge as an underwash before applying a layer of phthalo yellow green and a mixture of new gamboge and Winsor blue. Texture was built up in the trees by using the side of a flat sable applied to dry watercolor paper. In this area, several mixtures of color were applied once the preceding layer had dried. The palette ranged from Winsor red and cerulean blue to new gamboge and vermilion. The darker shadow areas were executed by combining a mixture of Winsor blue and Winsor red.

In the end, this finished watercolor looks much like the actual site, but there are a few key elements that have been altered. While the slope of the foreground is quite accurate, the fence has been moved more into the foreground to strengthen the directional flow of the painting. I also removed the fruit trees from around the side of the farmhouse, and the ones I did include have been altered in size and shape to fit more harmoniously into the overall composition. I used the tree in the right foreground as a device to keep the viewer's eye from going outside the painting. The lighter, warmer color in the field has a tendency to draw your eye too quickly; the tree helps to slow that process a little.

Working with Available Light

The term *available light* means just what it sounds like: It is a method whereby scenes and objects are photographed using only the light that is naturally present to illuminate the subject. In practice, there are ways of enhancing the light through the use of reflection. For example, you might use a white matboard or a white sheet to reflect sunlight back into a dark shadow or area of the picture. But for the most part, I use available light in its purest form; that is, I don't rely on reflected light unless it is naturally present in the situation I am photographing.

Using available light affords me the opportunity to get some fine dramatic lighting. This effect can then be translated into strong paintings. I use the approach because I want to capture the natural essence of the scene before me. If I start introducing flash attachments, I can run the risk of upsetting the natural light that is affecting the scene.

Study the following examples of available light photography and see how the sharp contrasts make it easier to see the underlying basic forms.

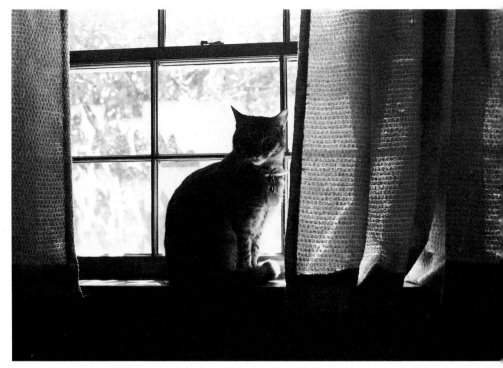

CAT IN THE WINDOW

Although some people may think this photograph of my daughter's cat is too dark, it perfect for my purposes. Look how the large shapes work together and how the details in the shadows are clear enough to evoke both texture and form.

I often think of the photograph as the seed, the sketch as the vine, and the finished painting as the fruit. Without good seed and a hardy vine, the fruit is no good. After you have studied this example, see if you can determine how the sketch has transformed the photo into a stronger design. My interpretation is that the sketch simplifies the detail and natural shadows in the photo to enhance the design. Look once again at the photo and the sketch. How many changes do you see? What would you do to improve the picture?

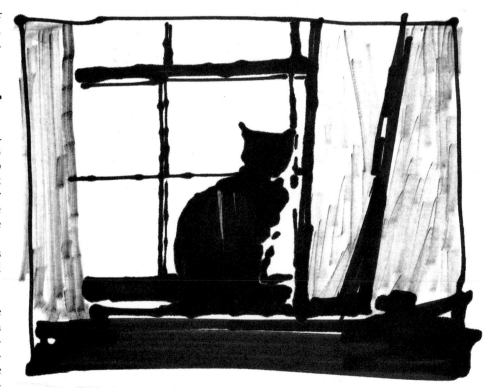

DAVID
DREAMING

I captured my son in a moment of play when for one brief moment his guard was down and he was relaxed in a world of make-believe. The contrast of light and shade in the photograph provides the element for a powerful painting. As you study this photo and the accompanying sketch, ask yourself what does the eye see and what does the mind suggest that it sees? Can you see the bricks in the shadowed right hand side of this photo? In my sketch you can see the movement of light is suggested by the direction of the pen strokes. The effect is to fill the area next to the window with light. Perhaps you would interpret this scene similarly, or would your perception offer you another suggestion?

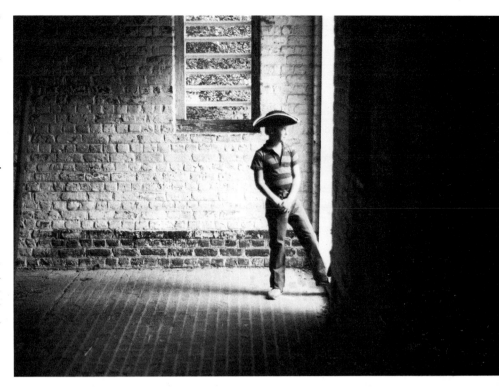

Working with Available Light

WILLIAMSBURG INTERIOR

Light behaves differently at various times of the day and year and in different geographic locations. The light in this photograph is bright summer sun and tends to be a little stronger than autumn sun. The serious part of my study focused upon the basket and the light playing upon it. As you look at the photograph, notice now the light burns out the detail in the windowsill and in parts of the basket. This helps to convey the intensity of the light upon the subject. Think about how this scene would have looked if I had used a flashbulb to photograph it.

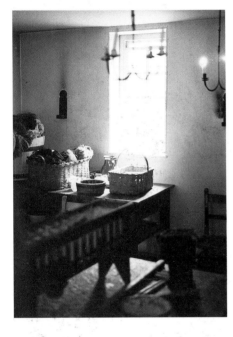

HOLDING YOUR SHOTS STEADY

Shooting in available, or natural, light in low-lighting conditions calls for slower shutter speeds. While it is possible to use a tripod, there are times when it is not convenient. Usually a shutter speed of 1/30 second or slower is justification for support of the camera. If you are using a telephoto lens, the need to eliminate camera movement will be even more critical. This is because both wide-angle and telephoto lens magnify the effects of camera movement. The effects will be displayed in your photos with blurred or otherwise distorted images. When making pictures under ordinary circumstances, the camera is held at eye level. If you are using a relatively fast-shutter speed, about all you need to do is to make sure that you are standing with your arms and index finger in a comfortable position. When using slower shutter speeds, the position of your feet becomes somewhat critical, and you should make sure that your feet are planted firmly at least shoulder width apart. If possible, you should seek out additional support for you and the camera. Perhaps you can lean against a wall, a fence, a telephone pole, or the top of your car. Or, if you can't find any nearby object for support, you can stand with your elbows pressed into the sides of your body or kneel on one leg and prop your elbow on the other. Another way to hold the camera steady is to sit cross-legged on the floor or ground and use your knees to support your elbows while you take your picture. In these ways, you are lowering your center of gravity, which helps to stabilize and decrease the likelihood of body movement.

I find that it is often easier to take a picture when the camera is held horizontally rather than vertically. When you shift to the vertical position, your arms, fingers, and wrists are all under some tension, which means you must exercise greater care in order to prevent movement.

A final note: I have found over the years that my manner of breathing drastically affects the steadiness of my camera. So I have learned a way to control my breathing. First, I take a deep breath, exhale, and *then* I snap my picture. However, if you merely hold your breath, your body will probably move slightly and give your camera the shakes.

SLED RIDERS

I took this picture because even though my subjects weren't going anywhere, and I could have spent all the time I needed sketching them, there was one subject that refused to stand still—the light. Now it is frozen in time. I can study the light in this picture at my leisure and learn all of its secrets as it glows around the sledding bears.

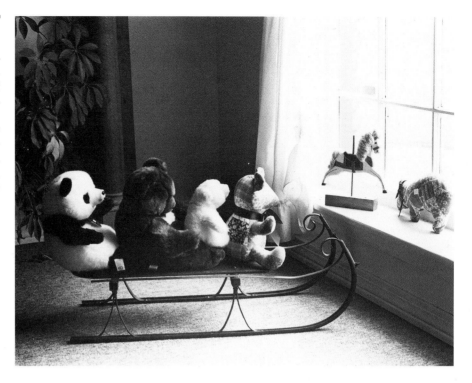

THE CHAIR

This interior shot was taken at a time of day when the fog had just lifted. I took it because I became intrigued with the play of light as it flooded the room and defined the small and large dark shapes that make up the chair. Note that all of the straight lines as well as the curved lines of the chair's seat are depicted as definite shapes.

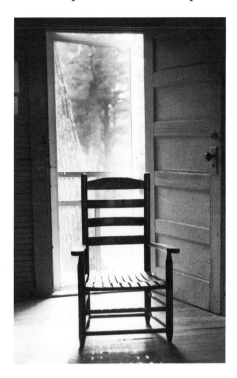

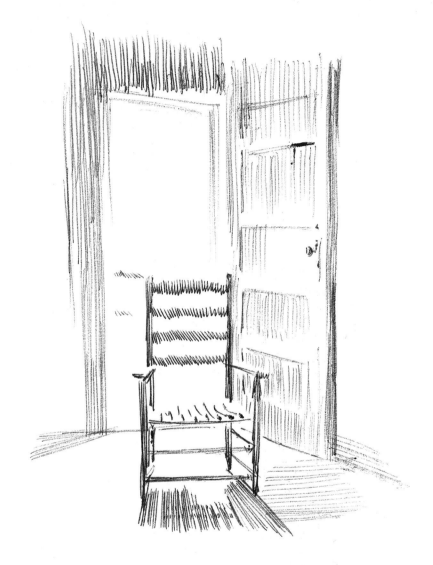

Taking Advantage of Changing Light

Just as light is essential to life, it is essential to representational painting. Anyone who has observed nature knows that the quality of light changes during the course of the day. In fact, light changes so fast that many of us are not really aware that it is constantly changing. Light changes are most evident at sunrise and sundown, while changes between those hours aren't as readily apparent. In some cases the only noticeable difference will be in the temperature of the color of the light and shadows. The fact is that light changes can have a great impact on your paintings.

I have observed that the conditions created by natural light generally fall into five categories. Remember, though, that like many other phenomena of nature, these categories are at best general descriptions. The following is a list of the five types of lighting conditions that you may encounter in nature:

Front Lighting. I often think of this type of lighting condition as uninteresting, mainly because it has the effect of eliminating fine detail; at its most extreme, it can flatten objects out. Also at full peak, intense frontal light can produce strong contrast between light and shade areas. The value scale can range from absolutely white to pure black.

Backlighting. This dramatic effect is a powerful attention-getter. When used at full capacity, the subject becomes a strong, dark silhouette that is almost a full black in value. But depending upon a number of other factors the subject can be a light to middle-tone gray. For example, a subject backlit in a light fog or haze by contrast will take on a middle-tone gray. Values range from the lightest white to the darkest black.

Top Lighting. This is high noon light. All shadows are directly underneath, and contrast is usually very strong. As with front lighting and backlighting, the value scale can range from a middletone gray to a full black.

Side Lighting. If you observe nature, you can find side-lighting at early dawn and just before sunset. It is characterized by long shadows and light that illuminates the edges or sides of a subject. The highlight is in a high key, the middle-value shadows range from 20 to 50 percent gray, and the deep black shadows range from a middletone gray to full black. Side lighting makes a good setting for dramatic painting.

Overcast Lighting. This light effect comes about when sunlight is filtered through clouds or haze. The filtered effect creates a wide range of values and textural tones. As a general rule, the shadows will be soft and diffused, and the highlights soft as well. Under typical overcast conditions, there are no extremely warm-colored, or "hot," highlights. Many photographers favor this type of lighting because of its subtle color effects.

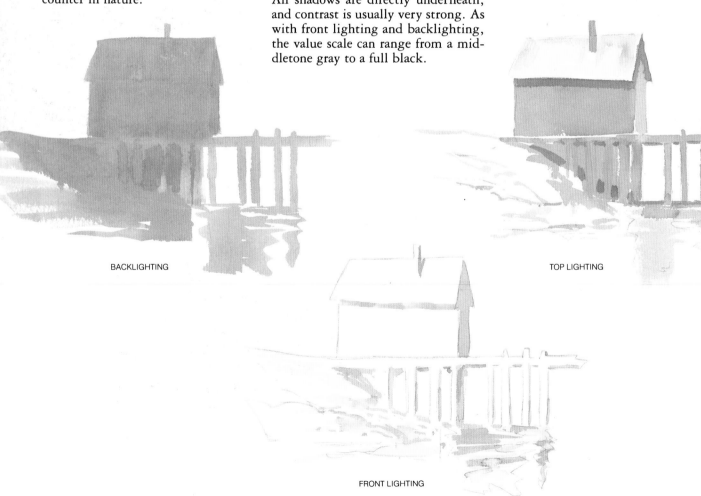

BACKLIGHTING

TOP LIGHTING

FRONT LIGHTING

As I classify these general lighting conditions, I am aware of confusing contradictions. For example, it can be argued that the only difference between frontal light, backlight, and sidelight is the location in which you are standing. While this is partially true, it is my hope that these classifications will be of some help as you begin to work with your own outdoor subjects. Of course, lighting conditions can also be created in the studio, but you should remember that there is a vast difference between the quality of natural sunlight and artificial light.

PHOTO REFERENCES

Here is one approach I use for taking advantage of changing light. This site is part of Tannehill State Park; it's not far from my studio and it provides an excellent place for walking, sketching, and an occasional workshop on painting the landscape. One of the reasons I like this area is because the lighting conditions are so changeable and they create some interesting light and shade problems. Consider the following three photographs. All three came from the same roll of film and were taken on the same day.

3:30 PM. As you look at this photo, think about its possibilities as a painting as well as its limitations. One rather obvious problem here is that you can't see much of the cabin. A great deal of it is covered up behind trees and saplings. Note that light and shadow play a prominent role in this scene.

4:00 PM. The second shot was taken a half hour later—and the light has changed dramatically. The hill in the background has blocked out much of the light. While some of the light patterns are similar to the earlier photo, the overall light is much dimmer and the contrasts are much weaker. In situations like this, I find it is often a good idea to give up and wait for more favorable lighting conditions.

5:00 PM. By this time the light has changed dramatically again. As the sun sinks into the horizon, it shines through a small valley between the hills behind the cabin. The effect of raking light you see here won't last long before it really gets dark.

3:30 PM

4:00 PM

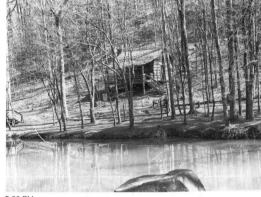
5:00 PM

OVERCAST LIGHTING

SIDE LIGHTING

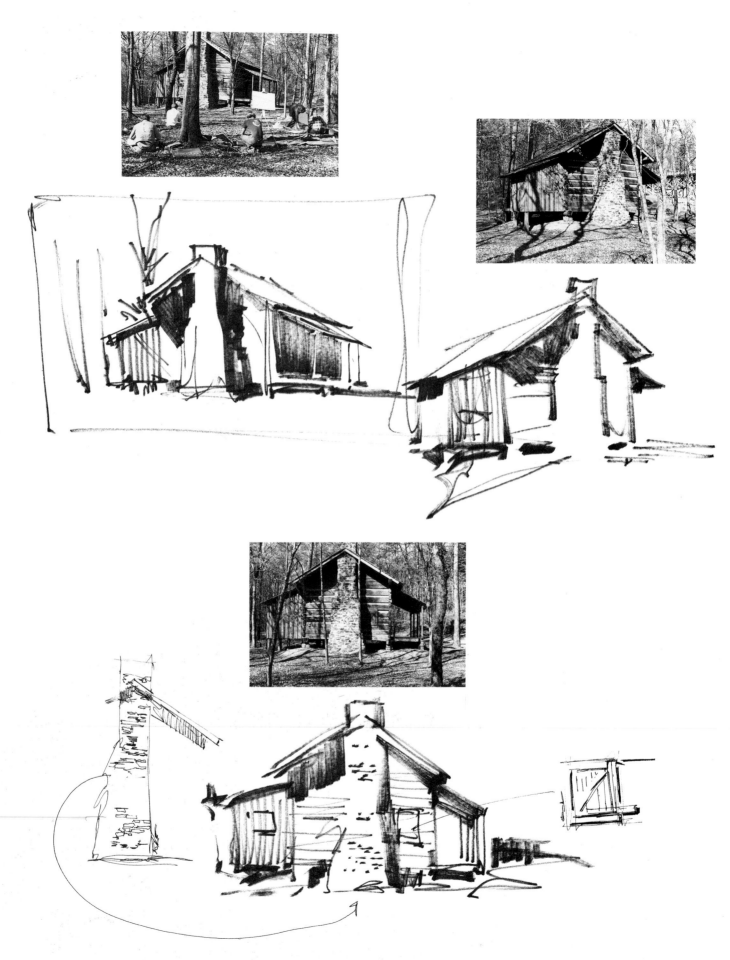

QUICK INTERPRETATIONS
ON THE SITE

A bit farther down the creek where the light tends to be more constant sits another cabin. This series of sketches and photographs takes advantage of a steady clear light that illuminates the subject and provides strong shadows. If you study the photos and sketches, you will see one element that is common to all—strong, dominant shadows. Remember that without an understanding of shadows, you won't understand or be able to depict the effects of light. Light and shadow go hand in hand.

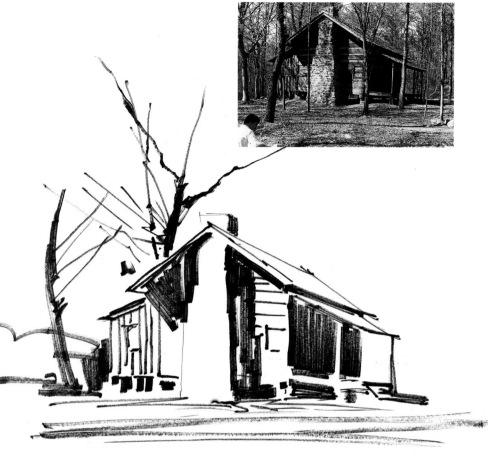

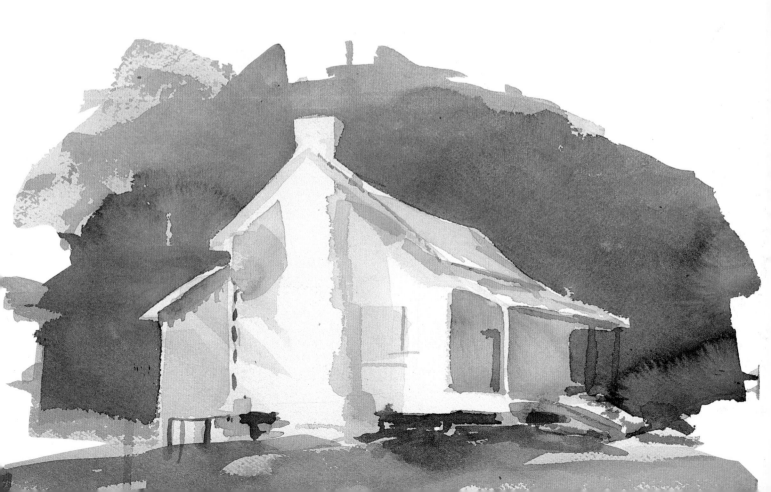

Taking Advantage of Changing Light

PRELIMINARY SKETCHES

Although photographs are helpful, they can't tell the whole story. In this case, the primary interest—the house—was partially obscured in the photographs. If you look at the preliminary sketches, you will see that even though the first sketch records the entire scene, I have already begun to edit out trees from the cluttered foreground area.

The quick sketch of the cabin helped to give me a better feel for areas of the cabin hidden from view. A value sketch was done to reduce the cabin to its simplest forms. Value sketches are important because they enable you to see where the strong contrasts occur. While nature isn't always so obliging about revealing value areas, in this case it was easy to see the shadow area as basically one dark shape. But even in less obvious situations, where the shadow is com-

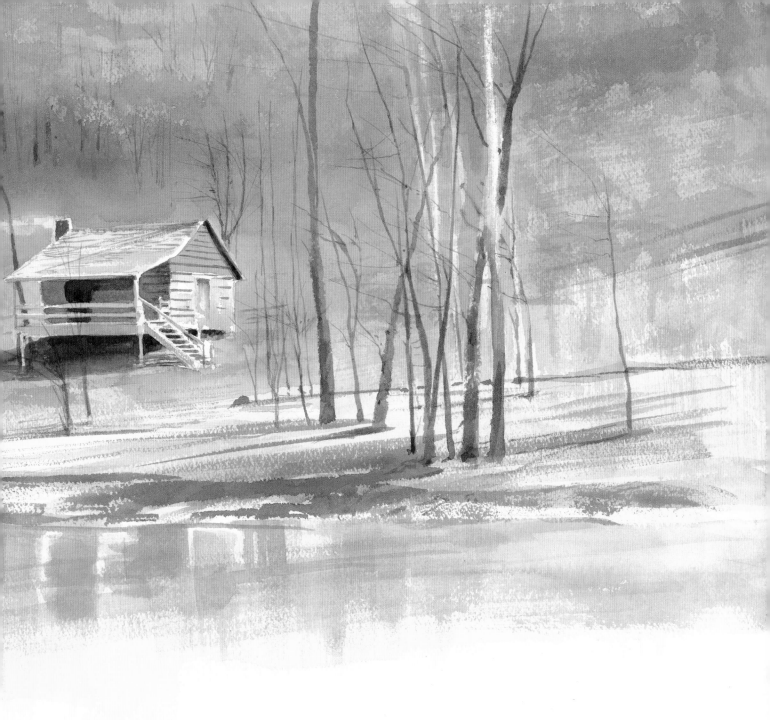

prised of several values, it's a wise approach to try to simplify it into a unified shape or value in the planning state. Then later, as the work progresses, you can add a wider value range to the shadow areas.

The color sketch is the result of my on-site observations and preliminary work. As you compare it with the photographs, you'll note that some changes were made. The first order of business was to remove some of the

trees and then rearrange the remaining ones into clusters to complement the painting. For example, I created a unifying compositional effect by bending some of the trees to the right while others lean to the left. Notice that the vertical trees work in counterpoint with the diagonal sweep of the light. The darker shadows at the left side of the painting help to convey the feeling that darkness is creeping up on the scene.

Making the Transition from Value to Color

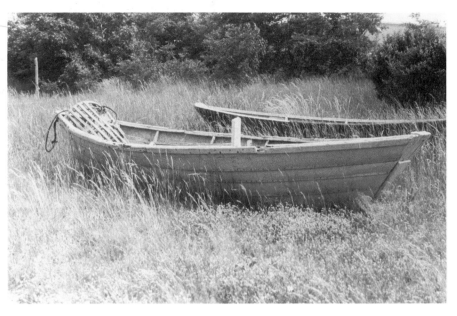

The evolution of *South of Wellfleet* makes a perfect subject for discussing value scales. The development of the painting begins with a 35mm color slide and a black and white photo. Next come a rough sketch and a three-value study. The painting is the final product.

In this section, we will also look at a method of converting gray values into appropriate color values. Every color in the spectrum has its counterpart in a value of gray. So when I encounter a scene like the one that inspired *South of Wellfleet,* my mind automatically begins converting color values to the gray scale. Although there are some maverick colors that can be difficult, you will usually find some place on the gray scale to put them. Also, not everyone sees color in exactly the same way. Therefore, when it comes to converting color to gray value, you will have to trust your own judgment. At first you may want to see what everyone else is doing, but eventually you will have to rely on your own perceptions.

You may at this point wonder why you would want to take beautiful color and see it as gray. After all, that is not very colorful. The answer is that understanding the gray scale will give you a stronger command over developing the forms of your painting. In a way, it's similar to understanding the principle of spotting the essential shapes in nature and in photographs. When you can take your image and reduce it to a graphic, three-or-four value study that works, then you have the makings of a successful painting. Conversely, when you understand how color converts to a gray scale, you can turn the process around and translate a gray photograph into beautiful color.

Color Photo Reference. Often it is form and not color that catches my eye in color photographs. In the color photograph shown, I was attracted by the sweeping, elegant lines of the overlapping shapes. I also was intrigued by the unexpected image of boats landlocked in a grassy field. I wish I could truthfully say that I was the first artist to ever see the similarity between grasses waving in the breeze and ripples on water, but I'm not; nonetheless, I was drawn to the subject's charm and decided it made an excellent painting subject.

Black and White Photo Reference. A good black and white photograph can have as many as ten distinct values, by which I mean tones of gray ranging from absolute white to solid black, with a number of gradations in between. A typical value scale has ten gradations, but it is often very difficult for some people to make a clear distinction between some of the values when a scale of ten is involved. This is because the change, or shift between values is so subtle that many untrained eyes—and in some cases, trained eyes—will miss it. To help you overcome this problem, I have compressed the values by reducing the number of gradations in the value scale to six. Juggling fewer values makes it a little easier for us as painters. In fact, if you have never paid much attention to value progressions, I strongly advise you to plan your paintings based upon three values. Then, as you gain experience, you can expand the value range.

The black and white photo you see will help you to understand some of my planning processes when I paint from a photograph. I often use black and white because when color has been stripped away, you are confronted with very apparent shapes. You are forced to look at the image in an abstract way. After all, one of the elements of reality has now been removed—color—and without color, you are able to see the values more readily. Thus, if you squint your eyes and look at this photo, you will see several values of gray. But if you stop squinting, the number of values perceived will undoubtedly increase. By squinting, you may be seeing as few as four values, but by looking naturally you may be overwhelmed by the range of values.

Two-Value Sketch. In this planning sketch I have reduced the values to black and white. If you compare this sketch with the photographs, you'll see that certain alterations have been made for design's sake. For example, in both photographs, the sky area was almost nonexistent. In the sketches, I enlarged that area and made it the light value component in the composition. And this solution is not unusual, as few photographs convert intact to successful paintings.

Three-Value Sketch. The two-value sketch pretty much expresses what I want to say, but I find its mood a little harsh. The three-value study suggests a softer feeling and acts as a bridge between the photographs and the finished painting.

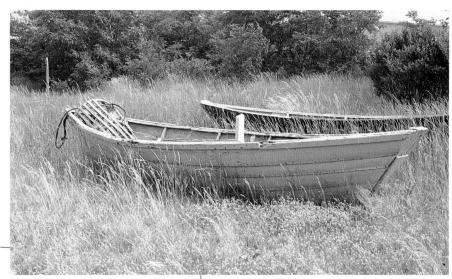

TWO-VALUE SKETCH

THREE-VALUE SKETCH

Making the Transition from Value to Color

Finished Painting. Now the metamorphosis is complete. The actual scene had sparked my interest and emotions, but in order to communicate that feeling, I had to speak the language of painting, where form and shape as well as color must carry the message. One transformation from photo to finished painting that is very obvious is the difference in the amount of sky area. In the painting, I wanted to open up the space by adding more sky. And in other areas as well, I didn't allow the photographic image to tie me down. While the photo has some merit as a photograph, it also has weaknesses as a potential painting. For example, the boat shapes are easily lost in the grassy field. While that is not necessarily a problem, I wanted the boats to be a little more distinct, so I altered the values and increased the contrast. I also moved the wooden post farther into the background in order to enhance the feeling of distance. Keep in mind that this was not the only approach I could have taken; a painting has many solutions. In fact, if I were painting this scene today, I would probably approach it quite differently.

Another set of decisions had to do with color and value. In making this translation from value to color, bear in mind that I had the advantage of knowing the site firsthand as well as having the photo references. The palette for *South of Wellfleet* consisted of new gamboge, Hooker's green, Win-

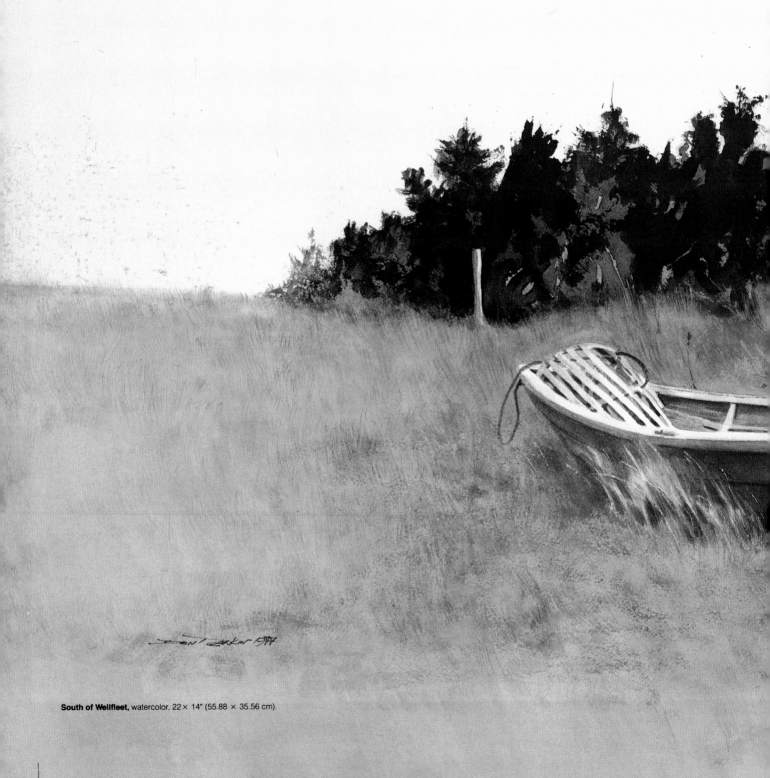

South of Wellfleet, watercolor, 22 × 14" (55.88 × 35.56 cm).

sor blue, Winsor red, and indigo. These colors were mixed in various proportions to create the range of values you see. The grass is a mixture of new gamboge, with a little Winsor blue. The drybrush shadow areas are made up of Winsor blue, Winsor red, and a small amount of Hooker's green, just enough to influence the resulting color. The boats were created out of a mixture of Winsor red and Winsor blue for the near boat and a much lighter wash for the distant boat. The sky is a pale wash of Winsor red and new gamboge. The base color in the tree line is Hooker's green dark and new gamboge, while the shadows are strong mixtures of Winsor red and Winsor blue, with the strongest values containing some indigo.

These colors were my personal choice, based on intuition and the photo references. However, these colors are not the only ones that I could have used. When you develop your own value scale you will find that there are many colors that fall into the same gray value category, which gives you a great opportunity for variety when it comes to translating gray scale to color. So take the time to experiment and eventually you will develop a natural feel for the relationship between value and color in your paintings.

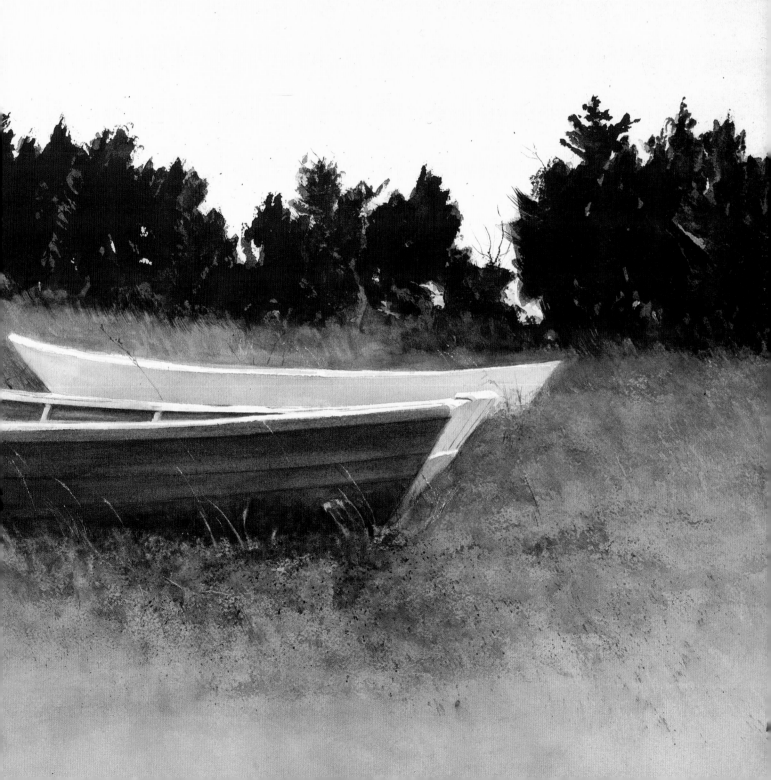

Making the Transition from Value to Color

100% WHITE

20% BLACK

40% BLACK

60% BLACK

LEMON YELLOW

NEW GAMBOGE

VERMILION

PHTHALO YELLOW GREEN

WINSOR RED

MANGANESE BLUE

OLIVE GREEN

80% BLACK

100% BLACK

WINSOR VIOLET

INDIGO

HOOKER'S GREEN DARK

PHTHALO BLUE

COBALT BLUE

PREPARING A VALUE SCALE

To help you to see color as value, study these value scales and prepare to make your own scale. You'll need to work a while until you no longer have a problem translating a gray value to a corresponding color. When you paint, it's important to be able to identify each color you use as a definite value. Don't mistake value for intensity, they are two separate qualities that each color possesses.

To simplify the chart seen here, I have included some of the most commonly used colors and also those colors that I often use in my own paintings. I suggest that when you set up your own scale that you choose the colors that you use in your own work. Using familiar colors will make it easier for you to recognize equivalent values.

To make your own scale, begin with a small gray scale, using either three or five values. Then apply the colors you want straight from the tube in a corresponding spot under the appropriate square on the gray scale. At first you may find trying to match up the values difficult. If you do, I suggest that you squint your eyes and compare the pure tube color with one of the gray squares. If they look the same, that is, if the color blends in and harmonizes with the gray square, you have found the right spot for that color. Take your time. If you mess up start over. With a little practice you will gain accuracy and speed. Remember, this is information you will use throughout your painting career.

A word of caution: Some colors may prove difficult to place correctly. For example, bright red and possibly cadmium yellow may fool you. To match these values, take your gray scale and place it next to your color; then squint and continue to compare gray scales until the color and the gray look to be the same value and appear to blend together.

Also, if you use an abbreviated gray scale, primary colors in particular may not seem to fit. You may find that one gray value is too dark and the one adjacent to it is too light. In that case, you may need to place your "difficult" color between the two grays. In an abbreviated scale, some colors won't fit exactly.

Planning Whites in Your Work

Those of you familiar with watercolor painting are aware that a successful watercolor often depends upon the proper placement of white space. Especially if you use a toned paper, the introduction of white creates a dramatic effect. Also, a neutral background tone makes a perfectly controlled surface for using lights, darks, and middle tones.

Most of the examples you'll see in this section begin with toned paper sketches. When you compare the sketches with the finished work, see if you can pick up the continuity as it reveals itself from sketch to watercolor. Remember, I am using the white on toned paper to plot and develop the lightest values in the final painting, although the white areas in the sketch may not be pure white in the finished piece. However, they typically will be the lightest value.

DAVID

David is my son and I have had the pleasure of watching him grow and play through several years of change. Regrettably, with both my son and daughter, I have not recorded their growth with enough portraiture. Most of my efforts have been confined to pencil studies. In the case of David, I began this series of drawings when he was about ten years old. The following two sketches are a series of preliminaries for a painting that has yet to be completed. They form a progression of thought that will finally be realized in a finished painting. (All were done with a goose quill pen.)

Goose Quill Pen Sketch. I think that a portrait should look like the person. If I can't capture the essence of the person, even if the painting is a competent work, then I feel that the result is a failure. Children are often thought to be difficult to capture on paper. Many reasons are given, but I feel the primary difficulty has to do with their relatively unformed and often delicate features; simple little formulas are useless. Capturing the likeness of a

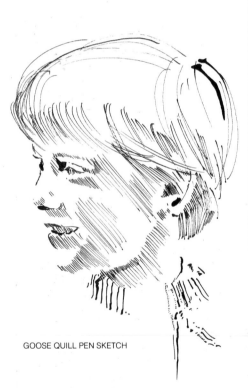

GOOSE QUILL PEN SKETCH

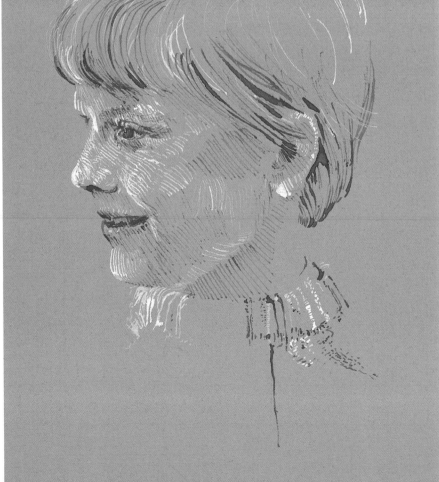

TONE SKETCH

young child requires deliberate care in modeling the planes of the face.

So when I set out to develop these drawings of my son, I was mindful of these pitfalls. Young children are lively and they are not accustomed to sitting still for any length of time. Even using a camera sometimes requires the utmost patience. All too often children—like all people—will pose for the camera in a stilted, unrevealing pose. However, if you are willing to persevere, you can find ways to overcome these obstacles. First, you can watch your subject closely, looking for characteristic mannerisms. You can also capture your subject on film if you catch him or her in an unguarded moment. Once I felt comfortable with the development in these drawings of David, I was ready to go on to a more finished version.

Tone Sketch. I find the toned paper ideal for developing this type of sensitive drawing. With the use of the quill pen and the uniform gray surface, I can pretty well control all of the lights and darks. As I began to develop this drawing, I started out with the light shadow values on the neck, the side of the face, and the ear. Once these values were established, I moved into the hair and the sweater. Finally, after the grays had set the stage, it was time to develop the whites.

If you study the whites carefully, you'll see that not all of the highlights are of the same intensity. Compare the strength of the whites on the top of the head, the tip of the nose, and the tip of the earlobe to those on the side of the face. The variation in strength was accomplished using lighter strokes and by spacing them farther apart from one another. In this way I can control the intensity of shadow or highlight. This is especially valuable when you are dealing with a sensitive subject like a portrait of a young person. Their features are soft and often require delicate handling of light and shade.

I now have a finished tone drawing that will prove to be invaluable when I transform the drawing into a full painting. Using this sketch as a roadmap, I can produce an accurate painting of the subject; all of the lights and darks and their relationships to one another are now in place.

MAKING A GOOSE QUILL PEN

In several places in this book I have mentioned using a goose quill pen. While there may be some specialty shops that still sell goose quill pens, it's not the kind of thing you are likely to find in any corner drugstore or in a local art supply store, for that matter. I favor the action of the quill pen over most pens. It moves quickly across the paper and in many ways reminds me of the freedom of movement you get with a fine felt-tip pen.

Making your own goose quill pen is relatively simple; all you need are the goose feathers. Once you have obtained them—either directly from the bird or from a commercial outlet—you'll need to shape them into a pen.

To make your own quill pen, you'll need a sharp X-Acto knife, although any sharp knife will probably suffice. Just make sure your blade is keen enough to make a clean cut without making any fuzzy or jagged edges that could adversely affect the quality of the pen line. Examine the feather closely to make sure that it is not fractured of broken before you trim off the feathers. Then, make a clean incision at an angle on the quill tip.

Your first cut should give you the proper angle on the quill. You may need to trim it a little more in order to approximate the sweep of a metal pen. When you are satisfied with the angle and you're sure that the pointed end is strong yet flexible, you'll need to split the end point to create a filling area for the ink. To do this, lay the quill on the table and cut a line down the center of the point about one-half inch long.

If you become as fond of goose quill pens as I am, you may decide to cut several points of different sizes, from the extremely fine to the broad nib. Commercial-grade India inks, watercolors, casein, or acrylic paints all diluted to a proper consistency, make excellent mediums for the goose quill.

A PATH TO NEWTOWN

This is a portrait of a pair of beech trees that I painted several years ago. In this case, the photos were used to help me remember some of the detail of the spot. Compare the photos and the sketch, then study the painting. You'll see that the tone sketch is very close to the final work and that not much alteration has taken place. I was able to make this smooth transition by carefully controlling the highlights. In this way I have found that it is easy to maintain a likeness from sketch to final work.

A Path to Newtown is comprised of a series of greens. The palette consisted of new gamboge, phthalo blue, cerulean blue, Hooker's green, Winsor red, and phthalo yellow green. A predominant wash of new gamboge was applied to most of the painting surface, with a few exceptions, such as the highlights of the tree trunks and the sky. This underlying wash helped to give a warmth to the subsequent washes of cool dark greens. You can detect the warming influence of new gamboge on portions of the tree trunk and in the foreground area. These little spots of warmth amid cool color helped give a sparkle to the final work.

The division of color is very important in this work. The composition is formed by light color breaking through a broad band of dark green. The dark background was developed through a series of washes, but I left the areas of the tree trunk and the two limbs that veer off to the left free of paint. They are rather large shapes and I had no difficulty directing the flow of wash around them.

For applying the washes, I used my favorite technique—first letting one layer dry completely and then applying another one. This is an effective way of building luminous, interesting darks. There was one thing I wanted to avoid, however. I didn't want the accumulation of washes to produce an unsightly harsh edge next to the areas of the tree that I had left white. The best way to handle this problem varies depending upon the colors you are using. In this case, I was using Hooker's green for my darker green and a mixture of new gamboge and phthalo blue for the intermediate green value.

Since this combination can build up quickly, I made sure the edge of the wash was feathered just a little and blended as it approached the white tree trunk. Hard edges are not always a problem, but from time to time they can occur. If you see a hard edge build up once the paint is dry, just take a damp brush and soften by gently scrubbing the brush into the area. If necessary, you can blot up the excess with a clean tissue.

Once the middle values in the background were firmly established, I began to develop the middle values in the tree trunks with a mixture of Winsor red and phthalo blue. This combination produced the soft gray characteristic of beech trees. Once the middle-ground areas were completed, I carefully dampened the background areas, taking care to avoid the mixture of cerulean and phthalo blue wash that I had applied to the sky much earlier and to the main segments of the tree trunk. I then began to apply some very strong mixtures of Hooker's green, phthalo blue, and Winsor red, mixtures so dark they were almost black. The wash was initially applied near the base of the tree trunk, but the dampness of the paper made it flow outward into the surrounding areas. Note that this dark wash was applied over the green underpainting, which allowed the dark color to modify and enrich the underlying color.

When the background was dry, I turned my attention to the tree trunks and the immediate foreground. Now it was time to begin to develop texture. My primary objective was to recreate the texture of the beech's trunk. My color choice was phthalo blue, Winsor red, cerulean blue and some Hooker's green. Since, the main portion of the tree trunk had already received some of the earlier new gamboge washes, there was already a base of yellow to provide some warmth to the color in this area. The predominant gray was created by mixing phthalo blue with Winsor red; secondary grays were comprised of mixtures of cerulean blue and Winsor red. The Hooker's green was used sparingly, usually mixed with Winsor red for the darker shadow spots.

If you look at the foreground, you'll note that it is surrounded by darker color and that it has a very soft edge. This effect occurred because the foreground had initially been washed with a layer of new gamboge. And while the background was being darkened this area had been dampened, too. The darker washes had flowed up to the edges but were not allowed to cover this area completely. As a result, the immediate foreground just seems to float between the darker elements as though it were being illuminated by a ray of light.

The final application of wash to this area was a diluted wash of Winsor red, which, combined with the new gamboge, produced an earthy, red-yellow color. Then, into this dried passage of color, I spattered some darker mixtures of red and brown to suggest the effect of small stones.

Final adjustments were made to the shadow areas of the painting and to the branches veering to the left. These areas received a wash of phthalo blue mixed with Winsor red, which allowed them to recede into the shadows. Darker color was spattered onto the trunk to give a little texture, and phthalo yellow green was spattered onto the ferns in the lower right-hand corner. At this point, it was hard to resist using the point of my X-Acto knife to pull out a little highlight here and there on the branches, the main trunk, and in the path among the stones.

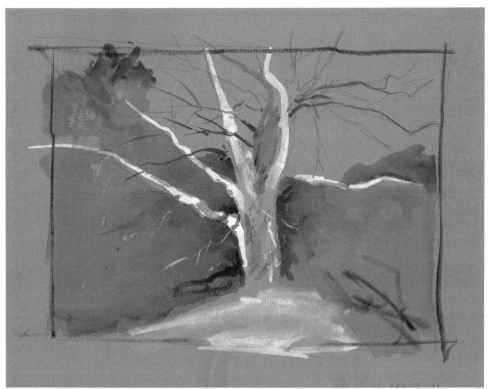

TONE SKETCH

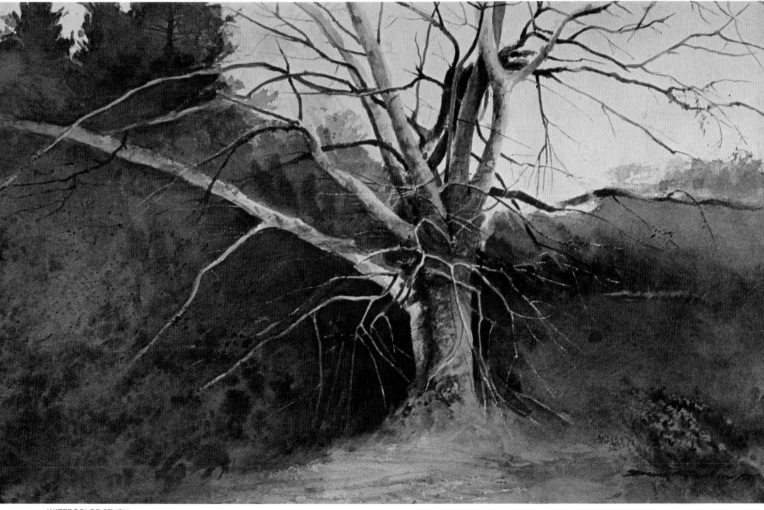

WATERCOLOR STUDY

Planning Whites in Your Work

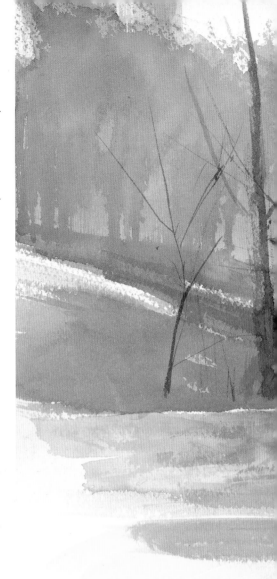

SMYER ROAD

Reference Photo. The photo below gives a fairly accurate feeling for an old mountain road near my studio. Pay particular attention to the light-filled areas in the photograph, such as the streaks of light that cross the road.

Tone Sketch. A well-planned sketch can be a strong bridge between the photo and the finished watercolor. Note that some of the whites seen in the photo become a little darker in the sketch, but are still used to indicate highlight value. Note also that a great deal of tedious detail has been translated into gentle shapes and lines in the sketch. A good example of this can be seen in the distant tree line. In the sketch it is nothing more than a thin line suggesting the contour of the backdrop of trees. So, in essence, I zeroed in on the major elements of the scene and only

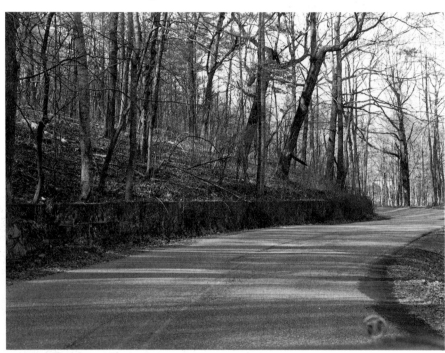

suggested the details. The energizing element is the light, depicted by the white of the paper.

The sketch should reflect all the desirable qualities of the photo and alter or enhance any limitations. So if your sketch is working properly, it should become your main reference source for the finished painting. Of course, there will be times when the photo will be a handy item for observing detail.

Each sketch in this section was done with a goose quill pen. A goose quill is one of my favorite sketching tools, especially if I am thinking of the possibility of developing a painting in the medium of egg tempera. I favor the goose quill for the sensitive line it gives. The quill flows with the freedom of a felt-tip marker, yet it has a wider variety of line. I keep a number of quills sharpened to various widths. Also, homemade inks, watercolors, egg tempera, and acrylics can all be used with this type of pen.

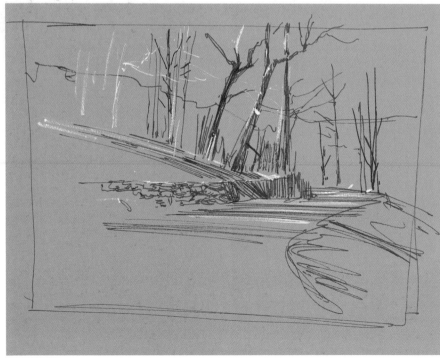

TONE SKETCH

Smyer Road, watercolor, 22″ × 14″ (55.88 × 35.56 cm).

Finished Watercolor. For this piece, I used a very basic palette of new gamboge, Winsor red, manganese blue, cerulean, and Winsor blue. The range of blues was especially helpful in creating the tones of gray in the landscape. Since this is a place on the road that I enjoy seeing, I relied more on my color memory to convey my feeling about the spot.

Various tones of gray make up this landscape. Often gray conjures up an idea of drabness and dullness, but if you mix your grays on your palette, you'll find you can use them to create some of the most beautiful passages in a painting. In this particular setting, I was enjoying a winter landscape with a broad range of grays not only in the trees, but in the road and the rock wall as well. By mixing each of the blues that I had chosen individually with the Winsor red and new gamboge, I was able to create grays that harmonized and complemented one another.

The grays in the trees were developed by using mixtures of Winsor blue and Winsor red along with some cerulean blue. In several areas, the Winsor red was allowed to dominate the mixture. If you examine the rock wall, you can see hints of manganese blue as well as some Winsor blue interspersed in the rocks. Although these colors are not, in fact, local colors and are not really present in the actual stone wall, the blue colors harmonized very well with the warm colors of the ground. Not only that, the blues somehow convey my feeling about the location perfectly.

The final result is a painting that is balanced between harmonizing grays and some soft blues and rusty browns. The overall effect is one of winter and quiet solitude.

Freezing the Action

People and animals have always been artists' natural subjects. Although I do not always put people or animals in my paintings, I still practice drawing them because it's easy to lose the fine edge of your skill without regular practice. Depicting living forms are an important area for artists to master. While there are no magic formulas for success, I have found that both sketching the moving figure and using a camera to freeze action on moving targets can be very helpful.

Sketching the living figure forces you to depict the essence of form, so often a sketch's intent is to capture the gesture of a subject. While learning to draw the figure accurately is very important, I believe that capturing the spirit and mood of the person or animal is also important. For example, when I am drawing people or animals on-the-spot, I find I am most interested in conveying a mood, and a loose gestural spirit is what I am after, not an accurate portrayal or realistic interpretation of the model. An exception would be a still or posed figure where I knew that I had time to double-check proportions.

One way that I have found to improve my sketching abilities is to become a people watcher. After a while you will see that many people fall into certain poses and that there are several universal stances and gestures. Become familiar with the obvious; then learn to draw it. If you make it a habit to carry a sketchbook and spend enough time drawing that it comes naturally and easily for you, you'll find yourself improving fast.

If you like to use a camera this is a good place for you to put it to work. The camera can help you out when your time becomes limited or your subjects start moving too rapidly for you to adequately capture their forms. However, one of the greatest dangers about relying upon the camera too often is that you will become lazy, especially when it comes to sketching people. It takes discipline, but use your camera as a sketching backup. Make yourself work, draw directly from the subject, and use the photos later in the studio to help you remember the session.

Some artists—even some experienced artists—have blocks about drawing figures, and they freeze up on the moving, living form. One way to overcome this fear is to try to look at people or animals as just another element or group of shapes to be placed in your landscape or interior. Another way is to simplify living figures and think more about the movement of lights and darks as they form the overall patterns of the figure.

For everyone who begins to sketch people on location, there is always a first time. To make it easy on yourself in the beginning, I suggest you pick out slow-moving targets. For example, if you commute to work on a train or bus, you'll find plenty of seated subjects there. Or, you may like to stalk your subjects in a restaurant or waiting room. With a small sketchbook in hand, you probably won't even be noticed as you sketch. Begin with easy subjects until you feel confident to tackle fast-moving subjects. The sketching principles are the same—look for shapes and put them into a proper relationship to one another. Think shapes—not hair, teeth, and eyes.

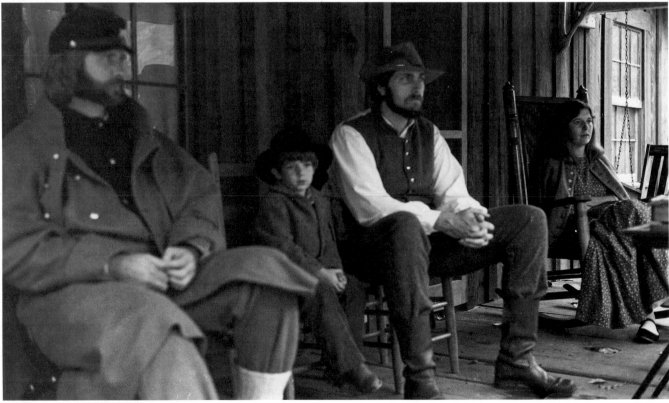

PHOTO 1

TANNEHILL

The sketches on the following pages reflect a rare opportunity for me. I was at Tannehill State Park, Alabama, witnessing a reenactment of a raid on Tannehill furnace. While I don't normally paint historic conflicts or battle panoramas, this subject matter was too good to pass up. These were real people walking around in authentic uniforms, with authentic weapons and equipment. Since it was a beautiful day and I had a camera, a ballpoint pen, and willing subjects, I decided to plunge in.

During the course of the day I took several rolls of film. From these, I used four photos and developed them into twelve line sketches. Remember, I was dealing with large masses of people moving around busily occupied with their own tasks. In the sketches, I think you will get the feeling of this movement in that many of the sketches are very quickly drawn and incomplete, whereas in the photos everything is frozen in place and time. In photos the figures can't move, but if I wish I can move them about on paper to create all sorts of design and compositional patterns. With both, I can create my own reality.

I began sketching with some of the Confederate soldiers sitting on the porch. Since they were sitting still this was a good place for me to warm up. Actually, I had spotted this young man sitting on the porch wearing a great coat and it caught my eye. After everyone on the porch consented to having his photo taken, I began work.

Photo 1. In this shot you see a fairly straightforward picture of four figures sitting on the porch. Although by technical standards the shot is not all that great—shadows obscure some of the detail—it was still a strong reference source.

Photos 2–4. These photos catalog a series of events. In the first photo of the series, my attention was caught by the cluster of men on the left side of the photo and the cluster of men on the bridge. I see an interesting pattern in this configuration. In fairly rapid succession I took the next shot, which was the cluster on the left side. Then I photographed the men on the bridge.

PHOTO 2

PHOTO 3

PHOTO 4

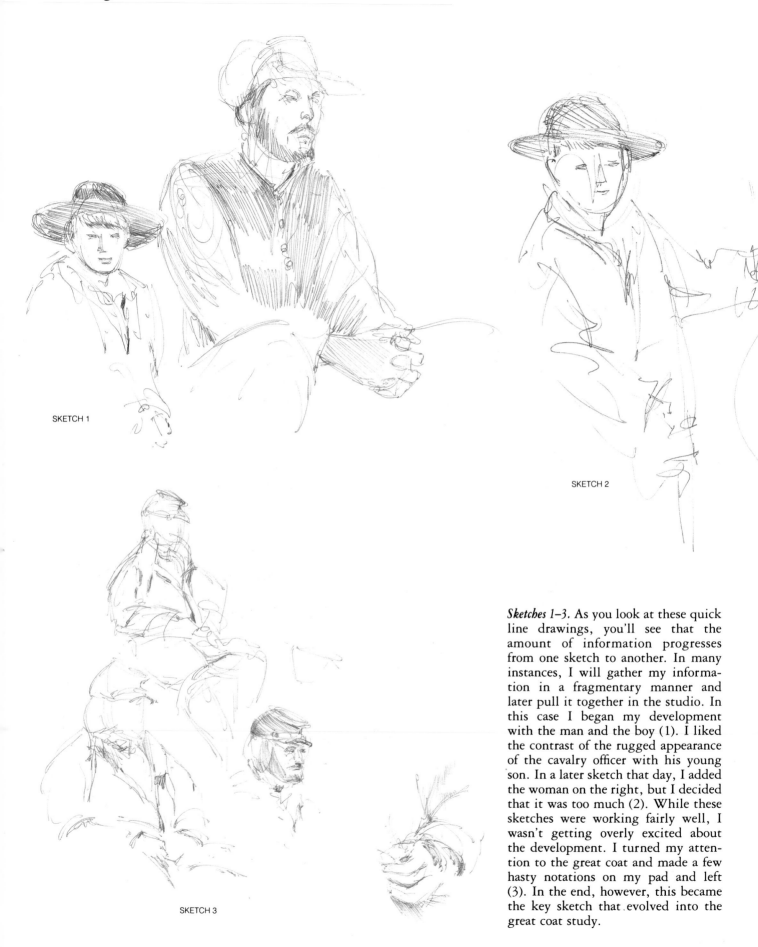

SKETCH 1

SKETCH 2

SKETCH 3

Sketches 1–3. As you look at these quick line drawings, you'll see that the amount of information progresses from one sketch to another. In many instances, I will gather my information in a fragmentary manner and later pull it together in the studio. In this case I began my development with the man and the boy (1). I liked the contrast of the rugged appearance of the cavalry officer with his young son. In a later sketch that day, I added the woman on the right, but I decided that it was too much (2). While these sketches were working fairly well, I wasn't getting overly excited about the development. I turned my attention to the great coat and made a few hasty notations on my pad and left (3). In the end, however, this became the key sketch that evolved into the great coat study.

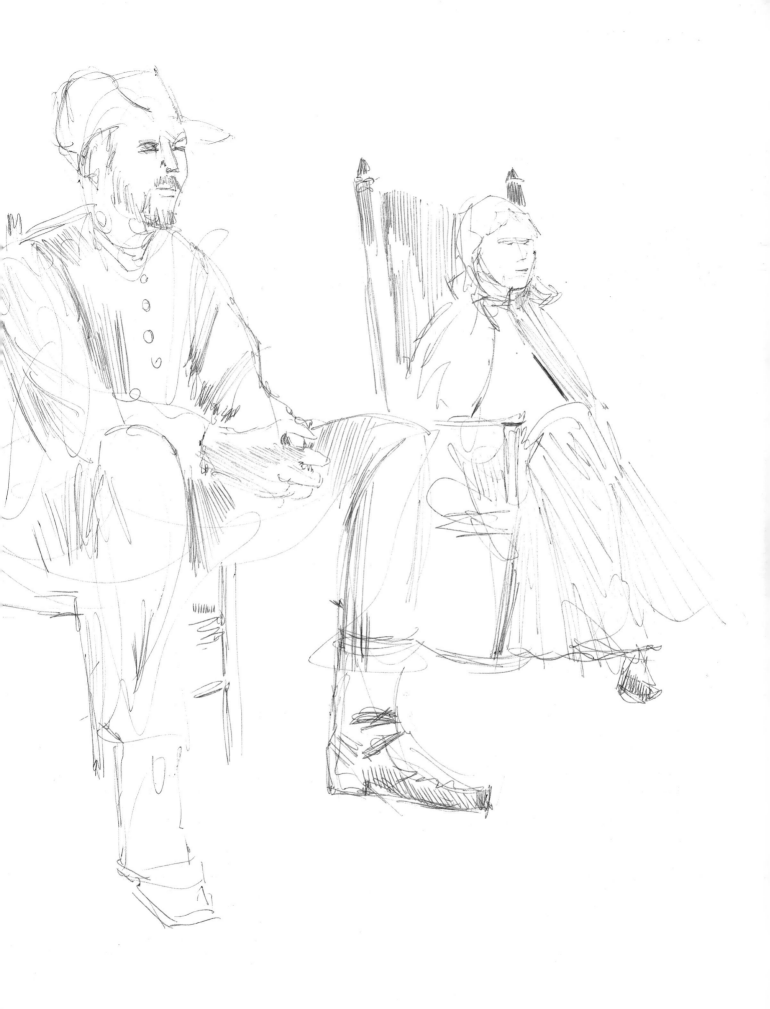

Sketches 4–9. Satisfied that I had some information on film, I settled back to develop some sketches. My approach in dealing with a moving, on-going situation is to pick on a focus and keep working at it regardless of what changes take place. For example, in sketch 4, there were more men present than I showed. But as soon as I began to sketch, some of them changed position or moved out of the area. Rather than panic, I just kept working out the idea that had originally caught my eye. Very quickly, however, this cluster of men broke up and were sent somewhere else. I took a few additional minutes to record my memory images. Fortunately, the guards on the bridge stayed in position for several hours and I was able to do a little more work on them.

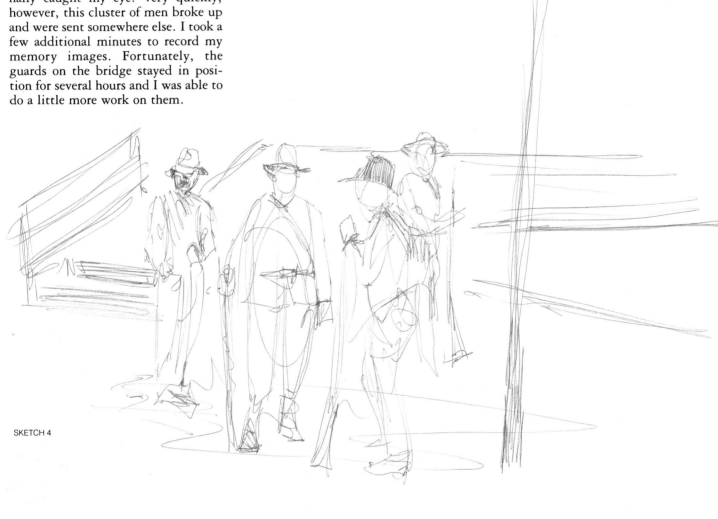

SKETCH 4

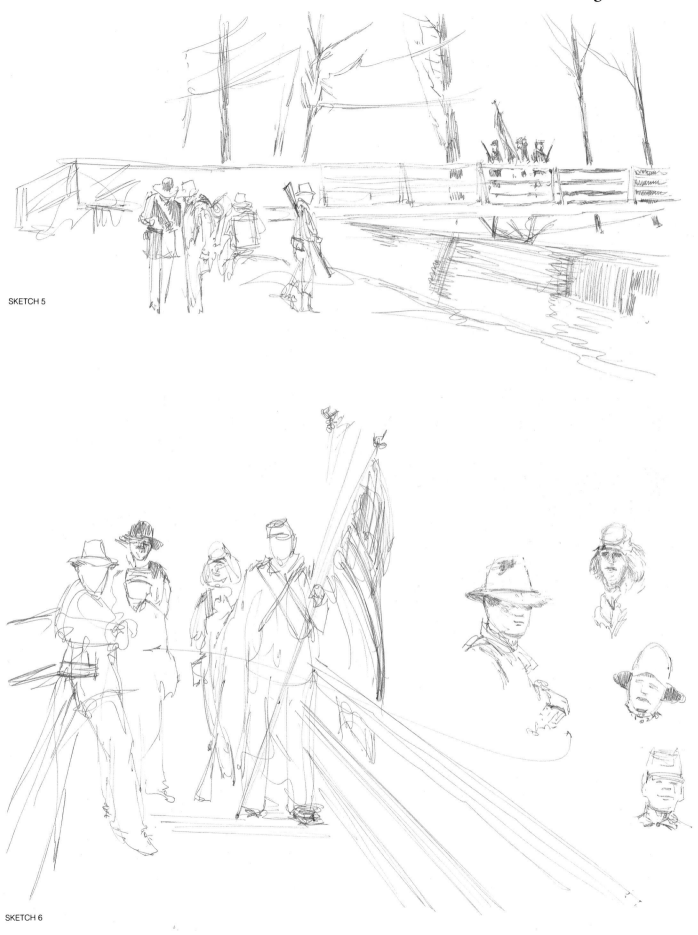

SKETCH 5

SKETCH 6

Freezing the Action

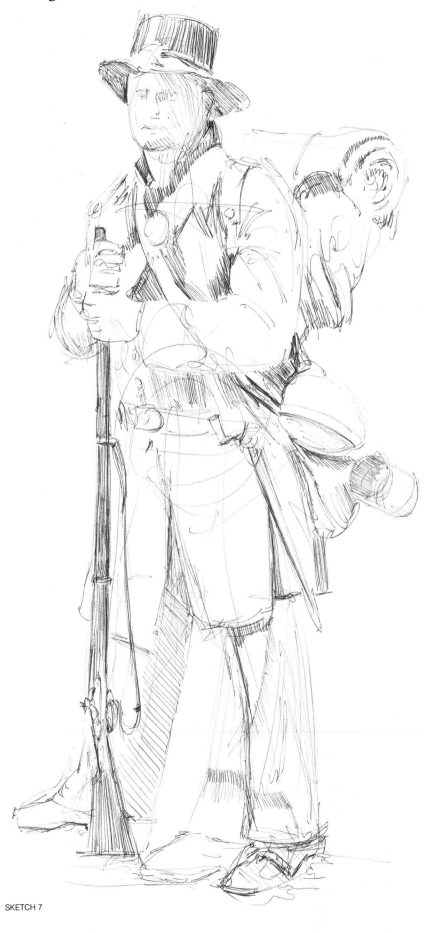

SKETCH 7

Back in the Studio. Through all of the sights and sounds of that day at Tannehill, I was thinking of painting applications. I was also thinking that historic battle epics weren't the kinds of things I had ever seriously considered painting. However, in this case, I had been drawn into the past by talking with and observing living human beings act out a part of history. This encounter gave me a different perspective on the issue. Regardless of the time they were portraying, my subjects were alive, and I had been with them and experienced some of their excitement and enthusiasm. For a few hours I had traveled back in time. In a situation like this my camera had been a very valuable tool. With all of the action and the moving crowds, no artist could have captured adequately all of the subject matter available. Although I took several rolls of film for future possibilities, and I had several quick on-the-spot sketches from my efforts I wasn't ready to paint. I put my sketches and photos aside. But from time to time, I would be reminded of them as I flipped through my sketchpad.

During all of this time I kept thinking of the soldier in the great coat, and when I would see the sketches the memory would be reinforced. For me that is always a sure sign that a painting is brewing in my mind. I retrieved my photos that had been taken that day and I found the photo that had been taken on the porch with the four figures. I began to make a new sketch of the heads of the two soldiers and the young boy (9). By this time, however, it was clear that the soldier in the great coat was the most compelling subject for the moment. This renewed activity took me back to one of my initial on-the-spot sketches (3). The tiny sketch in my sketchpad was the seed for the more developed studies to come. Combined with the initial sketch, I had my memory and a photograph. When I looked at the photo there wasn't a lot to excite me. The photo is far from great technically. It is a candid photo taken on an overcast day in a shadowed area under a porch roof. But in regard to recharging my memory, it was worth a great deal.

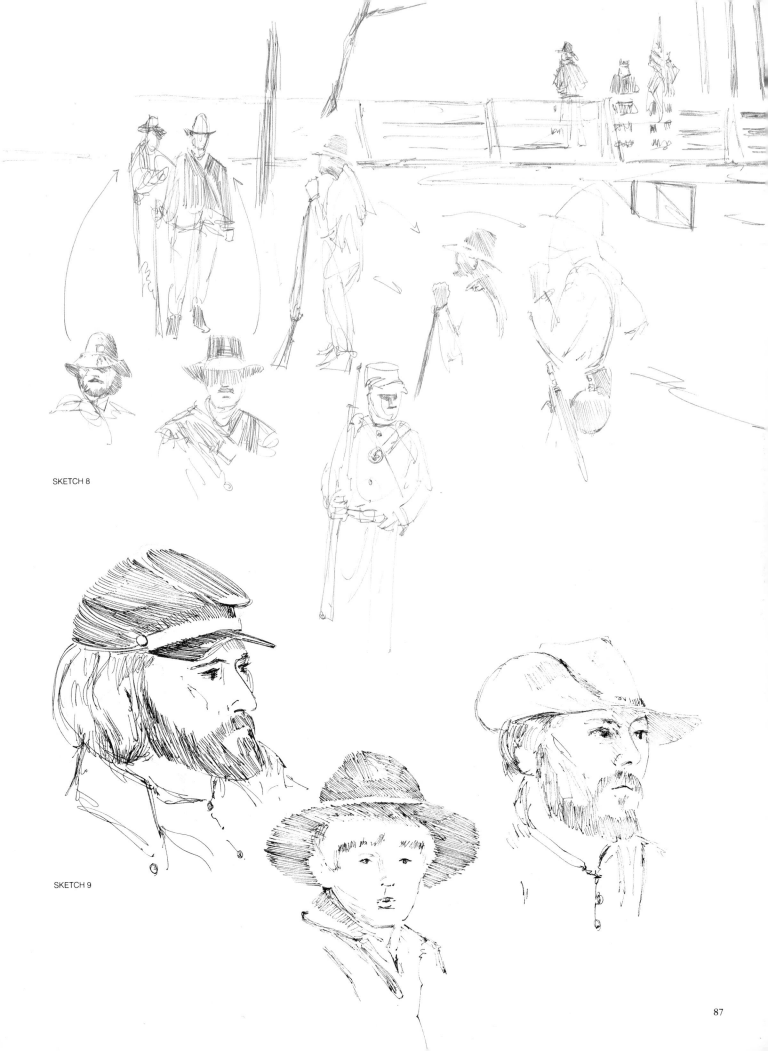

SKETCH 8

SKETCH 9

Freezing the Action

With the aid of the photo and a small sketch, I prepared to do a further study of the subject. My primary concern was with the coat, its color and texture and the way it flowed over the soldier's body. At this stage I was already visualizing the final painting. I felt that the flow of light and the highlights were of primary importance in developing a successful painting. I chose to work on toned paper with a goose quill pen.

Tone Sketch. As you examine the tone sketch, you can see that the highlights and shadow areas are comprised of hatched and crosshatched lines made with a goose quill pen. The middle-tone value is the tone of the paper. In my vision the most important aspect of the subject is the gray great coat slipping in and out of the shadows that surround the subject. The toned paper serves as a perfect vehicle for this concept.

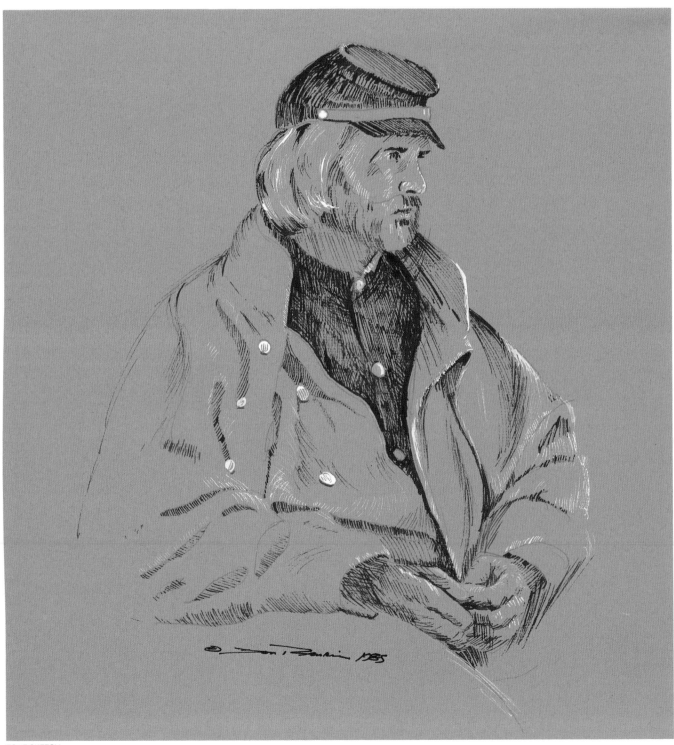

TONE SKETCH

Color Study: Great Coat. This watercolor study was executed by layering a series of transparent washes. If you compare the tone sketch with the watercolor, you'll see that light and shadow areas are similar. The crosshatching with white ink indicates the highlight areas just as the white surface of the paper in the color study does.

There is nothing fancy about the technique used in this color study. Most of the washes were laid in on top of each other, and some of the subtlety of color and tone comes about because of these layered washes. By contrast, however, the tones are flatly laid in on the hat. Note the use of warm and cool color areas to designate shapes.

The palette for this study was comprised of new gamboge, Winsor blue, indigo, cerulean blue, vermilion, and some Winsor red. The washes are very transparent, but their cumulative effect makes an impact.

Although there is no finished painting to look at here, the color study does hint at a possible solution for the final work. It is important to remember that color studies are just that: They are possible solutions to a color problem. As the artist you are free to explore alternate routes in the application of color. Making these types of explorations before you tackle a major work can make the difference between adequate and successful.

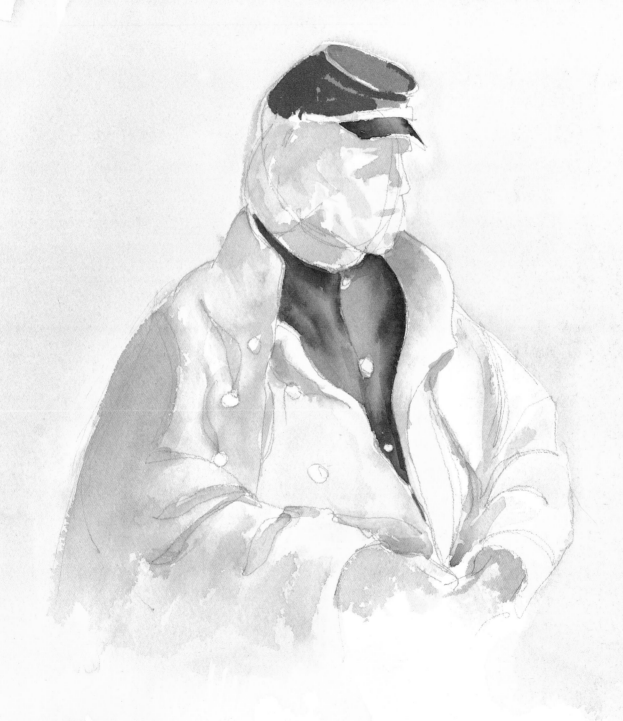

COLOR STUDY

Freezing the Action

WASH DRAWING

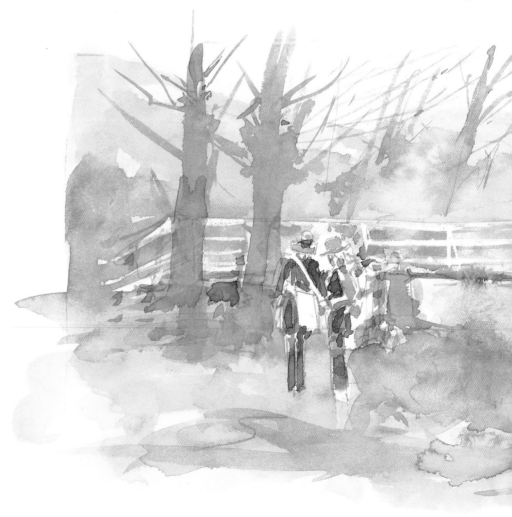

FINAL COLOR ROUGH

Simple Wash Drawing. After developing the studies of the great coat up to a certain point, I decided to go back and work with photos 2 and 3 and all the sketches that related to them. Time didn't allow me to develop this theme further, but I knew that I had all of the elements for a strong watercolor. At that point I didn't know if I would leave the figures in the scene or remove them.

If you compare the sketches and the photos with this color wash, you'll be able to recognize the design elements that attracted me to the scene. The two figures on the left fit in nicely with the two trees immediately behind the bridge. In this position they help to stop the diagonal sweep of the water as it converges with the horizontal movement of the bridge.

Final Color Rough. This color rough sketch helped me to determine if my concept would work as a painting. Now it was time to go one step further, and make a determination about color. Because it was essentially a winter scene I decided to work in muted browns and yellows. The stage was now set to begin a serious study.

Summation. My work at Tannehill is not finished, but the sketches and photographs that I took on that day will allow me to get a lot of mileage out of that one fleeting session. Although I invested four or five hours on the site that day, I can now extend that session merely by picking up the photos or by thumbing through my sketchpad. When I do this I find that my memory helps to filter out the unnecessary and focus on the essentials of picture making. After all, a great deal was going on; unfamiliar sights and sensations often require a buffer of time in order to be adequately digested. When the time is right, I shall begin painting. And when that time comes, the photographs, developmental sketches, wash drawings, and tone drawings will all play a vital part in the final creative process.

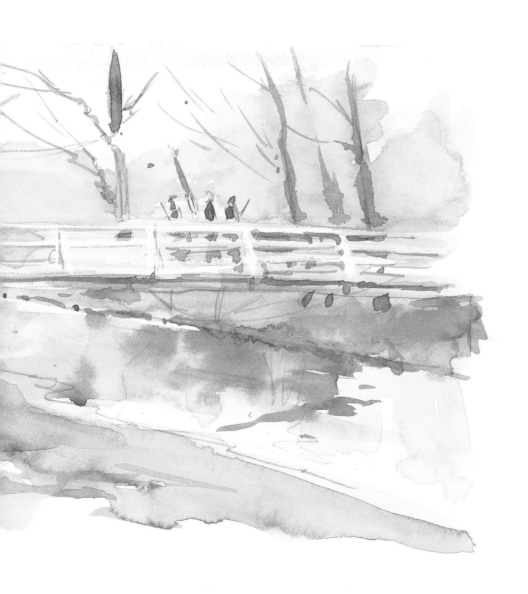

WILLIAMSBURG

This series of sketches and photographs were developed in Old Williamsburg. Most of the sketches are nothing more than gestures of the action, I often reduce the figures to simple geometric forms with little or no attention to detail. I find these fragmentary gestures very helpful for recording various aspects of the scene. Later on I can piece them together or omit them as I make comparisons between my sketches and any photos I may have taken.

While the photos are invaluable for providing detailed information about a given scene, I still prefer to base the feeling of my paintings upon these initial sketches. In order to clarify, I let my sketch rule over the photo. For some artists this is difficult to do, especially if they paint realistically.

There is often a tendency to use the photo as the standard for the creation of the painting. For example, in your sketch, you may have instinctively reduced some elements in order to make a more pleasing composition or to enhance the flow of certain elements. Yet when you compare your sketch to the developed photo, you see

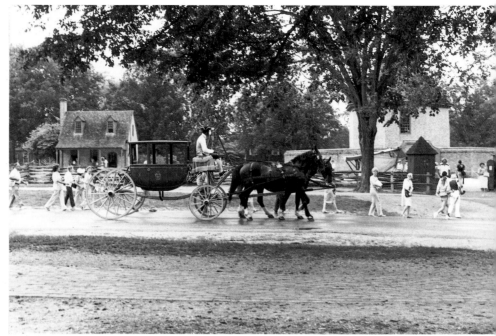

PHOTO 1

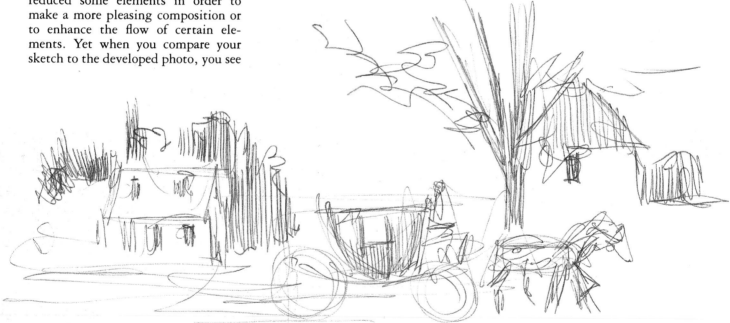

that your sketch is not in agreement. Many times the tendency is to bring the sketch into agreement with the photograph. But when this happens, the photo is ruling over your creation. Sometimes this tendency is difficult to fight. However, you must discipline yourself to maintain control and not allow your photographs to turn your art into a stiff or dead overworked rendition.

92

My stay in Williamsburg was enjoyable and rewarding but like all trips it had to come to an end. Very soon, I was back in my studio with a group of photos and a batch of sketches in varying degrees of completion. Now came the task of sorting this material out and making a judgment about what was immediately useful and what would be of possible future benefit. For discussion purposes, I have chosen five photographs that I took in the course of my stay. In conjunction with these photos there are a few ballpoint pen sketches that were hastily made on the spot. Let's analyze some of this material.

Rough Sketch. This rough sketch of the scene is little more than a gesture drawing and has barely any detail. The total amount of time spent in its execution was just a matter of seconds. But in that short period, I have produced a useful, informational sketch.

Photo 1. In its present state this photo would not make a good painting. This is true because the central focus—the carriage—almost disappears into a background of the same value. This is what I call graphic confusion. To be sure, you could alter the situation with color, but be careful because this red carriage is almost the same value as the green foliage of the background. By comparing the photo to the rough sketch, you can see my solution. I moved some of the major shapes around. The house and building on the right are fairly light in value, while the carriage is dark. To create contrast, I moved the dark carriage over so that it is closer to the light building. In this way I have light against dark contrasts, a very simple yet effective means of solving the confusion problem.

Photos 2–5. These sheep are much slower moving than the carriage. And there is less graphic confusion because of the lighter value of the sheep in comparison to the grass. Although it may appear that some of the photos don't relate to the sketches, they did provide supportive information that was of value as I developed my sketches. All four photos provide information about the house in the background and the fences and grounds leading from it.

PHOTO 2

PHOTO 3

PHOTO 4

PHOTO 5

PEN SKETCHES

Pen Sketches. In this group of sketches, I am concerned about gathering specific information about the key elements in the composition: the shepherdess, the group of sheep, and one or two specific "character" sheep.

Pencil Sketch. The sketch of the sheep's head is not a completely finished sketch, but it does give me a great deal of information for future reference. In the pen sketch, which was nothing more than a beginning rough, I defined the boundaries of the form, relying primarily upon the contrast of black against white to define the shape. This sketch gives volume to the form through the use of intermediate values.

Think of your sketches in terms of evolutionary development. In the beginning, simple, black-and-white two-value sketches are best, then three or more value sketches to fill out the form and further capture the mood. If you are anything like me, you won't spend a great deal of time upon highly developed tonal sketches. I prefer to save my energies for the final painting. However, if I feel the need to explore a subject in a thorough manner, then I will spare no pains to develop as many tone drawings or whatever as I need to get the work ready for final development.

PENCIL SKETCH

94

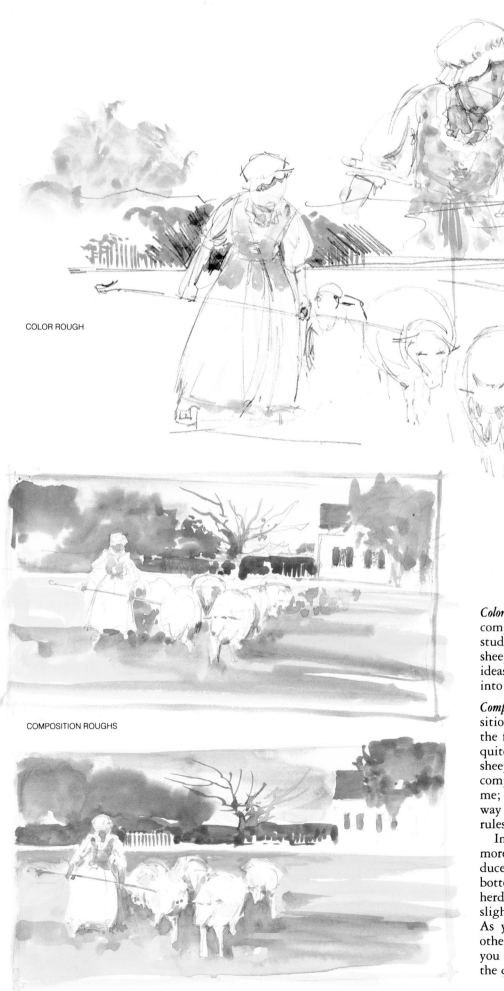

COLOR ROUGH

COMPOSITION ROUGHS

Color Rough. Once my sketches were completed, I began to develop color studies of the shepherdess and her sheep, along with some compositional ideas that would later be developed into a painting.

Composition Roughs. In terms of composition, there are several elements in the first rough (left, top) that are not quite right: The tree and the lead sheep are almost dead center of the composition. But this doesn't bother me; I might just decide to leave it that way because at best compositional rules are guidelines.

In an attempt to come up with a more satisfying composition, I produced one more color sketch (left, bottom), where I shifted the shepherdess and her sheep to the left while slightly shifting the tree to the right. As you can see, virtually all of the other elements remain the same. If you compare these two sketches, note the differences these changes make.

95

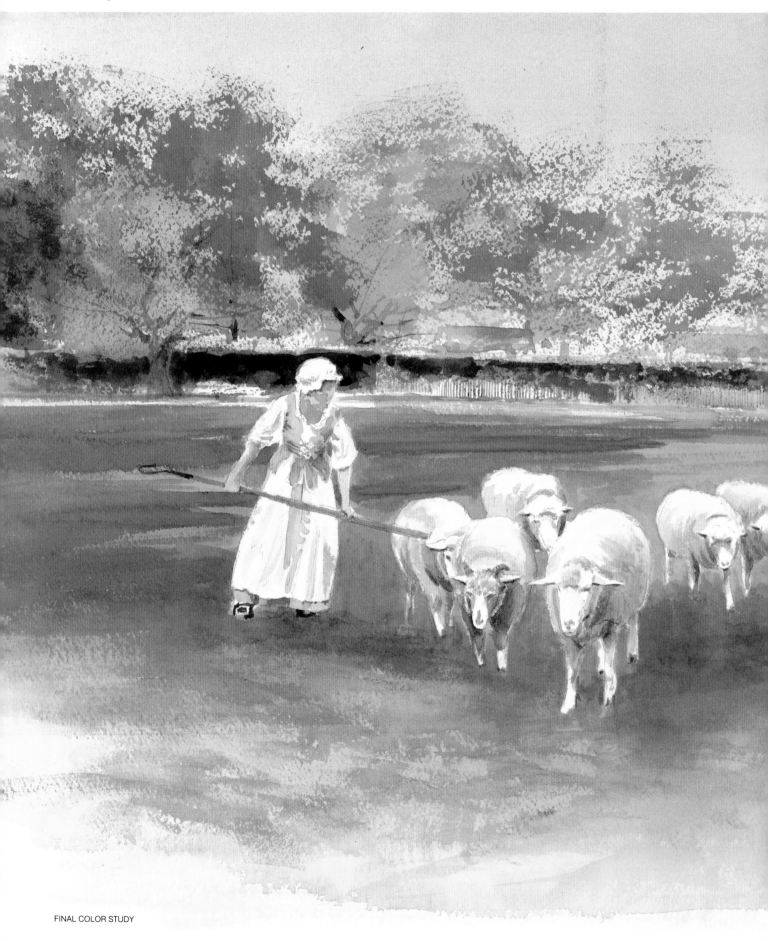

FINAL COLOR STUDY

Final Color Study: After exploring color and compositional possibilities, I was ready to paint. All of the sketches and photographs had brought me up to the point when I was ready to actually do some painting. I don't mean to imply that all of the difficulties of painting a finished work are removed by the preliminaries, because they are not. However, preliminaries help me to pinpoint potential failures or trouble spots *before* I encounter them in the final work. These little warm-ups help me to familiarize myself with the material to clarify my mental processes and reconsider my options. There are times when I like to prolong this process and slowly savor the possibilities before actually beginning the final work.

In this case, I had considered most of the problems. If you look at photos 2, 3, 4, and 5, you can see that I made some changes from the existing photos, but at the same time these photos provided detailed information that was transformed to fit my painting. For the most part the arrangement of the sheep and the shepherdess is very close to the arrangement in photo 4. However, I removed some of the sheep and rearranged their location in the group. The figure of the young woman has been altered to some degree and the sweep of her body has been exaggerated just a little as she leans on her staff.

Finally, the color that evolved in this painting is of my own choosing. It had been a beautiful, early summer day and everything was alive with the bright green of new growth. I don't exactly remember which colors were in the shepardess's outfit, but it really wouldn't have mattered. I would have chosen to use the manganese and cerulean blues, anyway. They tie in and harmonize nicely with the new gamboge, olive green, and Winsor blue mixture that was used for the foliage.

Freezing the Action

Fast speed

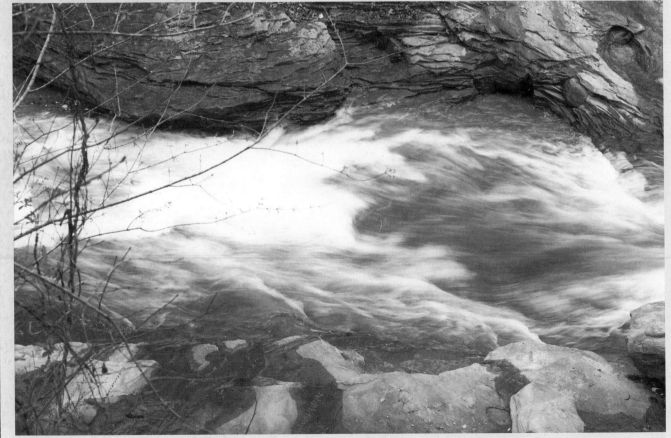

Slow speed

Variable shutter speed gives you many advantages when taking pictures. Not only does it help extend the useful range of your camera in different lighting situations, it can also be used to help you analyze form. Of course, a variable shutter dial is not available on all cameras, but you will find it on the better single lens reflex cameras. For example, a fast shutter speed, such as $1/1000$ or $1/500$ second, can freeze movement of falling water, a bird on the wing, or people moving about in normal activity. And with an extremely fast shutter speed you can literally stop your subject in mid-air.

When using a fast shutter speed, it's not a bad idea to use a tripod as well. I especially recommend the tripod if you want to shoot the same subject with both a fast shutter and a slow shutter speed. For example, water makes an interesting subject for comparing fast and slow shutter speeds. If you compare the two rushing water photographs that you see on these pages, the fast-speed photo is the result of using a fast shutter exposure and it literally freezes the water in place. The slow-speed shot was taken with a slow shutter speed and now the movement of the water looks blurred. If you examine the slow-speed photo more closely you'll see that the blurred image also lets you see more of the massing of the movement of the water. Thus, you might say that in the fast-shutter shot, the photo captures the detail and in the slow-shutter shot, the photograph captures the underlying form. *Both* are vitally important for a full understanding of the subject. With these two shots I was able to explore the mystery of water to a high degree.

This scene was captured on black and white Kodak Plus-X ISO 125 at a shutter speed of $1/1000$ second.

The same scene shot a few seconds later with the same film and camera, using a shutter speed of $1/30$ second.

Balancing Light, Color, and Texture

A painting that contains nothing but hard edges or only soft, blurred edges can quickly become very monotonous. All successful paintings depend upon contrasts of various kinds; the relationships of shape, texture, light, and color need to be delicately balanced. The camera can be extremely helpful for examining at length the details of texture, light, and color.

Artists are often intimidated by the thought of painting certain subjects found in nature. The list of intimidating materials is long: Water, wood, trees, rocks, fur, and grass come to mind; the world is full of complex textures, subtle light effects, and an infinite variety of colors. My first reaction to this fear is don't let yourself be afraid of these subjects. With the aid of your camera you have a method for studying nature's miracles.

For this section, I have chosen six photographs that present different problems, although the solutions are often very similar. The first thing to remember is *learn to simplify*. Later, if you want to embellish your subject, you'll do a much better job. The reason for this is that the act of simplification helps you to better understand the elements involved. Thus, the unifying theme, or common denominator, of your painting may be a color, a texture, or the quality (such as warm or cool) of the light.

As a painter you are looking for relationships between shapes, forms, colors, and textures. Every scene, every subject, possesses a key that will help you to convey or translate that scene into a successful painting. Now it may be true that the scene or material before you doesn't possess the most pleasing array of elements, but there is still a key. It is the artist's job to convert that material into a cohesive design.

1 2 3

4

5

6

7

8

BRUSH EXERCISES

There are many ways to produce textures in paint. But one foolproof way is to practice using a simple brushstroke to create various types of textures. My theory here is that if you have a basic mastery of brushstrokes, you'll be able to create any texture in the world. There is nothing more disastrous than for the beginning artist to get bogged down in gimmicks and slick techniques before he or she has developed a strong understanding of the basic tool—a brush. Many textures can be produced by using nothing more than the simple techniques outlined in the following exercises, but don't assume that these techniques are the only ones possible. They are merely a means to finding your own solutions.

This first series of brushstrokes were made with a 1-inch square-edged Aquarelle brush.

Example 1. For this demonstration, I used the classic drybrush technique. The brush was pulled at a moderate speed across a dry sheet of paper. This brushstroke strongly suggests weathered wood grain such as you might find in barn siding.

Example 2. For this brushstroke, I used the same Aquarelle brush, but this time it was executed a little more rapidly, especially in the center of the stroke. Because the brush only hits the highest ridges of the paper's surface another texture is created, that of distant, sparkling water.

Example 3. Although this brushstroke is basically the same as example 2, the speed with which it is executed is somewhat increased. Note that the faster the strokes, the less pigment is deposited upon the surface of the paper. This type of brushstroke could be used to show more light on the surface of a subject.

Example 4. This effect was created by using a scrubbing motion with the side of the square-edge Aquarelle.

Example 5. Here I switched to a pointed, red sable series 7 brush. The technique used is quite simple; the brush was loaded up with wash which is then splattered onto the paper. You can either sling the brush, which can prove difficult to control, or you can tap the handle against the palm of your hand or against another brush handle.

Example 6. Here, I used an old, slightly worn pointed sable. Once the brush was loaded with color, it was pressed against the surface of the paper making the brush hairs fan out in all directions. Then, I slowly twirled the brush to create the effect you see. The lighter passage to the left was created using a drybrush technique; that is, I did not recharge the brush with wash.

Example 7. This brushstroke begins by laying a square-edged brush on its side as it touches the paper. Once an area of texture had been laid in, I used a drybrush technique with the same brush, in order to combine the two effects. This type of combination is great for creating a grassy effect.

Example 8. A textured surface was created here by laying the side of the square-edged brush flat upon the surface of the paper. In this technique the pigment coats the highest ridges of the paper, leaving the valleys virtually free of color.

The above brushstrokes only begin to describe the various ways of creating textures. But it is important to master them because they work so well. Then once you really understand these techniques, you can add sponges, twigs, sticks, fingertips, string, tissue, and paper towels (as well as other items) to your arsenal of textural weapons. But most important, don't assume that these are the only solutions. These steps are but a suggestion to helping you find your own way.

A final thought: Textures can create additional painting problems. Sometimes, even a little bit of texture can produce an effect of "overkill." One way to avoid this problem is to make sure that textures in the background are not as highly rendered as those found in the immediate foreground. You need to become skilled at suggestion as well as actual depiction of close-up textures.

Balancing Light, Color, and Texture

TREE TEXTURES

When you look at this photo what do you see first? Do you see a portion of a tree trunk, some roots, moss, or rocks? Do you see color with subtle variations of green melding into browns and grays? Or perhaps you see variations in textures of wood, moss, and rock. It is also possible that you see a series of rectangles stacked upon one another with the vertical movement of the tree trunk bisecting the upper part of the picture plane. In fact, all these points of view or emphasis are correct. How you look at and analyze a scene or subject will determine your success as a painter.

If you were to make a painting from the color photograph, I would first suggest that you look for some kind of key element or common denominator. My first thought was that there is underlying yellow tone throughout the picture. Yellow also seems to be a key ingredient in both the green and brown tones you see in the rocks. A strong alternative might be to use green as the unifying color. You could also base the painting on the texture of the moss. The black and white photo is shown here to give you additional information about the texture and also to show the range of values in this small scene.

The demonstration on the next page explores the direction I took when approaching the color photo as a potential painting. Although this exercise could be carried much further, my intention here is to show you a solution for creating the textures you see in four simple steps.

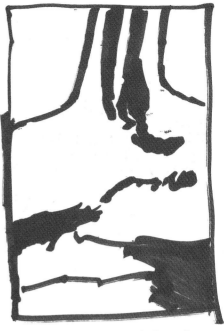

This marker sketch shows the basic shapes and the angle of the tree trunk. For all practical purposes it is the basic abstract design of the composition.

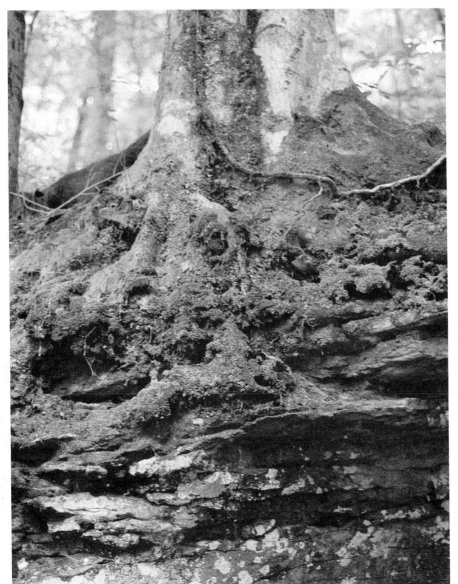

If you compare this sketch with the photo, you can see the green in the sketch occupies the mossy area of the photo. In this case, the moss texture became the unifying element in the composition.

This closeup of the sycamore tree gave me additional information to use along with my sketches. In the photo there is a great deal of texture and detail; in the sketches I have selectively edited the amount of texture and detail to create a balanced composition.

Step 1. After thinking it over, I decided to make the green tones and the shaggy texture of the moss the primary elements in this painting. The moss gave an overall underlying green to the picture; in some areas it has a darker value, but there is still a definite color uniformity. Starting with a square-edged Aquarelle brush, I used its side to apply a wash of phthalo yellow green to a sheet of cold-pressed paper. As I did this, I made sure that the paint didn't cover evenly. Instead, a mottled texture was created, not unlike the pattern you see in the moss.

Step 2. To the first application of phthalo yellow green, which was not allowed to dry completely, I added a wash composed of sap green and olive green. Note that in those areas where the paper was dry, the white of the paper and the first wash shine through. In wet areas, the two colors mingled and merged to form a new color, which suggests a contrasting texture.

Step 3. Since I had a fairly decent moss pattern developing, it was time to add some woodlike effects to the picture. To make the general shape of the root, I washed in a gray mixture composed of half Winsor blue and half Winsor red. Note that the brush was dragged rapidly over the lower portion of the root. This allowed the white of the paper to sparkle through. This simple technique merely requires dry paper, a loaded brush, and a little speed when you drag the brush across the paper.

Step 4. The final wash was a darker value of gray. The mixture of Winsor blue and Winsor red was the same one used in step 3. This time, however, the wash was a little stronger, and some sap green has been added to unify the gray tone with the green tones. This darker wash was used to suggest a shadow effect on the moss that further defined the root.

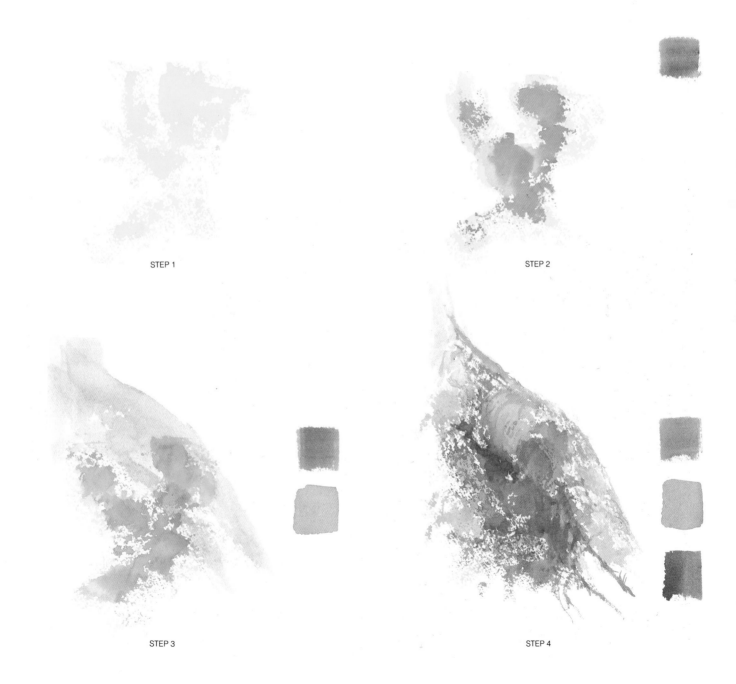

STEP 1

STEP 2

STEP 3

STEP 4

Balancing Light, Color, and Texture

BOATYARD TEXTURES

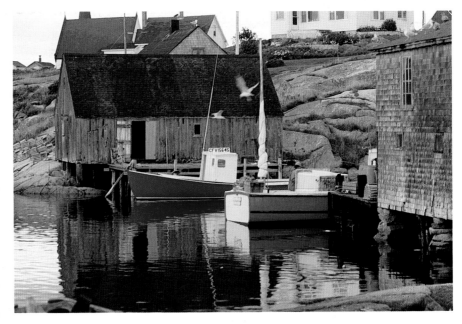

Although this is a quiet scene, there is actually a great deal of visual information going on in this photograph. For example, consider the number of textures you see: glassy, reflective water; weathered woods; rock formations; and flying seagulls. The smooth finish of the boats contrasts with the weathered siding, and the smooth boulders contrast with the grassy areas. The beauty of a photo like this is that you can do whatever you like. You can capture the entire scene or you can isolate one small element.

Whatever your choice of emphasis, there are some major factors to consider at this stage. As you analyze it, you'll see that even though the scene contains contrasting textures, there is also a sense of a definite color scheme. And the sky's reflection in the water creates a unity between these two major elements. Also, the buildings seem to blend in with the rocks in the background; only the white of the birds and the boats stands out in relief against the blue backdrop of the rocks and buildings.

Once I had arranged the blue and white shapes, I removed some nonessential details from the sketch (below). Liberties were taken by deleting the building in the right-hand foreground and by shifting the hillside and distant houses. While I want to retain some likeness to the subject, the strongest emphasis is upon design.

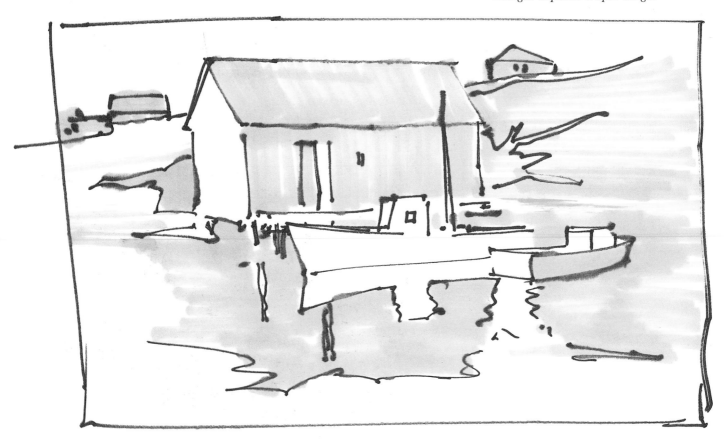

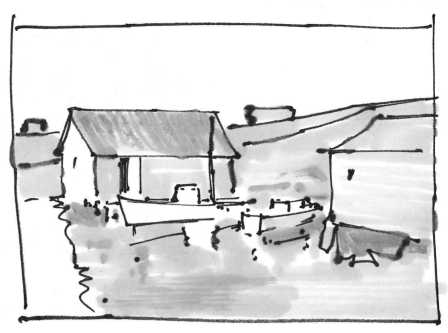

In the photo there is very little contrast between the primary building and the boulders in the background. In the sketch I took advantage of this unity of color in order to make a strong design unit. Note how the white shapes stand out in contrast to the blue areas. These shape areas fit together to create a pleasing composition.

If you compare these black and white sketches with the photograph, you'll see that a primary alteration occurred in the middle ground and the background; that is the roof line of the facing building has been blended into the building and land forms behind it. In the photograph, these converging lines could have created a visual confusion, but by changing the way the buildings relate to each other, the graphic impact of the painting was strengthened.

Balancing Light, Color, and Texture

WOOD TEXTURES

The photograph you saw on page 104 was taken on a rainy fall afternoon. By using the camera, I was able to record the seasonal and other changes that affect the color and mood of a painting. The following four steps demonstrate how I would approach painting weathered wood siding. The swatches that accompany each step show the exact color used for each application.

Step 1. As I examined the scene, I looked for a local color that could serve as a common color theme for the wood siding of the old fishing house. I chose a gray made up of new gamboge and manganese blue. These colors were blended with a great deal of water to produce a sort of greenish gray and applied in vertical strokes (to suggest the vertical planks) with an Aquarelle brush.

Step 2. While this first wash was drying, I began to mix a slightly cooler, darker gray to contrast with the previous warm gray. This gray mixture was made from cerulean blue and Winsor red. This time I drybrushed the gray onto the dry sheet, allowing a great deal of the warm gray to show through.

Step 3. Now comes an even darker gray made up of half Winsor blue and half Winsor red. This wash was only used to designate the wood planks.

Step 4. For the finished coat, I cooled the temperature of the gray by adding cerulean blue to the Winsor red and Winsor blue mixture. This wash was applied carefully with a drybrush technique. The drybrush strokes suggest the grain pattern of the wood.

STEP 1

STEP 2

STEP 3

STEP 4

My approach to painting the wooden roof shingles is very similar to the techniques used for creating the weathered siding. The paint is applied with an up and down movement to imitate the vertical movement I see in the shingles.

Step 1. The first wash was a mixture of Winsor red and Winsor blue.

Step 2. The second application of wash was a slightly stronger mix of wash number 1. Note that parts of the earlier wash is showing through, so it should be obvious that this second wash was applied to a dry surface. Otherwise the dots of original color wouldn't be shining through the second wash.

Step 3. By increasing the Winsor red in my wash I was able to produce a darker gray. This wash was also applied to a dry sheet.

Step 4. Still more Winsor red was added to make the darkest value. This wash was applied with the edge of the brush to simulate the pattern of roof shingles. Notice that underlying washes create color variation.

STEP 1

STEP 2

STEP 3

STEP 4

WATER AND GRASS TEXTURES

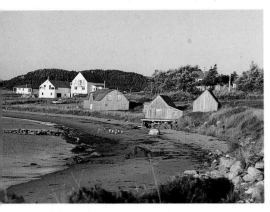

STEP 1

STEP 2

STEP 3

For color accuracy, this photograph comes very close to capturing the quality of light I saw one September afternoon. The unifying element for me in this scene was the clear, clean light. But because light quality is subjective, I find that it is best discussed and understood in terms of color. There was no smog or pollution to sully the air, so every color in this photograph comes through loud and clear. In particular, I got a sense of a pale yellow light permeating the entire scene. In developing a painting of this site, I would use that color influence to advantage. While the photo helps you to see the interplay of light and color in this scene, there is also an interplay of textures at work. Many of these textures are somewhat subdued because of their position in the picture plane, but they still exert an influence. In the following demonstrations, you will see how I go about translating the common textural elements of water and grass into paint.

Water is such a changeable element; it moves with the current or the wind and changes color depending upon what is in or near it. If you want to paint water well, I suggest that you relax and learn to observe it first. Water has many moods, but I have found that for every mood, water provides some clues for mastering it. For example, have you ever tried to paint pounding surf and then worked very quickly to try to capture a particular wave? Did you know that if you wait long enough, that wave will invariably repeat itself? So if you keep watching, you'll be able to capture the basic shape and texture that a fast breaking wave makes. Of course, one foolproof technique is to carry a cam-

era and capture that wave in time. But sometimes it's more fun to capture the feel of a wave with a pencil or pen and ink. The point to remember is that water typically has a pattern or rhythm, and that knowledge can be very useful when you are trying to capture water on paper.

Step 1. For an overall unifying color, I chose a mixture of new gamboge and manganese blue. The new gamboge is so weak as to be barely noticed, but I used it to liven up the wash.

Step 2. While the wash was still wet, I mixed up a darker wash of Winsor red and Winsor blue. Using the edge of my Aquarelle brush, I painted ripples into the still wet initial wash, and let it dry. Note the mottled effect produced. This technique is often all you'll need to create the desired effect.

Step 3. Once these layers were dry I applied another wash. This time the mixture was darker because I added more Winsor blue to the second wash. Toward the top of the example, I used a fast horizontal stroke with the Aquarelle brush. Note that some of the

paper is covered completely by the darker color, but toward the left side the color begins to break up into a spotted, more mottled look. This breakup is due to the speed with which the brush was pulled across the sheet. I moved the brush so fast that only the top portion of the cold pressed paper was colored in, which left the previous color that lies in the depressions untouched. Note the subtle variation in color between the waves. This variation occurs because some of the areas were still damp when the second wash was applied, causing color to merge in some of the little waves and not in others.

As you look at the grass in the photograph, you can probably see at least four distinct colors or variations. For my base color, I decided on a golden tan. The steps have been minimized to show that grass can be developed quickly and easily.

Step 1. I mixed new gamboge and Winsor red to create this golden tan wash, then applied it to the entire area except for the rocks.

Step 2. While the tan wash was drying, I added a little green and let it bleed into the damp portion of the wash. The green is a mixture of sap green and new gamboge.

Step 3. Once the previous wash had dried, I added a mixture of Hooker's green dark and sap green. This time I scrubbed the brush around to suggest a little weed texture.

Step 4. The final application is a brown composed of Hooker's green dark, Winsor red, and new gamboge. This wash was first applied with a square-edged Aquarelle brush using a dry-brush technique. After this first application, I recharged the brush and used the edge of the brush in the foreground behind the rocks. I allowed the side of the brush to scrub around in this area to create a little more texture. My last application of the dark brown wash was made with a size 4 brush in the shadow areas around the rocks and the two or three well-defined stalks of brown grass.

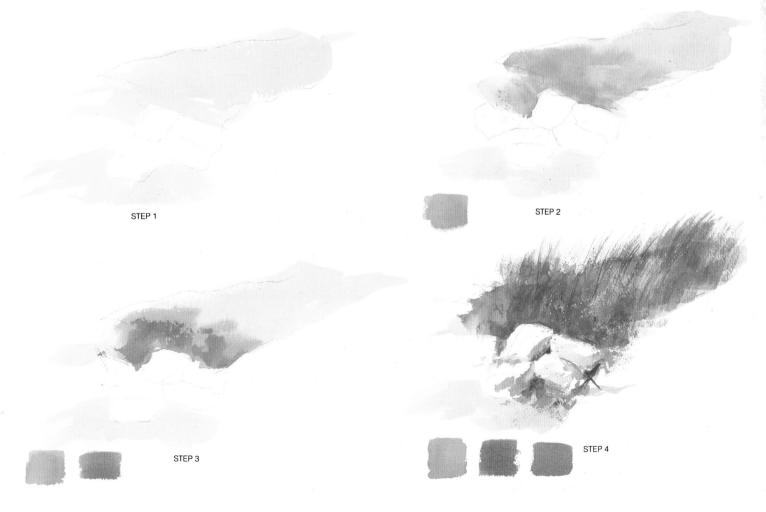

STEP 1

STEP 2

STEP 3

STEP 4

Balancing Light, Color, and Texture

BEACH TEXTURES

For this prospective painting, I wanted to confine my attention to the beach in the foreground. To successfully visualize this scene, I knew I had to begin with an overall unifying color. I also felt there were some interesting shapes in this scene that would help to create a cohesive design.

Step 1. To create the sand, I used a gray mixture of new gamboge and manganese blue. The water is also composed of new gamboge and manganese blue, although I used more blue in the second wash. Notice that the washes have been applied in imitation of the two dominant shapes found in the foreground. The beginning stages are not the time to get fancy—they are a time to lay in the basics.

Step 2. Here I was still coming to grips with the basic patterns of light and shade on the beach. I added more manganese blue to both the far side of the beach and to the foreground water.

Step 3. Now that the basic color values have been established, it was time to texture the color areas. For this job I used a combination of the beach and water colors. Both were spattered onto the paper.

Step 4. For the final stage, I mixed Winsor red, Winsor blue, and new gamboge to create a warm brown. The brown was applied full strength around the rock pile; it helps to define the rocks. It was also diluted and used to sharpen the reflection in the water and to further define the texture of the rocks. As a final touch; I used an X-Acto knife to pick out a few prominent rocks.

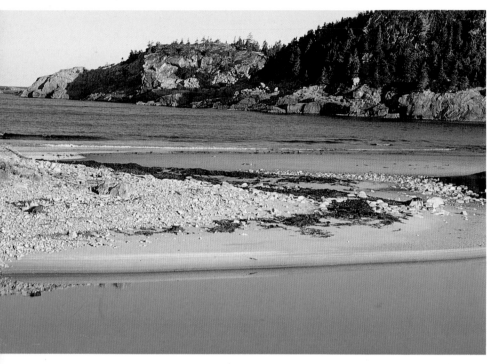

At first glance, the color sketch below may look as though the color is just too subtle to give you much information. However, if you study the color in the photograph, you'll detect a similar yellow cast. The wash was a very diluted mixture of new gamboge and Winsor red designed to suggest the effect of sunlight as it appears in the original photograph

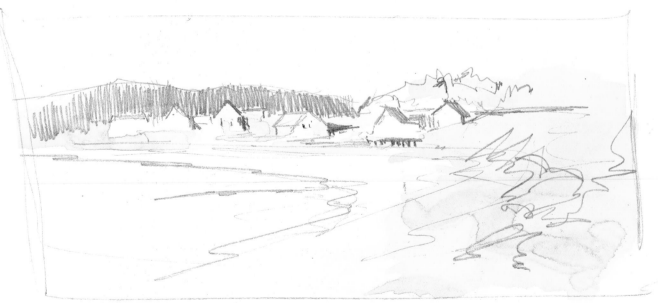

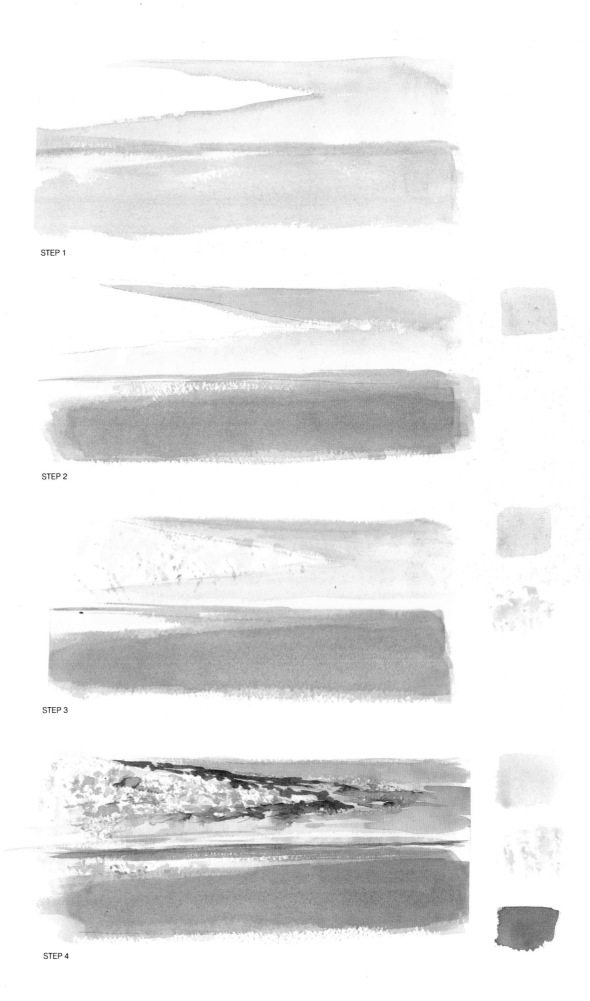

STEP 1

STEP 2

STEP 3

STEP 4

FUR TEXTURE

Animals make excellent subjects for paintings, and this little fawn had a great deal of appeal. When he was found dazed and injured by the rescue service, I was asked to paint a small portrait. Although I worked rather quickly on this sketch, I found the camera a much better tool for capturing the energies of a young animal.

Step 1. Whether you are painting fur, grass, or water, it's essential first to determine a unifying color upon which you can successfully build your textures. In this case, my first wash was a combination of new gamboge and Winsor red. Note that I reserved some of the white of the paper for later highlights.

Step 2. The second wash was confined to the side of the fawn's head, ears, and neck. Note how some of the light and shade modeling was suggested in this second wash. At this stage, I am slowly modeling the form of the fawn's head.

Step 3. This rust color on the fawn's head is a mixture of new gamboge, Winsor red, and Winsor blue.

Step 4. The darkest value, which is also a mixture of the colors found in step 3, was applied. At this point we have a basic unrefined head with all color in the proper place. The only problem was that everything is basically flat and uninteresting.

Step 5. In this final step, I went back into each color area and applied the same color using the drybrush technique. Then more dark wash was applied around the nose, mouth, and eyes. A very diluted dark wash was drybrushed into the neck area (value 4) very sparingly. The wash used in step 2 was drybrushed into the ears. Also, in a few spots, a little of the darkest wash was diluted and used in shadow areas around and in the ears. In short, I refined the fur and the image of the deer by applying second and sometimes third coats of wash to some of the darker areas. But before I did all of this, I made sure that I had a basic image with fairly correct color balance from which to work. Some of the final highlights were scraped out with an X-Acto knife.

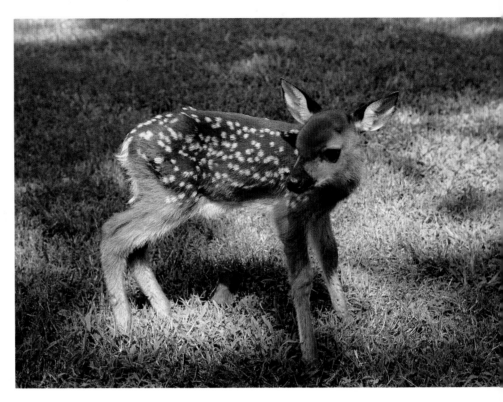

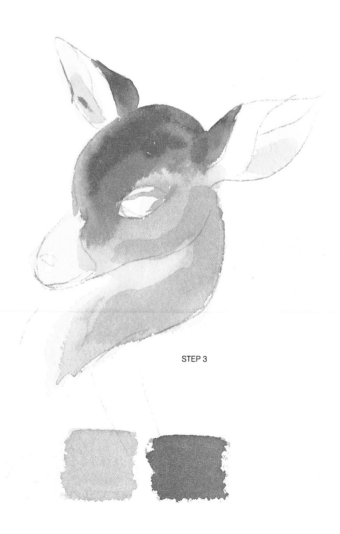

STEP 3

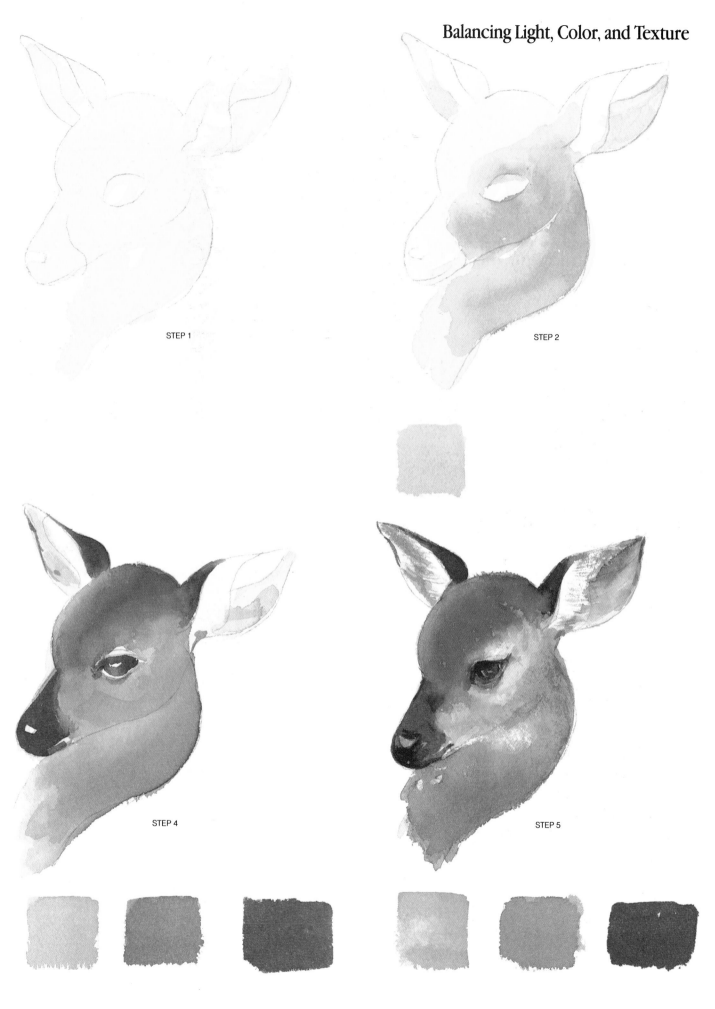

STEP 1

STEP 2

STEP 4

STEP 5

FUNGUS TEXTURES

As with the others, this exercise in developing a funguslike texture on a tree started off with a broad pattern of color. With each step, additional refinements were made to that broad pattern until the final stage was reached. Note that each of these exercises began as a nebulous shape of color. That color was then refined and altered to create a final image through the use of succeedingly darker color. In this manner you are making corrections, or better yet, you are slowly refining your image. You cannot expect to always achieve perfection with the first stroke. Rather, you start with a strong foundation and you build upon it.

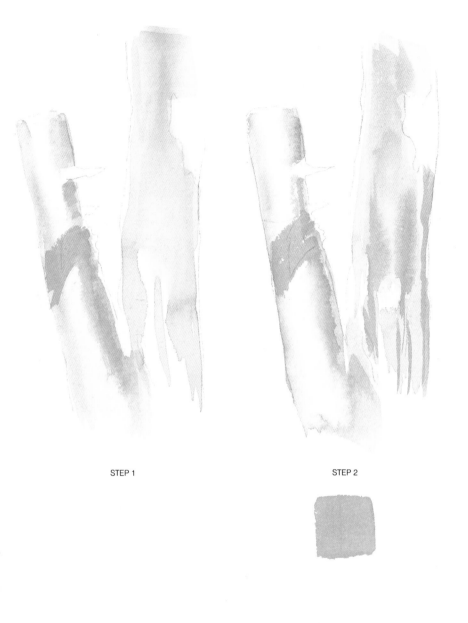

STEP 1

STEP 2

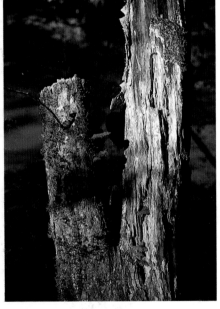

Step 1. In the first application of wash I chose two colors: one warm and one cool. The cool gray was a mixture or new gamboge, Winsor red, and cerulean blue; and the warm side (right side) was new gamboge and Winsor red. The warm wash was applied in a fairly direct manner; and the cool wash was applied in two thin strips, one on the left and the other on the right of the trunk. This left a gap of pure white paper. I then took a size 5 brush loaded with clear water and dampened the center section causing the two washes to flow together, creating a highlight in the center.

Step 2. While both washes (the warm and the cool) were drying, I mixed a wash of new gamboge, Winsor blue, and Winsor red. This wash was applied to the still damp, warm section of the tree. It was added to set the stage for some of the later washes.

Step 3. To the brown mixture, I added a bit more Winsor red to produce this rust color, which was added to both the left and the right side of the tree. On the left, it would provide the basis for the lichens or mossy growth on the tree truck; on the right side it was used for some of the darker shadows.

Step 4. The reddish brown mixture was further altered by adding Hooker's green dark to produce a dull brownish green. Note this color application in the darker areas of the trunk.

Step 5. In the final wash I used Winsor blue mixed with Winsor red to create a gray blue color. I used this color to refine some of the shadow areas. In some of the darker areas, I added the blue over the dark green to intensify the shadows. An even stronger mixture was used to create some of the darkest shadow passages. This color was also used on the left side of the tree to suggest a barklike texture.

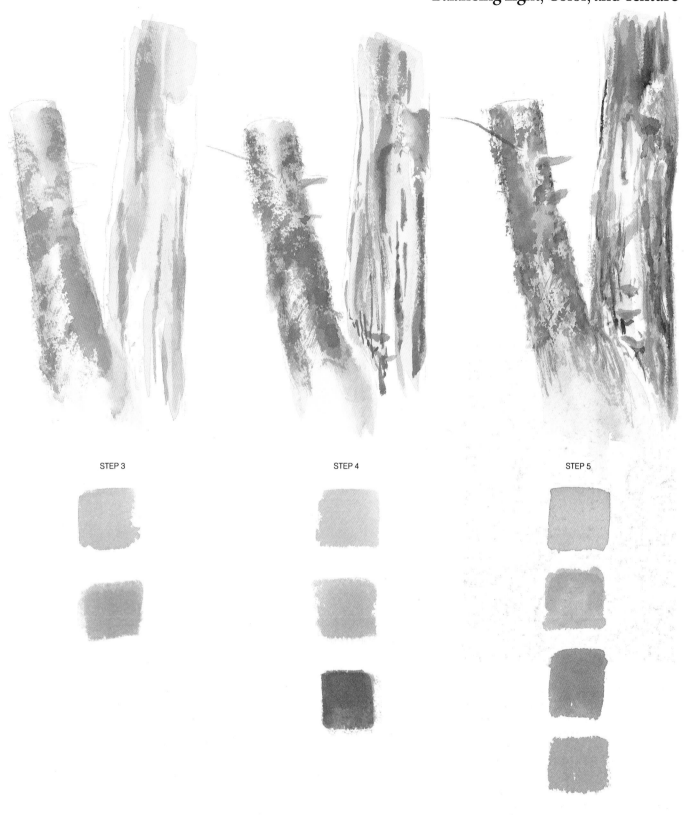

STEP 3

STEP 4

STEP 5

Painting from Sketches, Photographs, and the Imagination

The realm of the imagination and its relationship to art can be a very subjective and elusive topic. What is the imagination anyway? How do we define it? The dictionary defines imagination as "the power of the mind to form a mental image or concept of something that is not real or present," or "the ability to confront and deal with reality by using the creative power of the mind." As these definitions suggest, imagination is not a mystical quality but can be a tool for the artist that is firmly grounded in reality. Thus, once you are confident in your skills and knowledge of the painting process, you are then free to let your imagination fly—from the wellspring of your inner feelings and conceptions.

It is my belief that experience is the foundation for mastering any art form. Once you have mastered technique the inner part of yourself can be released to create in a more personal and meaningful way.

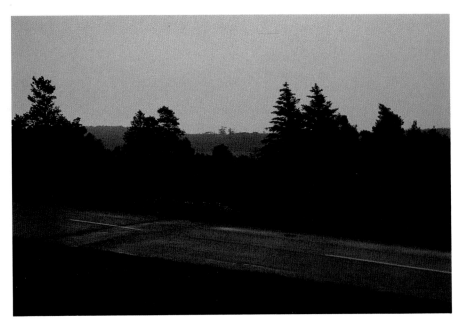

Throughout your lifetime and as you are learning the craft of painting, your mind is constantly collecting memories. These memories and your experiences form a backlog in your mind of accumulated knowledge. Out of this emotional data, you will eventually be able to make painting decisions. You will be able to tap into stored memories to create textures, colors, moods, and altered perceptions. The world is then mirrored through your mind's eye and translated into art. The longer you work, the better able you will be to create images—convincing images—out of your mind's eye.

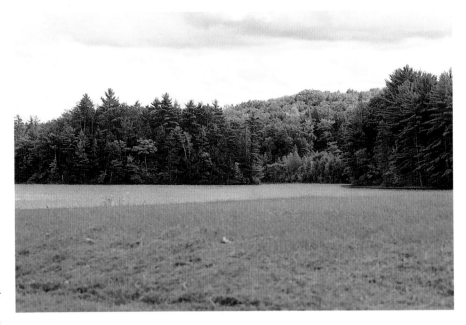

The imagination can be trained and utilized just like any other part of the human body. You can begin this process by forcing yourself to deliberately change specific elements in your resource material. For example, if your photos and sketches depict a dreary day, transform that image into a radiant, sun-drenched scene. Remember, the more conviction your inner images have, the more powerful they will appear in your work. One way to

As you look at the four reference photographs for Marsh Mist, *you'll see that none of them is directly related to the painting (see following pages). Elements of each were taken to compose the painting I wanted. In some cases I was interested in the misty quality of the air and in others my concern was in capturing the shapes and attitude of the trees along the water's edge.*

increase the conviction is when you get a visual image in your mind, take time to give it all of the realistic, sensual detail you can: Smell the smells; feel the texture, the movement of the air; hear the sounds connected with the image in your mind. While this may sound bizarre to some, it is a valid way of putting your imagination to work. As you become acquainted with this kind of mental discipline and put it into practice, very soon you'll find it will start to work for you.

In each of the following paintings, you will see the various processes that went into its creation. Each one was developed from some reference sources—either photos or sketches, or both.

INVENTING COLOR FOR EMOTIONAL EFFECT

Marsh Mist is an example of a painting that relies strongly upon the imagination. This is true mostly because of my decision to use color in this piece in a personal way. After all, as you can see in the reference photographs at left, the grass really wasn't blue. The point is, there have been times when I have "felt" that grass was blue. So in *Marsh Mist* I turned the image I saw in a photograph into a symbol of my feeling about a specific location. The way I look at it, perhaps this painting has been evolving inside me for years and goes back to a time when I would walk with a friend through the fog in a little seaside town in New Jersey. I can recall this scene very clearly: The sounds are muffled, and the air felt like I was walking through clouds. In this private landscape, shapes and colors changed, and familiar objects took on strange and fantastic forms. The inspiration for this piece came on a trip to Acadia National Park in Maine. Even though it was foggy and rainy and the view was definitely restricted, the park was still very beautiful. It conveyed a mood to me that I wanted eventually to capture in paint.

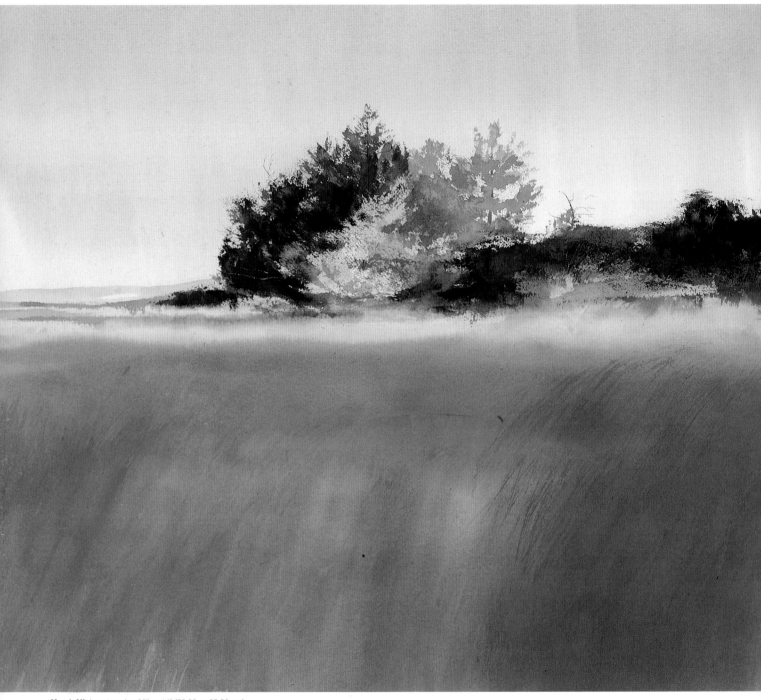

Marsh Mist, watercolor, 22″ × 14″ (55.88 × 35.56 cm).

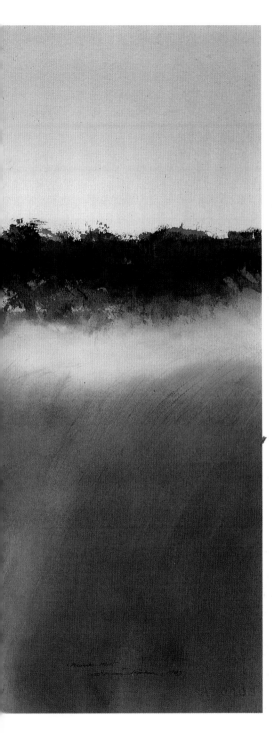

Ordinarily, I might work up some sketches or a few preparatory drawings, but in this case I wanted the work to be spontaneous and unstudied.

To begin, I stapled a dampened sheet of 260 lb. cold press paper to a plywood board. My palette consisted of vermilion, indigo, Winsor blue, Winsor red, and cerulean blue. The first washes were very broad, very pale sweeps of vermilion and Winsor blue. In fact, these initial washes were so pale that if you saw them you would wonder what effect they could have upon the outcome of the painting. But that is the nature of watercolor. As I continued to apply these washes, layer upon dried layer, I was able to create the mood one feels on a day when heavy fog is present. I was largely able to do this through the successive layers of blue tones. This color mood then became the underpinning for the finished watercolor.

Once these initial washes were completed, I established the tree line by applying direct brushwork to dry paper. (The preceeding washes had set the stage for the trees.) The colors used for the trees were indigo, mixed with Winsor red, Winsor blue, and small amounts of cerulean blue. Then while this strip of darker color was drying, I added darker blue values into the various areas of the tree line.

Once these basic masses were set, I used an X-Acto knife to scrape out small limbs, but most of the detail work was saved for the later stages.

Once the tree line was dry, it was clear that the foreground needed work. Although my initial plan for the painting was to place the dark trees in and make everything else a pale blue value that suggests the presence of grasses, the strength of the tree washes and their prominent shapes created a need for additional work in the foreground. In many ways this area proved to be the most difficult part of the painting because if I misjudged the effect of the final washes, the painting would probably fail. Starting at the area just below the trees, I dampened the lower portion of the sheet with clear water and I began to apply blue washes (Winsor red and Winsor blue). When these washes were dry, I swept washes of cerulean blue with a curving grasslike motion into the foreground area. Once these washes were established, much of the detail work in the tree line area and in the grassy foreground was executed with a no. 4 and a no. 6 rigger.

As I look back on this painting, I think it conveys more of an emotional response to a subject than a literal reproduction. Indeed if I had been faithful to my photos, this particular piece would never have been created.

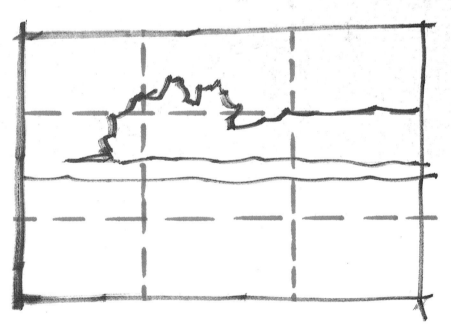

The composition of Marsh Mist *is very simply stated in this diagram: The horizon line is two-thirds up from the bottom of the paper; the background trees are located approximately two-thirds of the way from the right side of the painting.*

Painting from Sketches, Photographs, and the Imagination

IMAGINARY COLOR

Alford Orchard is another watercolor that relies heavily upon the imagination. It is also one that was created from one photograph without any preliminary work. As in *Marsh Mist,* the reference photo was used to recall the scene on a more or less subliminal level. Once again, the color in *Alford Orchard* is almost totally imaginary. When you compare the finished painting with the photograph, it is apparent that one of the most obvious

changes has to do with color. The sky has turned to soft shades of yellow, and the blues have been increased in intensity. It was my *feeling* that these colors are truer to some internal reality than are those colors found in the photograph.

Alford Orchard began with a series of controlled washes. The first layers were new gamboge, applied very pale to the sky area and allowed to become stronger in the immediate foreground. After each wash, the paper was allowed to dry. Remember, if you don't allow the wash to dry com-

pletely, the results will be a disaster of muddy, overworked color. I completed the sky in one operation. Then the foreground received at least two more washes of new gamboge before the balance between the sky and foreground was as I wanted it.

Although it may appear that the blue middle ground area fuses with the yellow in a smooth transition of color, the effect was created by separate applications of color. For example, the new gamboge was applied in two strong bands of color and allowed to bleed, forming a soft edge on both sides. Note that the new gamboge becomes very diluted as it nears the horizon and then begins to increase in strength as it extends to the bottom of the sheet. Once the paper dried, I dampened it again with clear water, and into this applied a pale wash of phthalo blue to cover everything in the foreground area. As this wash bled into the stronger concentration of a new gamboge, it became so diluted by the clear water that no green cast resulted. Once the phthalo blue settled toward the bottom of the paper, I used a large brush to sweep it up into the tree line and horizon line. Much of this was done instinctively and quickly.

Once the paper was dry, the entire sheet was wet down again with clear water, the only exception being the tiny area where the tin roof is located, which was kept dry. To the clear water surface, a blue wash of phthalo blue was applied and allowed to dry. While this wash was drying, I was busy stirring up a mixture of phthalo blue and vermilion, which I used to create the brown cast you see layered over the washes. This final wash of brown color was applied to the newly

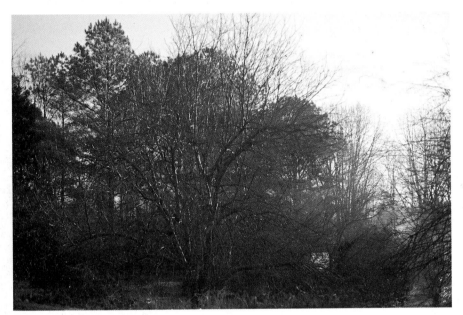

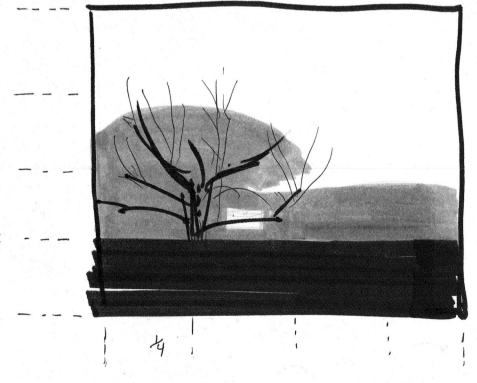

This color diagram is meant to give you a general idea of the color choices I used. The actual application, however, was more softly executed by the use of the wet into wet technique.

Alford Orchard, watercolor, 28″ × 20″ (71.12 × 50.80 cm).

dampened sheet. Once this wash dried, the brown was stronger in areas where the pigment was more saturated. One benefit of this technique is the subtle range of color you can achieve by applying so many successive layers. And since none of the washes is laid in a perfectly flat tone, the strength of the color varies from area to area. This allows for one wash to be strong and the next one to be weak and to even disappear in some strong areas of another color. The result is an intricate weaving of color that's very close to nature itself.

The next step was to draw in the trees. I typically approach trees with a great deal of care. In fact, when I was a beginning artist, I would draw in the forms of the tree with pencil. Then I would come back with a fine brush and paint the tree in. The result was usually a stiff tree or at best a tree that didn't always agree with the pencil lines. While pencil lines don't really present a problem, trees that lack life and spontaneity always do. For me, the solution came by concentrating on the tree image, visualizing its shape in my mind, then picking up the brush and painting in the image.

My method is to let the tree grow from the base up. I use the Oriental, or organic, approach to painting, following the lines of the tree as it would naturally have grown: first the base, then the trunk, then the fine branches, and finally the leaves and fruit. In this manner everything progresses in order; you don't have to worry about tracing the lines you may have already made with a pencil. All of your marks are fresh and spontaneous, and as your brush flows outward, you will find it quite easy to produce fine limbs and branches.

The colors I used for the tree were a mixture of phthalo blue and vermilion. For the darkest part of the tree limbs, I mixed up a strong optical black with the same two colors. The brush was a Winsor & Newton series 7, size 5.

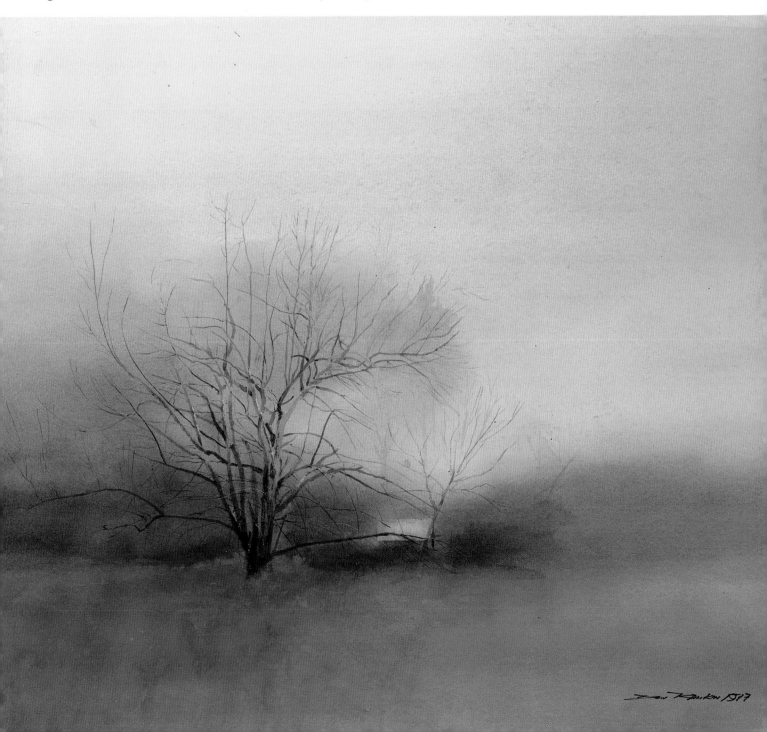

Painting from Sketches, Photographs, and the Imagination

PAINTING FROM MEMORY

I named *The Cycle* after the cycle of the seasons because I can't help associating the seasons of the year with the seasons of our lives from youth to old age. Perhaps that is what attracted me to this pile of dried-up leaves. Although a common enough site in the fall, I find their interlocking, delicate shapes quite beautiful. It was also the sort of thing that would have been futile to sketch, so I took a picture of the leaves with an old Polaroid; and, because it was dusk, did my best to concentrate on the various patterns the leaves took on as the light faded.

My own feelings became the foremost reference source for this painting. In many ways the photo was useless because the painting was locked inside of me. The task now was to let it come out. I decided that the best way was for me to relax and let it surface.

This photo of a pile of dried leaves should give encouragement to anyone who feels that they take less than professional photographs. My source of inspiration actually was this humble scene, but I held on to my notion that the way the light hit the leaves made an interesting and complex design.

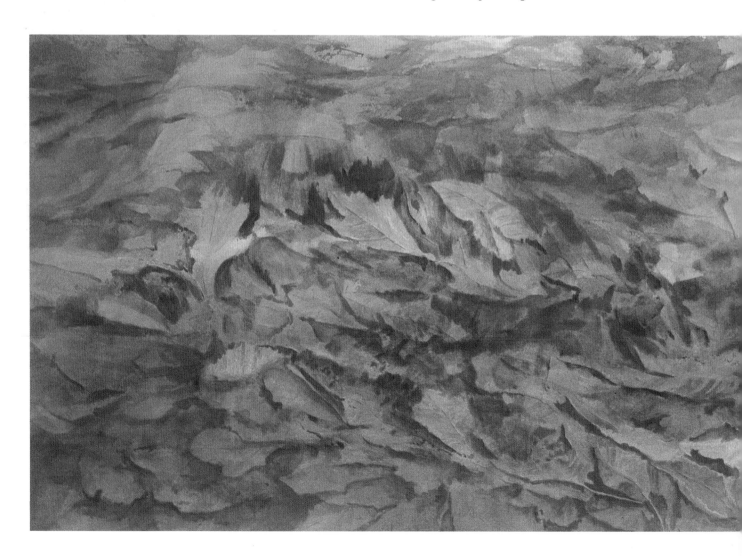

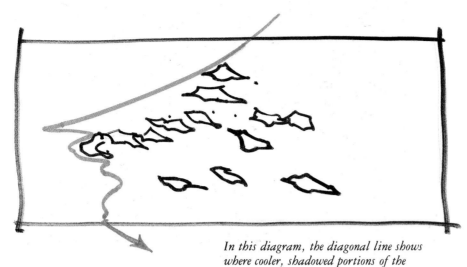

In this diagram, the diagonal line shows where cooler, shadowed portions of the painting occur; and the leaf shapes indicate where highlights soften areas of the painting. The rhythm, or overall movement, of the painting is indicated by the juxtaposition of these two elements.

For this piece, I didn't do any preliminary sketches because I didn't want anything to stand in the way of the painting. I started with a very large 42″ × 26″ (106.68 × 66.04 cm) double elephant paper. Once the paper was dampened with clear water, I stapled it to a thin plywood board to keep the paper flat, and applied three separate washes of new gamboge and Winsor red to achieve a varied color range. When these washes were completely dry, I dampened the paper again and applied diagonal sweep of pale phthalo blue to the upper left area. I did this to suggest the feeling of a subtle shadow. Later on, I used this same color to define some of the smaller shadow areas.

At this point, the painting was comprised of just two colors: the warm rusty brown-orange of the leaves and the cool blue of the shadows. So in terms of color the stage was set; now it was time to allow the painting to grow. Using a one-inch Aquarelle, I defined the leaf forms, not as individual leaves but as groups and clusters. Once the basic shapes and clusters were formed, I drew in the individual leaves. If you look at the left-hand portion of the painting, where the center of interest is located, you'll see that the leaves are fairly well defined. And if you look more closely, you'll see that the leaves are linked and form a larger overall pattern. The result is a mass of leaves, with the center of interest defined by more detail and refinement than the outlying areas. The center of interest area is heightened by allowing some of the leaves to be left in a fuzzy out-of-focus state. The total palette for this watercolor was limited to new gamboge, Winsor red, and phthalo blue.

The Cycle, watercolor, 36″ × 14½″ (91.44 × 36.83 cm).

Painting from Sketches, Photographs, and the Imagination

ENHANCING REALITY WITH IMAGINATION

Lockerbie is an unusual work for me for several reasons. First, of all it was a commissioned work, and second, a great deal of the subject did not exist when I painted the scene. I had been asked to convey the architect's dream of an idyllic setting where families could live and play. I eventually did several watercolors for this project, but the ones you see here were chosen because they deal with the utilization of photography as well as sketching.

Although I completed the final painting in the studio, a great deal of work was done on location. While walking the ground, I had gotten a feel for the land and had a very powerful word picture building up in my mind. I was also taking photographs. I used the "pan" technique of standing in one spot and taking several photos in a panoramic sweep. For example, the photos you see at right are panorama shots and gave me a fairly good idea of the sweep of the land. Obviously the ever-present heavy machinery had to be edited out. Reality was going to have to be altered and enhanced. This, of course, is not anything new to the landscape painter—we do it all the time.

My main objective for this project was to create a rather romanticized landscape that is based on but not tied to reality. While I don't believe anyone would have much difficulty recognizing the location, key elements have been radically altered. This can be best demonstrated by looking at the series of photos and comparing them with the sketches made prior to the painting. While a spontaneous appearing watercolor was desired, the complexity of the subject required a great deal of preliminary work.

MAKING PANORAMA SHOTS

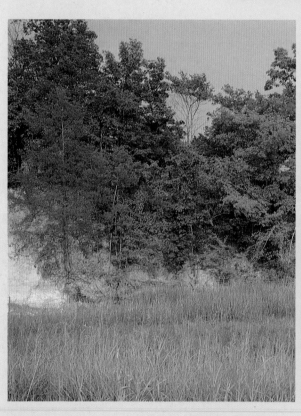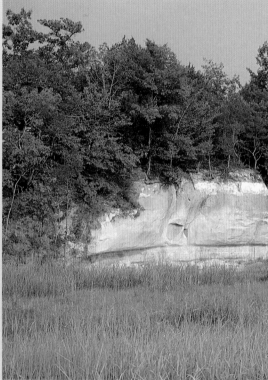

There will be times that you will come upon subject matter that simply won't fit into into your viewfinder. For various reasons it may neither be convenient nor possible for you to back up enough in order to get in all of your subject. A challenge like this need not defeat you because the solution is simple: capture the subject in sections and put the photos together in the studio.

When taking panorama, or pan, shots I have found that it's best to use a support for your camera, such as a tripod. But if you don't own a tripod or have one handy, there are other methods that you can use to keep your image as distortion free as possible. First of all, you must make sure that your camera remains on the same axis throughout the shooting, which means that you must remain stationary all the time you are taking pictures. This is why a tripod is so reliable for obtaining very accurate shots. When you use a tripod, the camera is held steady while you move the lens from frame to frame.

With practice, you can approximate the action of the tripod by swiveling your body at the waist without moving your feet. Incidentally, this movement is often referred to as "panning" a shot. The technique is used

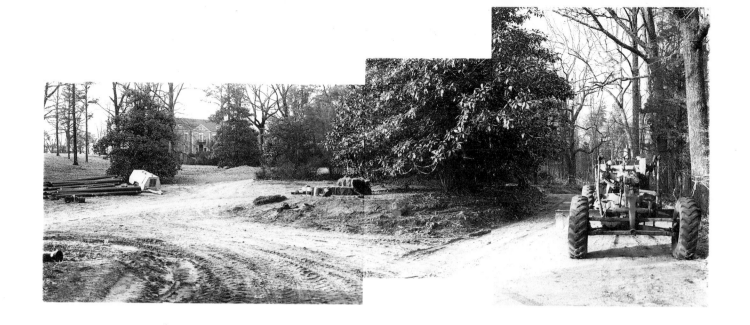

By using the panning technique for this landscape sequence, I was able to capture the entire scene without having to back up and shoot from a distance. In this way, the subject matter remains clear and details are easy to see and understand.

also to impart movement to a still photograph. For example, if you wanted a picture of a moving horse, you would turn your body at the waist and snap your shutter at the point when the running horse was abreast of you. The resulting photo would show the horse in sharp detail while the background would be blurred to suggest movement.

For the purposes of gathering information, the panorama shot remains one of the painter's most useful tools. When taking these sequential shots remember to allow the subject to overlap from frame to frame, so that no details are omitted from the final image.

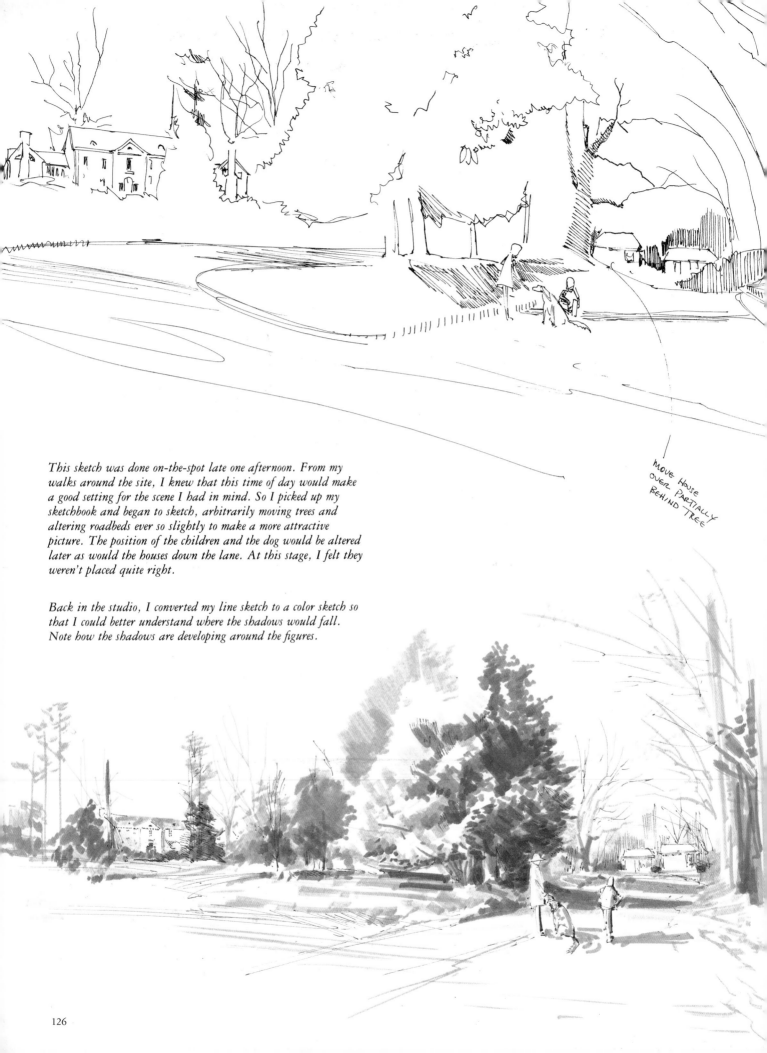

MOVE HOUSE
OVER PARTIALLY
BEHIND TREE

This sketch was done on-the-spot late one afternoon. From my walks around the site, I knew that this time of day would make a good setting for the scene I had in mind. So I picked up my sketchbook and began to sketch, arbitrarily moving trees and altering roadbeds ever so slightly to make a more attractive picture. The position of the children and the dog would be altered later as would the houses down the lane. At this stage, I felt they weren't placed quite right.

Back in the studio, I converted my line sketch to a color sketch so that I could better understand where the shadows would fall. Note how the shadows are developing around the figures.

This is the final sketch before I began painting. Here I went back to refine any areas that needed work and to place the main elements of the scene. One major change had to do with the placement and gestures of the figures. By pulling them into the shadows, they create a stronger contrast and at the same time they don't interfere with the view down the road.

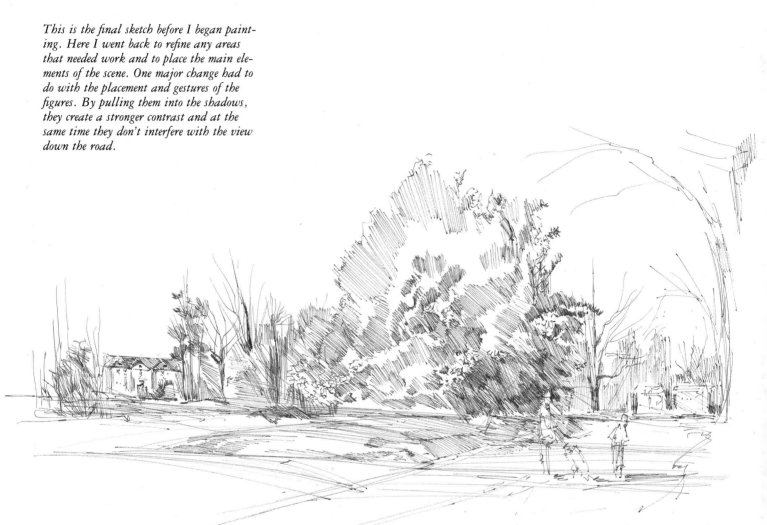

Once I had completed all my preliminary planning, it was time to do the actual painting. Because the finished watercolor was going to be reproduced in sales brochures and various printed materials, I needed to use a paper that had a bright white finish. Fabriano Esportazione proved an excellent choice for this project.

I used sketch 3 as a position sketch to trace the main elements onto the watercolor paper. I did this by placing the watercolor paper over the sketch and then laying both sheets on a light board. I find this is an excellent way to transfer my more detailed drawings because the resulting pencil line is far more senstive and delicate than any line that has been transferred through tissue and tracing paper. In this case I traced over only the main elements so that the watercolor retained a spontaneity that in no way resembled the traditional architectural rendering.

Painting from Sketches, Photographs, and the Imagination

The arrows in this diagram indicate the sweep of the afternoon light, the tunnel effect of the trees, and the focal point created by the road leading to the houses on the right. All these elements conspire to draw your attention to this area of the painting.

My basic palette consisted of new gamboge, Winsor blue, Winsor red, vermilion, phthalo yellow green, manganese blue, Winsor violet, and indigo. The initial washes were composed of diluted new gamboge so that warm tones were imparted to the overall work. Upon that layer of soft yellow color, diluted washes of Winsor violet and Winsor blue were washed into the background tree line area. I reserved the blue for the most distant background plane. The same combination was also used in the foreground area. Since the type of paper used can be unpredictable if you apply several washes, I tried to limit the number of successive layers to two or three in any given area.

The detailing of the houses was simplified and used to depict the basic identifying shapes. The darkest values—indigo and Winsor—in the trees and shadows were saved for the final application.

One of the main objectives of this painting is to draw your attention down the winding road to the houses in the background. I felt I accomplished this by making the houses bright white, even though they are in the distance. I also made the houses stand out by indicating that they are in full sunlight. In contrast to this bright area, the other lights in the foreground are duller and most are cooler. To bring out the houses even more, I surrounded them with a background. When you combine all these devices to draw attention to the houses with the tunnel effect created by the tree limbs and foliage, it is clear where the center of interest is in this painting.

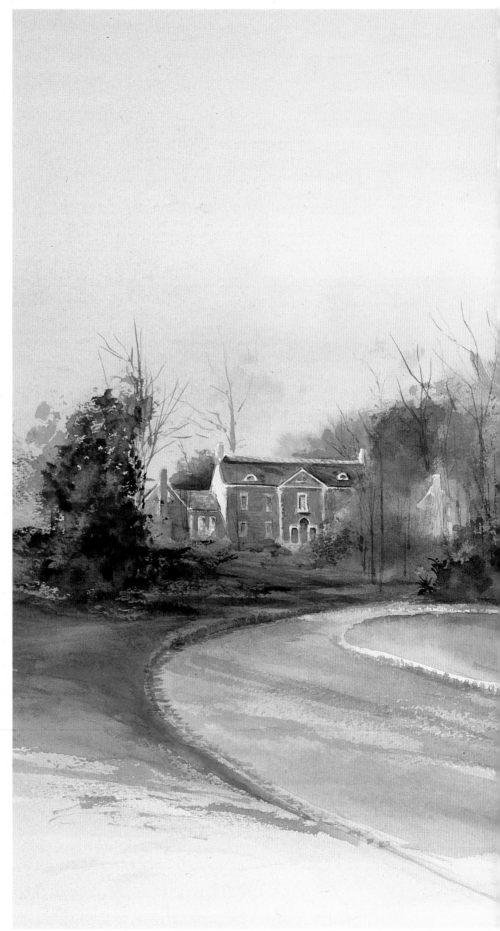

Lockerbie, watercolor, 22″ × 14″ (55.88 × 35.56 cm).

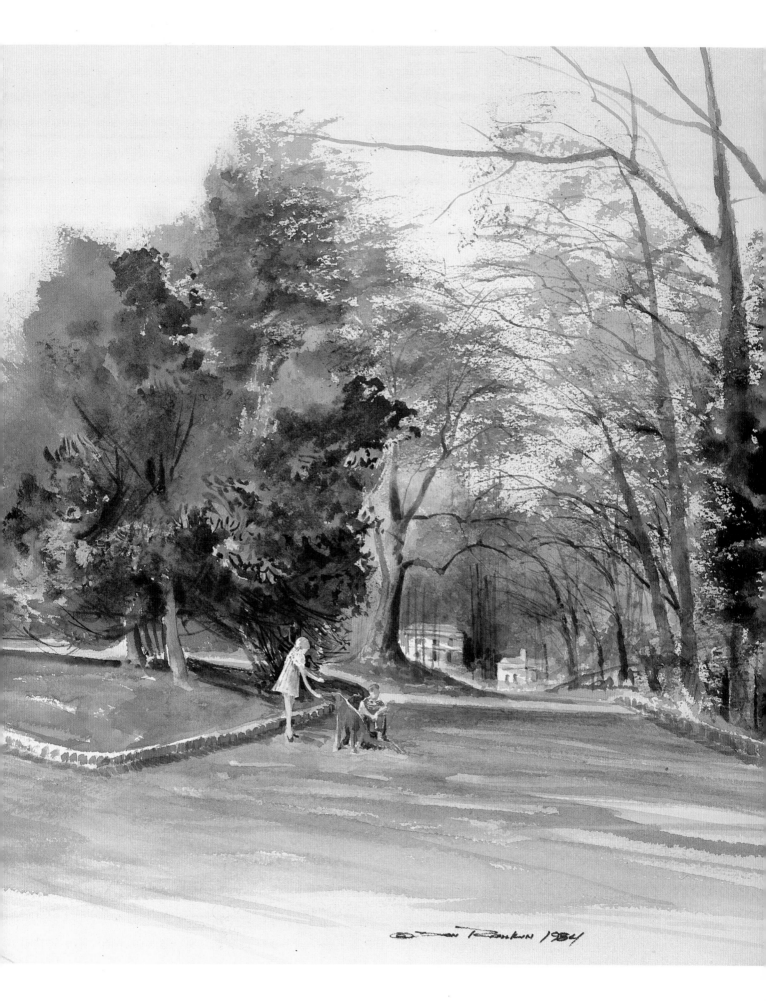

Painting from Sketches, Photographs, and the Imagination

IMAGINING THE PAST

This historic old house known as Arlington is a subject that I have grown up with. For years I have passed by the house and said that someday I would paint it. But last year, my procrastination ceased. I began sketching the house in the late summer to try to find the key to creating a good painting of this stately landmark. At approximately the same time, a large corporation commissioned me to paint Arlington for their collection. The painting was to be used as that year's Christmas card. The house was to be depicted as it probably looked in the nineteenth century. And because it was meant to be a Christmas card, it was requested that the scene be wintry and decorated for Christmas. To help me be historically accurate, the curators at Arlington were very helpful in supplying me with factual information concerning Christmas decorations and probable house color. Armed with sketches, the rest was up to me.

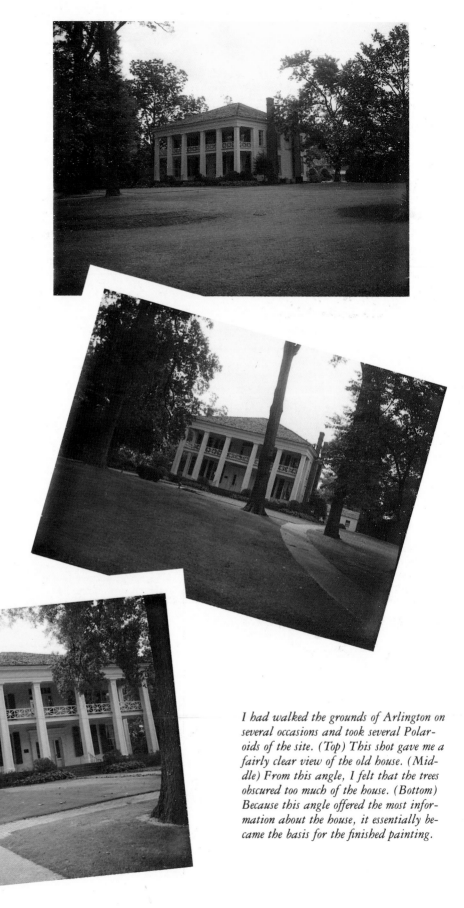

I had walked the grounds of Arlington on several occasions and took several Polaroids of the site. (Top) This shot gave me a fairly clear view of the old house. (Middle) From this angle, I felt that the trees obscured too much of the house. (Bottom) Because this angle offered the most information about the house, it essentially became the basis for the finished painting.

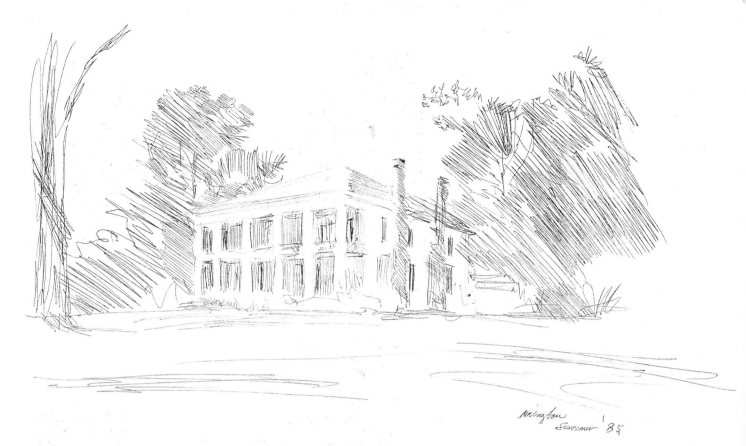

Although both of these pen and ink sketches were done in the full-blown greenery of late summer, I knew that in the finished work the vegetation would need to be transformed into its winter look.

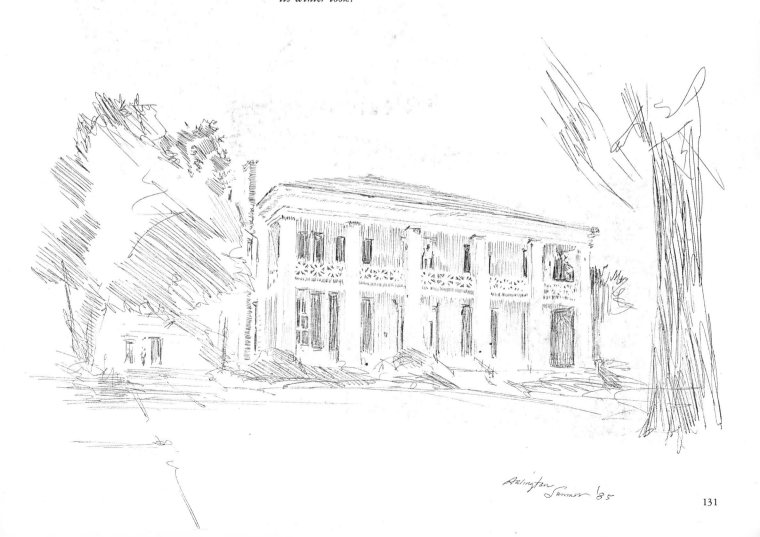

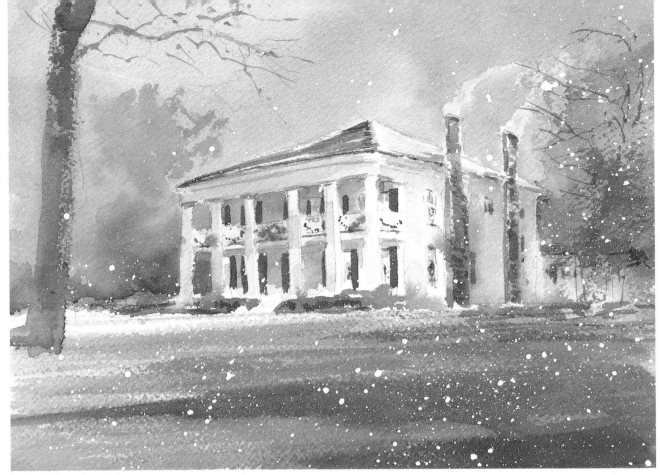

COLOR ROUGHS

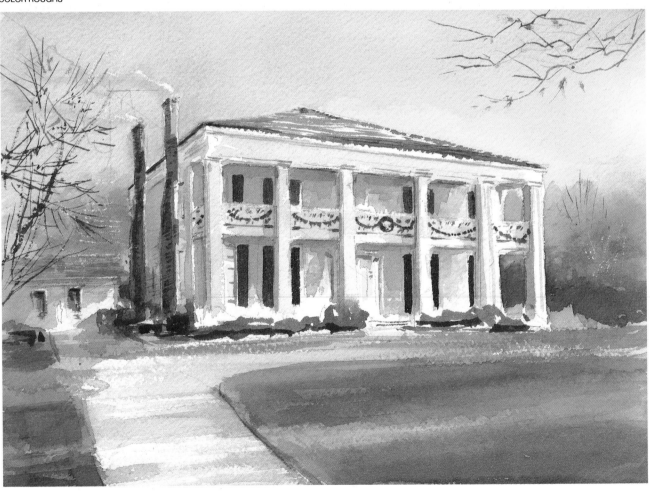

132

Color Roughs. Since a commissioned work often requires more preliminary work than usual line sketches, I did these color roughs. Note that here the landscape and light quality has the look and feel of late afternoon on a winter's day. At this point, I also used the input of the local historical society to guide me in the choice of house color and nineteenth-century Christmas decorations.

In the first color rough (opposite page, top), the only elements that resemble the early sketch or the photo is the placement of the house. The summer palette has been changed to winter; and since it is late day in winter, the lights are on in the house, smoke is coming out of the chimneys, and it is snowing.

In the second color rough (opposite page, bottom), I developed another look for the house. I found this view to be more pleasing and felt that I could generate more interest in the painting from this angle. By using the walkway, the smaller outbuildings, and light and shade effects, I could effectively add points of interest to the composition. A further concern is that since a white Christmas is fairly rare in Alabama, I thought this version would be closer to actuality.

Finished Painting. For the final piece, the client and I compromised on a light snow flurry. Also, figures carrying a tree, obviously intended to be a Christmas tree, were added to give the painting a personal touch.

My primary purpose in sharing the development of Arlington is to convey ways in which photographs can help you paint more believable paintings. If you look back to the photos and sketches, you can see how the reality of the photos was turned in another direction to depict a different time of day and a different season of the year in another century. The final piece evolved from a logical sequence of gathering and processing bits of information and then putting that information back into a painting.

To begin, I made a careful pencil sketch of the house, the walk, and the horizon line. Not all of the detailing was included in this sketch, just the barebone elements such as the columns, window placement, contour lines of the main house and outbuildings. I almost always try to keep line work to a minimum at this early stage because too much drawing can tighten up the image. Actually, it is not so much the drawing that causes one to tighten up, it is more like the mind set that made you think all of the detailed drawing was necessary in the first place. However, for some types of drawings, specifically those with complicated angles and a multitude of intricate interactions, a careful drawing is wise. But even then the brushwork should not follow the drawing in a rigid, slavish manner. Rather, the pencil lines should act as a guide only, so that the brush can give full expression to the work.

My palette was very basic. I used new gamboge, Winsor red, vermilion, Winsor blue, indigo, and phthalo yellow green. Since the setting was late afternoon with a sprinkling of light snow, the light source is limited. I wanted an excuse to "turn" the lights on in the house. Not only would this add a warm, inviting feeling to the work, but it would allow me to show off the window wreaths. I also love the glow of late afternoon winter light and I wanted to explore some of the color relationships common to that time of day.

Since the house was to be a yellowish ivory color, I began by flooding the entire watercolor sheet with a diluted wash of new gamboge. After the initial wash, I was careful to avoid painting the highlight portions of the house with any more color, so I let the first wash establish the highlight color for the house and subsequent washes were then routed around these highlight areas. I continued to apply the washes of gamboge, then modified them with a small amount of vermil-ion. This series of washes resulted in the peachy glow you see in the sky.

The background tree line is a mixture of Winsor red and Winsor blue applied over the preceeding sky washes. The foreground is a wash of phthalo yellow green that was allowed to dry over a layer of diluted new gamboge. Once the phthalo yellow green had dried, a mixture of Winsor red and Winsor blue was applied to tone down and "brown" out the lawn. This gives the lawn area its appropriate winter color.

Once I had established the large color masses, it was time to develop the house a little more fully. It is true, however, that the house has been developed up to a point, even at this stage. For example, as the sky was being finalized with layer upon layer of washes, some of that color was simultaneously being applied to the shadow areas of the house. In that way, the basic elements of the house were developing right along with the rest of the painting. You will note that many of the shadow areas are broad planes of color with little or no detail depicted. Even the railing on the balcony was treated as negative space, where color was applied in wedges around the railings. I wanted this effect because I knew the color of the paper would be more lively and inviting than if I had painted it in with opaque color.

The light in the windows is new gamboge in varying strengths. Since this color naturally contains a slight hint of red, it can often be used sparingly in a nearly pure state. Note that in some cases, I overpainted the window opening so that some of the gam-

boge would spill over onto the windowsill. Later, when a mixture of Winsor blue and Winsor red was applied to the shadow areas, some of the new gamboge was left untouched, creating a warm glow of reflected light in the shadow.

The draperies and window mullions were indicated with a diluted mixture of the shadow value (Winsor red & Winsor blue). The shutters are a dark value of green mixed from new gamboge and Winsor blue. Some of the darkest areas have an additional element of Winsor red to cool the green just a little. Winsor red was also used for the darkest value of the Christmas decorations, shrubbery, and Christmas tree; and the light and middle values were mixed from new gamboge and Winsor blue. In some areas of greenery, a mixture of new gamboge, Winsor blue, and indigo was used for the very darkest value.

The branches, the figures, and the snow were the last items painted in. The branches were executed with a fine-tip, Winsor & Newton series 7 brush, no. 6. I used a gray mixture of Winsor red and Winsor blue diluted with water. The two figures crossing the lawn are a mixture of transparent as well as opaque passages of watercolor. The blue of the taller figure's trousers and the yellow of the smaller man's coat contain a mixture of transparent watercolor mixed with acrylic white. I used the acrylic white to block out the darker color underneath the figures.

The light falling snow was simply a mixture of acrylic white and water. I thinned the mixture enough to spatter out of an old toothbrush and an old square-edged brush. Note that in the foreground and in some areas of the middle ground, you can see streaks of white paint that are meant to suggest blowing snow. This effect was accomplished by dragging a brush through the partially dried white spatter.

A final observation: When you want to create the look of falling snow, make sure your shadow values are strong. Some dark values are necessary because the accumulative effect of spattering softens the image. The white spots of paint will drain the color and detail out of your painting. So if you don't have strong values that are clearly defined, your painting takes the chance of looking weak and unfinished.

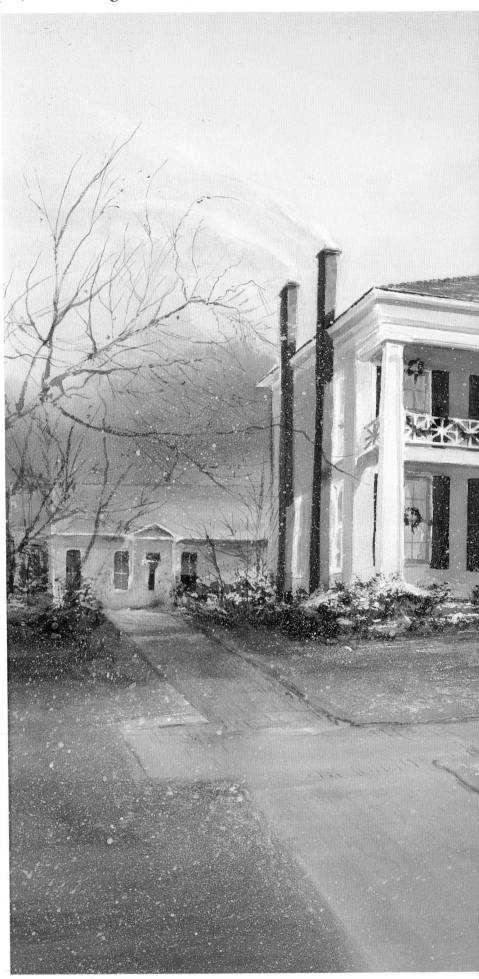

Painting from Sketches, Photographs, and the Imagination

THE INSPIRATIONAL SUBJECT

Some paintings and places are special, and *Winter Afternoon* and the place that inspired it will always be special to me. When I accidently happened upon this site, I knew that I would have to paint it. This old house seemed like a proud old lady whose head was bowed but she wasn't beaten.

As you can see from the photograph, the house was decaying and the grounds were overgrown; many of the trees and shrubs were dying for lack of

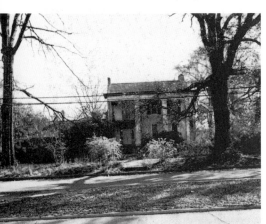

attention. It is also difficult to see much of the fine details of the house in the photograph. But this proved to be somewhat of an advantage, for the obscured image added an air of mystery to the scene. As I began to develop the painting, I had trouble deciding whether to leave the large trees in the foreground. After some thought, I decided to remove the large stately tree on the right because it was interfering with the flow of the painting.

My palette for this painting consisted of new gamboge, phthalo blue, vermilion, Winsor red, and indigo. Although I had first seen the house at midday, I decided to paint it in late afternoon, when in this part of the country the light becomes clear and golden. I had noticed this type of light before on afternoons such as this, and now I had found a suitable expression.

When I began to paint, I loosely sketched in the basic outline of the house, taking care to be fairly accurate with the placement of the pillars and windows. Once I was satisfied with this positioning, I dampened the

sheet in a tub of clear water and stapled it to a varnished plywood board. My first wash of new gamboge was applied to a damp sheet. That wash pretty much covered everything, although some of the lighter portions of the pillars didn't receive too much of the color. After this wash was thoroughly dry, I dampened the paper again, this time with a mixture of new gamboge combined with a slight hint of vermilion. With this wash, I began to take care to avoid the white areas of the house. If you look closely at the painting, however, you'll see that the

coverage was selective, because the shadow areas of the house did receive some of this wash.

I continued to apply the mixture of new gamboge and vermilion several times until the strength of the washes had built up to what you see now. At that stage, I found that the sky had become too brilliant. To tone the sky area down, I dampened the paper again and applied a very diluted wash of phthalo blue to the sky and allowed it to flow down into the foreground area. This blue subdued the yellow-red cast in the sky.

Winter Afternoon, watercolor, 28″ × 20″ (71.12 × 50.80 cm).

Once all of this was dry, I began to strengthen the foreground area with several washes of new gamboge, vermilion, and Winsor red. These washes were allowed to bleed up into the sky which had been dampened with clear water. The shadow areas in the foliage and foreground were created by adding phthalo blue to this wash. Some of the darkest shadows in the foliage were applied through stippling with a drybrush technique using phthalo blue and Winsor red.

Once the foreground and background areas were developed, I devoted my attention to the house itself and the large trees flanking either side. With a fine brush, I began to strengthen the wash in the windows. I decided to take advantage of the setting sun and let the yellow wash cast some light into the upstairs. Once this was dry and I was satisfied with the effect, I scraped out the window mullions with the point of an X-Acto knife. The shutters and doors were painted with a mixture of phthalo blue and Winsor red, and much of this same mixture was used for detailing the roof.

The tree on the right was painted with a mixture of phthalo blue and Winsor red, but I let the red dominate. For the tree on the left, I used the same mixture, but let the blue dominate. The shadow details on the house were painted using diluted vermilion and some phthalo blue. Note that similar to the trees, in some areas the red dominates and in others the blue has control. For the finishing touch, I added the birds as I felt that gave the painting that little extra sparkle of life.

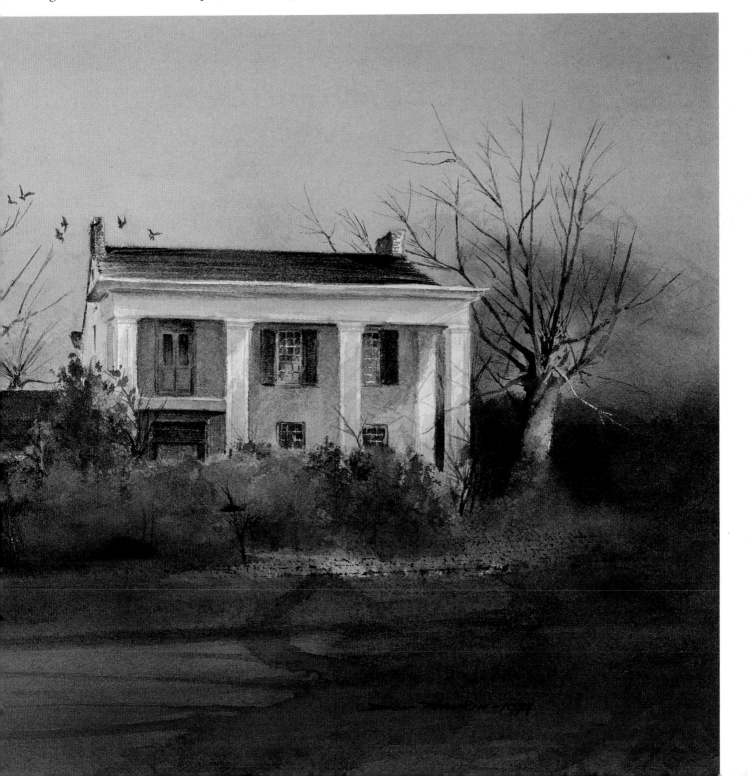

Painting from Sketches, Photographs, and the Imagination

PAINTING FROM MEMORY

This scene caught my eye as I was driving down the interstate. Because I had no time to photograph it, I kept its memory in my mind until I reached my destination. Once there, I immediately found a piece of paper and sketched in the elements of the scene from memory.

It had been a dark, rainy day when I encountered this barn in Pennsylvania. Although the lighting was subdued, some parts of the barn were glowing with reflected light. The effect of a dark, moody sky punctuated by spots of intense, warm light made this old barn a delightful subject.

My first thought was to capture the scene exactly, but puddles of water-reflecting side lighting added too much activity to the subject. Instead, I decided to simplify the subject into an assemblage of geometric shapes. The foreground became a horizontal mass of dark color, with very little detail; and the sky is a simple band of luminous color. The relationship between the shape of the sky and the foreground gives a sense of form to the painting.

South of Harrisburg was created with a controlled series of washes. The first wash of new gamboge virtually covered the entire sheet of paper. The near-black foreground received the heaviest concentration of color, which I used almost full strength. The mixture was comprised of a large portion of vermilion, with enough phthalo

blue and black India ink to create a rich chocolate brown. To lay in the foreground, I washed in a dark passage of color and allowed it to come to a nearly dry state. Then I dragged a bristle brush through the passage to roughen up the texture. To form the shadow on the side of the barn, a very diluted portion of this wash was used with little or no India ink.

At the same time as the foreground was being developed, the sky was washed in with a layer of manganese blue. The sunlit roof of the large barn was comprised of a mixture of diluted manganese blue and vermilion, while the sides of the barn and storage tank were painted with a mixture of diluted vermilion and new gamboge. In some areas manganese blue was used in the shadows of the storage tank. The rusted roof was achieved by mixing new gamboge, vermilion, and phthalo blue. Note that a limited palette was used very effectively to emphasize the moody effect of side lighting.

South of Harrisburg, watercolor, 30″ × 16″ (76.20 × 40.64 cm).

PAINTING FROM FEELING

This watercolor definitely falls into that category of work where imagination has held a greater sway over the image than have the facts of reality. Although this site actually exists, the work is the result of altering the scene a great deal.

The Stream Bed was painted quite a few years ago, but I still remember its inspiration: a dried-up river bed overgrown with various types of shrubs and scrub trees, and lit with a rather dazzling light that filtered through the leaves and bounced off the rocks.

To begin, I made some mental notes and began the watercolor without any pencil notations or preparatory sketches. This piece was more of a visceral approach to painting, somewhat akin to abstract expressionism where the artist is more concerned with shape and color than with depicting a recognizable image. Here, too, I was intrigued with the play of light and the movement of shapes and form. For example, in reality the tree had been situated on the riverbank, but in the painting it made more sense to place the twisting, light-reflecting tree form in the riverbed.

My palette was limited to Indian yellow, cadmium yellow, Hooker's green, phthalo blue, and vermilion. The surface was cold press, 140 lb. Fabriano, a smooth paper that behaves much like a hot press paper. For the uninitiated, this means that the color retains a little more brilliancy on the paper than more textured papers do. It is also much easier to disturb the previously applied layers of wash, as a smoother paper can prove to be a challenge if you intend to build up a number of color layers.

The *Stream Bed* began with an underwash of yellow in order to perk up the green that would be applied later; and washes in the upper portion of the paintings were applied diagonally, sweeping from left to bottom right. I did this partly as a design device and partly because I wanted to avoid painting the trunk of the tree. (Note that a great deal of the tree's highlight areas are the white of the paper.)

Once the yellow underwash was applied and had dried, I washed in a mixture of Hooker's green and a small amount of phthalo blue to the entire sheet. (Just enough blue was applied to keep the green from being too raw.) Then, only a few places, such as the tree trunk and some select rocks, remained uncovered. While the Hooker's green–phthalo blue mixture was drying, I began mixing the darkest values—a fully saturated wash comprised of Hooker's green and phthalo blue. This dark color was then applied directly to the dry paper. For the rust color seen in some areas of the rocks, I used a combination of Indian yellow and vermilion. Note that some of the darker rocks were painted over the earlier washes to help create a sense of depth and form.

Once the rocks were basically established, I turned my attention to the tree. The texture of the tree was created through a series of controlled washes; and much of the softer, muted passages were done in a wet into wet technique. When these washes were dry, I used additional line work with a fine brush to create the effect of wood grain. Also, many of the tree shadows are created from a combination of phthalo blue mixed with some vermilion to create gray.

Note that the highlight areas in the tree are very simply defined: light on one side, dark on the other. Some of the paler limbs were scraped out with an X-Acto knife, and the darker limbs were created from a mixture of vermilion, phthalo blue, and Hooker's green to create optical black.

The Stream Bed, watercolor 36″ × 28″ (91.44 × 71.12 cm)

Early Summer, watercolor, 28″ × 19″ (71.12 × 48.26 cm).

Index